ORCHIDS

The Library of Congress has catalogued the previous edition as follows:

Library of Congress Control Number: 2001134032
ISBN 10: 0-8109-0438-1

ISBN 10: 0-8109-5623-3 (reduced-format edition)
ISBN 13: 978-0-8109-5623-0

Created by Co & Bear Productions (UK) Ltd.
Editor: Alexandra Black
Design: Coralie Bickford-Smith

Printed and bound in China
10 9 8 7 6 5 4 3 2

HNA
harry n. abrams, inc.
a subsidiary of La Martinière Groupe

Harry N. Abrams, Inc.
115 West 18th Street
New York, NY 10011

OPPOSITE: Detail of *Anoecochilus Sanderianus*. (Nellie Roberts) 26.5.1897, Sanders, Herts.
PAGE 4: *Aspidonia Annabelle Ross 'Imperial'* (David Leigh) 28.4.1987, David Stead Orchids, Yorks.
PAGE 7: Illustration from *Orchidaceae of Mexico and Guatemala*, James Bateman.

ORCHIDS

FROM THE ARCHIVES OF

THE ROYAL HORTICULTURAL SOCIETY

BY MARK GRIFFITHS

ABRAMS, NEW YORK

CONTENTS

FOREWORD

By Joyce Stewart President of the World Orchid Conference Trust

O RCHIDS TODAY NEED LITTLE INTRODUCTION. Once rare, hard to find, and difficult to maintain in cultivation, flowers can now been seen in every florist's window and plants are offered in many supermarkets and garden centres. Most of them are hybrids produced in horticulture and sold at modest prices. Anyone can grow them – even on a windowsill in the home or office, if no glasshouse or conservatory exists.

The Royal Horticultural Society has been closely associated with orchids since its earliest days. Examples of extraordinary species from the wild, especially from tropical lowlands and mountains, were sent back to the Society's glasshouses at Chiswick in the 1830s. Some flourished, others failed, until growing techniques improved. Species and hybrids are grown in all the Society's gardens today; especially at Wisley, where there is always a fine display of plants in flower. Many have been illustrated in watercolours, over the years, but rather few of these drawings have ever been published – until now.

It is perhaps not widely known that members of the RHS with specialist knowledge are appointed every year to committees who, among other work, assess plants put before them to recommend awards. The Orchid Committee was formed in 1889 and it has been active ever since. We meet at the Society's flower shows in London and elsewhere and at specialist orchid shows throughout the country.

It was in 1897 that the Orchid Committee resolved that a record of their awards should be kept in the form of paintings in watercolour. This practice is still continued. A unique collection of more than 6000 orchid portraits is carefully curated in the Society's Orchid Room and is often referred to at current meetings. Perhaps the most remarkable are those completed by the first artist, Nellie Roberts, who worked for the Committee for more than fifty years. All are stunningly accurate.

Other illustrations of orchid plants and flowers have been acquired by the RHS as coloured drawings, paintings, and in colour-plate books and journals from a wide range of sources. These also form part of the treasures of the Lindley Library.

More than three hundred illustrations from these rich archives have been selected for this book. Mark Griffiths has prepared a stimulating text to accompany them. It is a pleasure to welcome this new look at orchid paintings preserved in the Royal Horticultural Society's collections, published now for everyone to enjoy.

ANGRAECUN SESQUIPEDALE

FROM THE WILD

FROM THE WILD

W HAT COULD POSSIBLY DO THE FOLLOWING? Steal the heart of the most famous coquette in modern fiction; entertain a legendary Secret Service chief on the rare occasions when he was not ensconced behind the green baize door; give the hardest-boiled gumshoe in town the creeps; send Biggles on a flight of fancy? The answer is 'orchids'. Marcel Proust, Ian Fleming, Raymond Chandler and Captain W.E. Johns are a small sample of the authors who have fallen under the orchid's spell. Some of them, like John Clare and Henry David Thoreau, confined their attention to the native orchids of the wild countryside they rhapsodised, and found in them tokens of an unspoilt beauty far removed from the world of man. But, for most of these authors, like most of their readership, the orchid's 'meaning' in the subliminal language of flowers could not have been further from the innocence of Nature, or closer to the sphere of human desires and intrigue. For them, the subtext of 'orchid' was not, as Thoreau thought it, 'fair and delicate, nymph-like', but something rather more like 'exotic, dangerous, extravagant, difficult, not quite of this world and, above all, sexy'.

When George Bernard Shaw wanted to describe 'The Improper Person of Babylon' (as he teasingly called her), he borrowed the word 'orchidaceous' from the realms of botany and horticulture. Arnold Bennett similarly pictured his fantasy courtesan as someone who, if properly kept, 'would become another being ... the same being, but orchidised'.

John Ruskin, who in his madder moments believed himself to be an arbiter of natural as well as art history, had already spotted the connection between orchids and sexuality. This link had existed in Europe since at least the fourth century BC. It derives from the similarity of many European orchids' tubers to the male genitalia; hence the ancient use of orchids as aphrodisiacs and, more enduringly, the name *Orchis* or orchid, which means 'testicle'. Ruskin did not like it one bit. The very name, orchid, he prudishly noted, was 'founded on some unclean or debasing association'. Ruskin proposed instead that we should call them ophryds, which he adapted from *Ophrys*. This is the scientific name of the genus that includes the bee, fly and spider orchids, a name which Ruskin held was entirely free of semiotic smut and suitable for use by ladies of even the most delicate sensibilities. But the term 'orchid', or *Orchis*, was too well-established to be displaced either in science or in folklore (where it had long lurked as the sign of a plant that both resembled men and was supposed to have power over them). More importantly, by the time Ruskin made his proposal, the orchid had acquired an entirely different and exotic mystique. Nobody listened to him.

To understand something of that mystique we must look to 1833 and a flower show held by the Horticultural Society of London, precursor to the Royal Horticultural Society. It was here that William Spencer Cavendish, sixth Duke of Devonshire, first beheld *Psychopsis papilio* (syn. *Oncidium papilio*), an orchid from Central and South America with liverish leaves and flamboyant – not to say menacing – tiger-striped blooms. Bewitched, the Duke resolved at once to devote his wealth and energies to building up the largest collection of orchids in the world. He began by hunting down plants that were already in cultivation.

At a time when exotic orchids were not only novel but also wreathed in tales of adventure and hardship, these were plants that enjoyed celebrity status and commanded correspondingly high fees. For one such specimen, a *Phalaenopsis* collected in the Philippines, Devonshire paid the plant hunter Hugh Cuming an astonishing hundred guineas. It is hardly surprising that he soon resolved to employ his own collectors. The Duke showed that mixture of connoisseurship and fanaticism that characterises all true orchid aficionados. He also showed the good sense to employ two men who were ideally qualified to help him in his new-found pursuit: Joseph Paxton, whom the Duke poached from the Horticultural Society's Chiswick gardens and appointed head gardener at Chatsworth; and John Gibson, who was Paxton's apprentice at the Derbyshire estate. Paxton would go on to supervise all the Devonshire

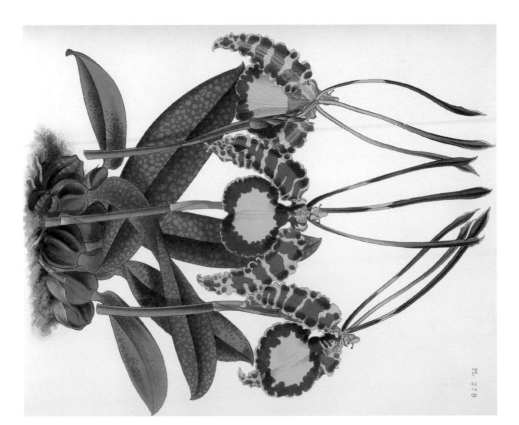

B S. Williams & Son, Publ^{rs}.

VANDA TERES ANDERSONI

J. Nugent, Fitch. del et lith.

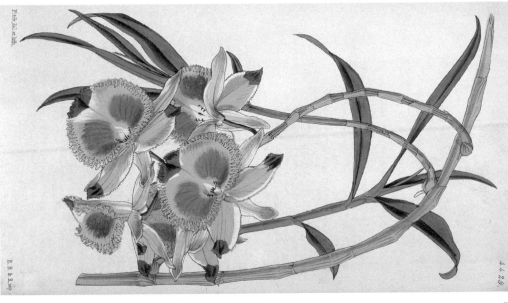

Fitch del. et lith.

R. B. & R. imp.

44.29.

PSYCHOPSIS PAPILIO
(syn. ONCIDIUM PAPILIO)

(Previous page) It was this species, widespread in the Tropical Americas, that first stole the heart of the sixth Duke of Devonshire at a Horticultural Society Exhibition in 1833, inspiring a passion for orchids that sparked Orchidmania, and moving the Duke to send his 'intelligent gardener' John Gibson to India to hunt for orchids. The popular name for this plant, butterfly orchid, is echoed and re-echoed in its scientific name which, translated, means 'butterfly-like butterfly'.

DENDROBIUM DEVONIANUM

(Left) Discovered by John Gibson while on his 1830s Indian expedition to hunt for orchids, this species was named by Gibson's colleague Joseph Paxton in honour of their employer, the sixth Duke of Devonshire. The names *devonianus* and *cavendishianus* both celebrate the Duke and are applied to many species that entered horticulture as a result of his patronage.

PAPILIONANTHE TERES
(syn. VANDA TERES)

(Opposite) Between 1835 and 1857, Gibson discovered dozens of new species, among them *Papilionanthe teres* (syn. *Vanda teres*). Crossed with *Papilionanthe hookeriana* (syn. *Vanda hookeriana*), this species produces *Vanda Miss Joaquim*, the most commercially successful orchid. It was this hybrid, produced by a Singapore grower in 1893 and named after his daughter, that launched the multi-million-dollar orchid 'industry' in Hawaii and Malaysia.

Mart: Drake del. Pub. by S. Ridgway 169 Piccadilly Dec: 1 1807. J. Sansom. sc.

ANOECTOCHILUS SETACEUS. Although we think of orchids as plants grown primarily for their exotic flowers, *Anoectochilus setaceus* is one of a group remarkable for its beautiful leaves. Known as 'jewel orchids', these plants with their colourful foliage were treasured as the gorgeous, if temperamental, aristocrats of many nineteenth-century Wardian cases and hothouses.

estates, become a successful horticultural publisher, design public works (most famously the Crystal Palace built for the 1851 Great Exhibition), gain a knighthood and the less formal title of 'Prince of Gardeners', and sit as Member of Parliament for Coventry. In the early 1830s at Chatsworth, however, he was charged with devising methods for keeping alive the Duke's new-found loves. He began with three stove houses in which the plants were plunged in beds of tanbark and kept at sweltering temperatures. This practice had been generally accepted as the only way of growing exotic orchids, even when the plants themselves were known to hail from temperate climates and thrive in cool conditions – the casualty rate was predictably high. Dissatisfied, Paxton looked for more rational cultivation techniques. He began to experiment basing his new approach partly on what he learnt of orchid habitats and growth habits from correspondence with John Lindley, the Secretary of the Horticultural Society and 'Father of Orchidology'.

Still more influential in Paxton's orchid revolution were the discoveries of the Duke's other 'intelligent gardener', John Gibson, who had been sent to India in 1835 to hunt for orchids and other exotics for the Chatsworth collection. Between 1835 and 1837, Gibson encountered dozens of orchid species that were new to science and horticulture, including *Anoectochilus setaceus*, *Dendrobium densiflorum*, *Phaius albus* and *Vanda teres*.

Among Gibson's discoveries were three *Dendrobium* species that were named, appropriately enough, *D. paxtonii*, *D. gibsonii* and *D. devonianum*. This last epithet, *devonianus, devoniana, devonianum*, is one of the most commonly encountered commemorative orchid names, as is *cavendishianus*. Both celebrate the Duke of Devonshire under whose patronage modern orchid growing began.

Back at Chatsworth, Gibson's discoveries had to be housed – and housed with some awareness of the cool, humid and buoyant conditions he had found in the hills of Assam. Paxton lowered the temperatures in the Duke's glass-houses and increased the ventilation. In time he would pioneer the system of growing orchids in separate quarters – cool, intermediate and warm – according to their origins and climatic needs. He would also develop more open composts and promote the use of rafts and baskets, successfully simulating the rooting conditions of many of the newly introduced orchids, which were either epiphytic or lithophytic. Paxton imposed his new cultural regime beneath the vaulting spans of one his most revolutionary constructions, the Great Stove. Visitors found themselves deceived by its name: the atmosphere within was comfortable, fresh, almost breezy. Chatsworth soon became home to the largest and most flourishing orchid collection in the world and the Duke, as patron to numerous plant hunters and through his presidency of what became the Royal Horticultural Society, stood first in a succession of giants who bestrode the orchid world in the nineteenth century, and oversaw its development from cult to craze.

Although the seeds of Orchidmania did not begin to germinate until 1833, exotic (i.e. non-native) orchids had been percolating into Western European horticulture for over two hundred years. For example, in *Theatrum Botanicum* (1640), John Parkinson, herbalist and gardener by appointment to Charles I, describes 'the great wilde hellebor or *Calceous Mariae Americanus* a North American slipper orchid that is almost certainly *Cypripedium reginae*. According to Parkinson, it differs from the native North European *Cypripedium calceolus* 'onely in being greater both in the stalkes

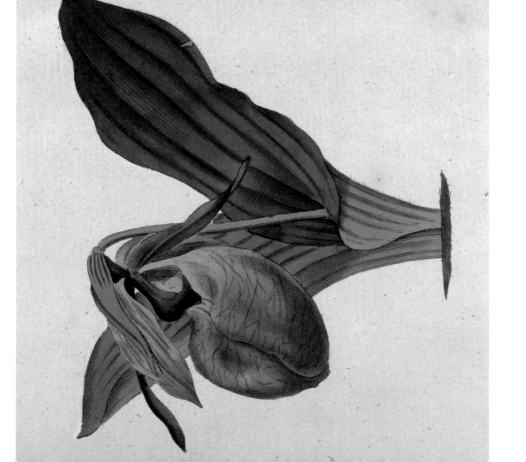

CYPRIDEDIUM REGINAE
(Right) This North American slipper orchid
was sent to England by British colonists
and appeared in John Parkinson's *Theatrum
Botanicum* of 1640 described as '*Calceolus
Mariae Americanus*'. Parkinson remarked
on its similarity to our native lady's slipper
orchid, *Cypripedium calceolus*, noting that
it differed in being larger and in bearing
flowers that 'are not yellow but white, with
reddish strakes through the bellies o' them'.

CYPRIPEDIUM ACAULE
(Opposite) A native of Eastern North
America, this was possibly among the first
exotic orchids to come to the notice of
British gardeners. With the recent growth
of interest in hardy orchids, it is once again
attracting attention. As long ago as 1793,
William Curtis described its somewhat
fastidious requirements: 'it requires a little
extraordinary care in its culture: its roots
should be placed in a pot filled with loam
and bog-earth or rotten leaves well mixed
and plunged in a north border'.

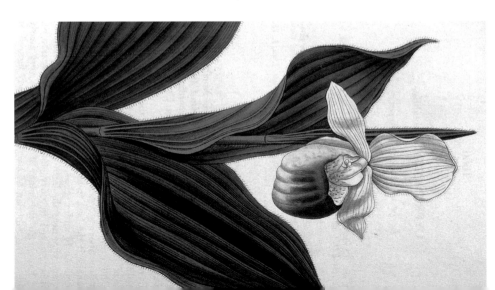

PHAIUS TANKERVILLEAE (syn. P. WALLICHII) Writing in 1888, Sir Joseph Hooker remarked that this plant (which he named *Phaius wallichii*) had 'far surpassed' *Phaius grandifolius*, a species which 'was in my younger days considered to be the finest orchid in cultivation'. In fact the two are forms of the same species, *Phaius tankervilleae*. This was one of the earliest orchids to arrive in Europe from the Far East, introduced to England from China in 1778.

and leaves, and flowers which are not yellow but white, with reddish strakes through the bellies of them'.

In the seventeenth century, it was the Dutch, however, who were the true pioneers of plants that were exotic in both its true sense of 'foreign' and its more demotic sense of 'having an outlandish appearance redolent of warm and faraway places'. Chief among Dutch collectors of exotics was Gaspar Fagel, some of whose collections were acquired by William of Orange and grown to spectacular effect at Hampton Court Palace once William ascended the English throne with his wife Mary One of Fagel's oddest prizes was a white-flowered succulent from Curaçao that apparently grew like mistletoe on the boughs of trees. As was then customary, it was given the prolix name *Epidendrum curassav-icum folio crasso sulcato* ('tree-dweller from Curaçao with fleshy, grooved leaves') and featured in Paul Hermann's *Paradisus Batavus* (1698). It was not until 1831 that John Lindley gave this orchid the name by which it is still known today, *Brassavola nodosa*.

One hundred years before Lindley christened Fagel's orchid, London had been the scene of what is generally thought to be the exotic orchid introduction to Northern Europe for which there is substantial documentation. In 1731 a specimen of *Bletia purpurea* was sent to the merchant and plantsman Peter Collinson from Providence Island in the Bahamas. The orchid arrived in London in a sadly desiccated state, but its corm-like pseudobulbs soon returned to life in the damp comfort of a bed of rotten bark, and, a year later, bore charming rosy purple flowers. Thereafter the pace of orchid arrivals quickened. Orchids sent to Kew from the West Indies in the 1760s included *Epidendrum rigidum* and *Vanilla*. In 1778 John Fothergill returned from China with the first Asiatic orchids to arrive in England, *Cymbidium ensifolium* and *Phaius tankervilleae*. Amid great excitement, the second produced tall spikes of buff and wine-red flowers in the custody of Fothergill's niece in Yorkshire.

A decade later, Kew was cultivating fifteen exotic orchid species and had coaxed the first epiphytes into flower. These were the green and maroon cockleshell orchid *Encyclia cochleata* which, once it starts flowering, rarely stops, and the deliciously scented, ivory and purple *Encyclia fragrans*. Neither of these, however, had quite the impact of another New World epiphyte when it flowered at Liverpool Botanic Garden in the early 1810s. With extravagant, gorgeously coloured flowers, cattleyas are for most people the archetypal orchids. The Liverpool plant, then still an unnamed oddity from São Paulo, was the first *Cattleya* to flower in Europe – not that it was recognised as such.

In 1812, the London nurserymen Conrad Loddiges and Sons of Hackney began growing exotic orchids commercially, becoming the first to do so in Europe. Loddiges featured Liverpool's marvellous plant in the *Botanical Cabinet* (1819), naming it *Epidendrum violaceum*. It had been the custom among botanists since the late seventeenth century to classify epiphytic and lithophytic orchids more or less indiscriminately as *Epidendrum* ('plants on trees'). In the early nineteenth century, orchid classification became more discriminating. This was made necessary by the influx of new species (by 1813, for example, Kew's living orchid collection had risen to forty-six species from the Tropics and twelve from the subtropical and temperate Southern Hemisphere), and made possible by the diligence and judgment of the botanist John Lindley, One of Lindley's early patrons was William Cattley, a wealthy North London merchant and assiduous collector of exotic plants. Cattley paid Lindley to draw and describe the finest of his collection, foremost among which was an orchid with extraordinarily large flowers, their tepals crepe-like and lilac-mauve, the lip funnel-shaped, lacy-edged and stained with ruby and gold. When this plant first flowered in November 1818, Cattley hailed it as 'the most splendid, perhaps, of all Orchidaceous plants' – an opinion many would still uphold. It had not been

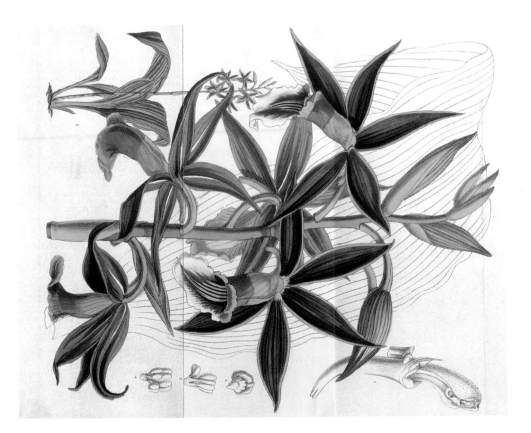

ENCYCLIA CORDIGERA
(SYN. EPIDENDRUM MACROCHILUM)

(Left) Widespread in the Tropical and
Subtropical Americas, members of the
genera *Encyclia* and *Epidendrum* were in
the second wave of exotic orchids to be
introduced to British gardens. *Encyclia
cordigera* was certainly known to European
scientists as early as 1805, although it was
not officially named (by the botanist Karl
Sigismund Kunth) until the same year as
the Battle of Waterloo.

RHYNCHOLAELIA GLAUCA
(SYN. BRASSAVOLA GLAUCA)

(Opposite) The orchid hunter John
Henchman first found a solitary example of
this species growing in Xalapa, Mexico. Soon
after, Karl Theodor Hartweg, collecting on
behalf of the Horticultural Society of London,
discovered it in quantity and sent plants back
to London in 1837. One plant flowered at
the Society's garden in Chiswick, providing
the subject matter for this plate. According
to orchid connoisseur James Bateman,
vast numbers of this species, together with
other Mexican succulents and air plants,
were offered in London at soaring prices by
the dealer Deschamps. When it became clear
that Londoners had had their fill, Deschamps
sold parcels of the orchids in the provinces
at greatly reduced rates: 'The author himself
purchased in a country town, a set of at least
twenty kinds for a sum which, in the metro-
polis, he had in vain tendered for only two.'

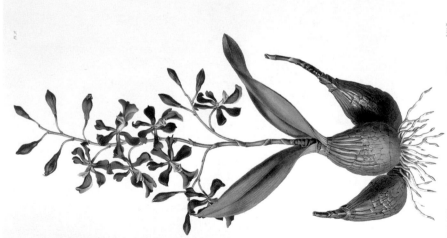

EPIDENDRUM MACROCHILUM var ROSEUM.

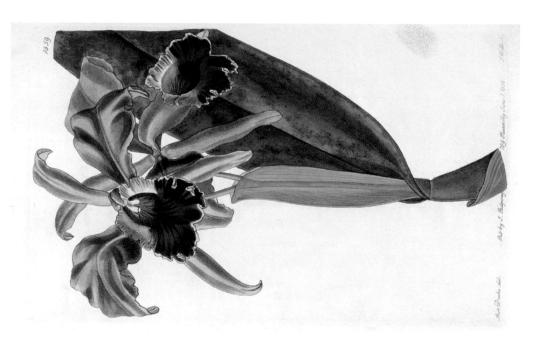

1659

Miss Drake del.

Pub. by J. Ridgway, Piccadilly, June 1, 1834.

Swan sc.

CATTLEYA LABIATA In 1818 the British naturalist William Swainson sent numerous botanical novelties from the Organ Mountains near Rio de Janeiro to his sponsor, William Cattley, one of the first Western orchid hobbyists. They were packed using some rather tough but nondescript vegetation, which the curious Cattley planted. A year later he was astonished when it flowered into an orchid that was larger and more luminously lovely than any he had seen. Cattley's protégé, the young John Lindley, named the new genus Cattleya in his honour, and this species labiata, in recognition of its satiny and extremely showy lip.

intended for such praise, however. When William Swainson, the plant's discoverer, had encountered it on the Organ Mountains near Rio de Janeiro in 1818, he did not see it in flower and was unimpressed. But there were plenty of other Brazilian plants that did interest him, and Swainson sent these back to England using the orchid's tough leaves and pseudobulbs as packing material. Cattley had the presence of mind to investigate and try growing what he was meant to throw away. He was richly rewarded.

In 1821 John Lindley took this species as the type of a new genus, naming it Cattleya for his patron, and labiata in recognition of its ample and gloriously colourful lip. He published it alongside a second Cattleya species, the very same plant that had bloomed in Liverpool a decade earlier. Lindley named it Cattleya loddigesii in honour of the Hackney nurseryman. Cattleya labiata continued to be the stuff of legend. Soon after its discovery, the orchid's natural habitat was lost as a result of deforestation, coffee planting and so forth – a tale only too familiar today. No sooner were new locations discovered than they suffered the same fate. Several new species were found that were capable of competing with the true Cattleya labiata in the flamboyance stakes. Some of these, like Cattleya mossiae and C. trianae, were even passed off as the true labiata, but few growers were fooled.

True Cattleya labiata was last seen in the late 1830s, then lost and rediscovered in 1891 when, through the offices of nurseryman Frederick Sander and auctioneers Protheroe and Morris, it returned to European horticulture in its thousands, with who knows what impact on its status in the wild. Cattley's orchid made its comeback in time for Marcel Proust to make it the favourite flower of Odette de Crecy in Un Amour de Swann, a fact Vladimir Nabokov relished:

This rose-purple mauve, a pinkish lilac, a violet flush, is linked in European literature with certain sophistications of the artistic temperament. It is the colour of an orchid, Cattleya labiata ... an orchid, which today, in this country [1950s USA], regularly adorns the bosoms of matrons at club festivities. This orchid in the nineties of the last century in Paris was a very rare and expensive flower. It adorns Swann's lovemaking in a famous but not very convincing scene.

Orchidmania might well have reached epidemic proportions in the 1820s: Cattleya labiata galvanised the gardening world. Loddiges was soon joined by other nurseries specialising in orchids; the Horticultural Society opened an 'orchid house' at its Chiswick gardens and held popular exhibitions of these new arrivals with their sensational flowers and strange growing habits. But the craze was kept in check by the fact that attempts to grow epiphytic orchids usually ended in dead plants and disappointed gardeners. Orchid growers had yet to benefit from the horticultural acumen of a Joseph Paxton.

For the time being, orchid fanciers laboured under the delusion that all foreign orchids needed to be grown in a stew of rotting bark and broiling heat. In the annals of orchid growing's muddled infancy, it is possible to find even stranger misapprehensions. John Lindley, for example, told his readers to grow Far Eastern Calanthe species in a 'stove' and mounted on bark or wooden rafts as if they were 'air plants'. He knew perfectly well that these plants hailed from the floors of cool mountain woodlands, but the mystique of the orchid somehow seems to have come between him and common

LAELIA ANCEPS The Father of Orchidology, John Lindley named the genus *Laelia* after one of the Vestal Virgins. *Laelia anceps*, which he first described in 1835. A native of Mexico and the Honduras, it quickly became popular in Europe due to its sturdy nature and habit of flowering in the dead of winter. Variants of this species range in colour from deep magenta to pale rosy lilac with a gold- and purple-flushed lip. Pure white forms are especially valued.

sense. Similarly, when in 1830 the Horticultural Society made public its research into orchid cultivation (conducted under Lindley's direction), it failed to mention that prime requirement of almost all orchids – ventilation. Since Lindley's authority was considered infallible, money and plant life went to waste. Then came 1833 and the Duke of Devonshire's epiphany. A few years after the Duke threw himself into orchid collecting at Chatsworth, his gardener, Joseph Paxton, began publishing the results of cultivation experiments in *The Magazine of Botany*, one of several publications he founded. For three decades frustrated in their attempts to keep these most desirable of plants alive, the orchid-growing public took heart. Before long a new breed of commercial nursery emerged ready to supply an exponentially rising demand.

Companies like Backhouse, Veitch and Loddiges ceased to be fringe players in one of horticulture's more arcane branches and instead became responsible for introducing hundreds of new species from the wild and making them available to any gardener with means and curiosity. To meet the new demand, these nurseries followed the example of the Duke and other great amateurs like James Bateman of Knypersley Hall in employing their own collectors. A new 'profession' was born, perhaps the most colourful of any linked with gardening – the orchid hunter.

The science of orchid propagation was young. Once in cultivation, plants could only be increased by division or by seed, and both were still slow and erratic procedures. As a result, almost all plants sold at the height of Orchidmania were mature specimens collected from the wild. Intense rivalry existed between commercial orchid nurseries, and between the collectors who were their suppliers. A new sighting of an old plant (like *Cattleya labiata*) could transform a nursery's fortunes. Reports of new discoveries stimulated insatiable demand at home and led to bitter battles among orchid hunters as they raced, often through hazardous and uncharted territory, to claim their prizes. A communiqué on the subject of a rival sent to the collector Arnold by his employer Henry Frederick Conrad Sander, The Orchid King', captures the spirit of competition and combat that prevailed:

Since the fellow has behaved so loutishly we must do all we can to get even. I hope that before you get these lines you will be on the way to Merida and get there ahead of White [the rival, Low's collector]. Just do the fellow down.

The least attractive aspect of this rivalry was the common practice among orchid hunters of destroying any orchids that they encountered but were unable to ship home, thus spoiling not only their competitors' chances of success, but also irreplaceable orchid habitats. Not that we should assume such vandalism was always necessary. As they became more organised, orchid hunters were followed by trains of bearers and mules and awaited at the nearest port by sizeable cargo ships. It was quite possible for a collector to remove an entire orchid population and despatch it to the clamouring public. In Colombia, for example, a single hunt for one of the period's most fashionable orchids, *Odontoglossum crispum*, entailed felling 4000 trees, from whose boughs 10,000 plants were culled.

In 1895, the collector Carl Johannsen reported from Medellin, 'They [the orchids] are now extinguished in this spot and this will surely be the last season. I have finished all along the Rio Dagua where there are no plants left;

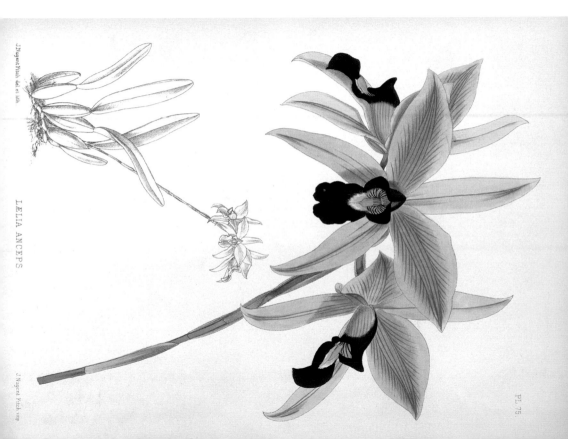

J.Nugent Fitch del. et lith.

LÆLIA ANCEPS

J. Nugent Fitch imp.

PL. 75.

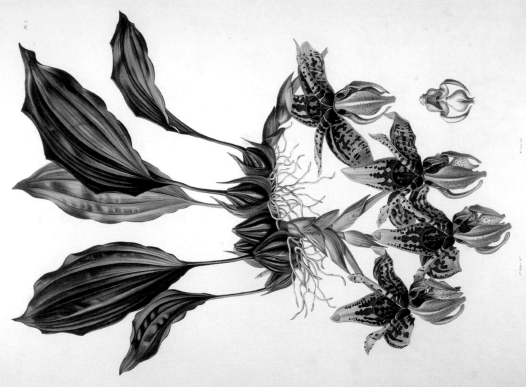

STANHOPEA TIGRINA.

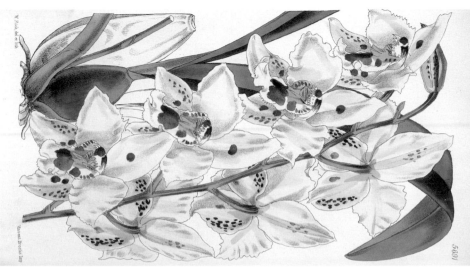

W. Fitch del. et lith.

Vincent Brooks Imp.

5691

ODONTOGLOSSUM CRISPUM (syn. ODONTOGLOSSUM ALEXANDRAE var. TRIANAE)

(Left) From the moment it was discovered in 1841, *Odontoglossum crispum* became an orchid of near-mythical status. It was found at elevations of 2000–3000 metres in the Colombian Andes by Karl Theodor Hartweg, a German-born collector working on behalf of the Horticultural Society of London. The purity of its blooms and its tolerance of (indeed, need for) cool temperatures won it instant popularity, and millions of plants were stripped from the wild as a result. In 1861 José Triana of Bogotá came across this striking form which was named after Alexandra, Princess of Wales.

STANHOPEA TIGRINA

(Opposite) One of the most spectacular orchids, *Stanhopea tigrina* produces huge waxy flowers that develop at visible speed, open with an audible 'plop', emit an overpowering perfume of Swiss chocolate and then collapse and wither in the space of a few days. James Bateman, who first flowered it in his hothouse in 1837, reported that it had been discovered two years earlier by John Henchman in Xalapa, Mexico, 'in the cleft of an aged tree in a deep and dismal glen'.

J.Nugent Fitch imp.

CYPRIPEDIUM FAIRRIEANUM

J.Nugent Fitch del. et. lith.

PAPHIOPEDILUM FAIRRIEANUM (syn. CYPRIPEDIUM FAIRRIEANUM) After arriving in Britain from Assam, this slipper orchid soon became loved for its diminutive stature and strikingly veined flowers. Writing in *The Gardeners' Chronicle* in 1857, John Lindley explained it was shown at the late exhibition of the Horticultural Society in Willis's Rooms by Mr Fairrie of Liverpool, an enthusiastic collector of orchids, who we think may fairly claim the union of his name with that of the vegetable gem before us'.

the last days I remained in that spot the people brought in two or three plants at a time and some came back without a single plant.' Sometimes these raids were an even greater assault on biodiversity than might be imagined – as when Roebellin's haul of 21,000 Philippine *Phalaenopsis* was destroyed in a hurricane before he could send them to the 'safety' of Europe; or when a ship full of *Dendrobium* collected by Wilhelm Micholitz caught fire in port in the Celebes.

Those orchids that did arrive safely were the property of the nurseries that had sponsored the collectors, but their route into the retail market was often through specialist auction houses which stage-managed spectacular public sales. For example, *Paphiopedilum spicerianum*, a subtly beautiful slipper orchid from Assam had been discovered in the wild once, only to be lost to the world. Then, without warning, one of the few plants that had survived from the original collecting trip flowered in the hothouse of a lady in Wimbledon, inciting unparalleled lust in the orchid-growing community. Sander lost no time in sending his collector Forsterman into the field to find more.

The orchid hunter's quest was not easy. So densely forested were the slopes where Forsterman suspected the plant grew that he was forced to ascend them via freezing mountain streams. When at last he found the elusive slipper orchid perched atop a crag, his porters refused to help him gather it – until that is, he had agreed to return to their village to shoot a man-eating tiger that had been preying on them. The tiger was duly despatched, as were the orchids: Sander sold 40,000 plants of *Paphiopedilum spicerianum* in one day. In its native India, the species has yet to recover from a fad that began in a South London garden. Much of this exotic booty went under the hammer courtesy of Protheroe and Morris, the most celebrated of all the auction houses that dealt with orchids. It was under their aegis that the much-coveted and long-lost *Cattleya labiata* made its return, having been re-introduced by Sander. It was, they trumpeted, 'the true old plant of Swainson', 'the true typical plant'. Two thousand specimens sold at a stroke.

Around this time, Sander was receiving as many as 300 cases of cattleyas per month at his St Albans nursery. To put this in perspective, Sander's British site was one of three (the others being in Bruges and New Jersey); the orchids were transported bare-root and packed tightly together. *Cattleya* is only one genus of hundreds in which Sander dealt. Orchidmania, the pursuit of the rare, exotic and exclusive, had become an industry.

The mass market for orchids had been developing since the 1850s, when technical innovations coupled with an influx of cool-growing species put orchids within reach of the middle classes. Writing in Paxton's *Magazine of Botany*, Donald Beaton urged 'amateurs o' limited means to cultivate a few beautiful plants of Orchideae; for hitherto this fine tribe of plants has only been enjoyed by the wealthier classes'. In 1851, Benjamin S. Williams contributed a series 'Orchids for the Millions' to the *Gardener's Chronicle*, and followed it with his *Orchid Grower's Manual*, which ran through seven editions between 1852 and 1894.

Although thousands (not millions) took their cue, the cachet of orchids went undiminished until the end of the Edwardian era. Orchid hunting continued; hundreds of guineas could still change hands for a single plant; and orchid amateurs continued to rarked the eminent and rich among their number. One of the most famous of these luminaries was Joseph Chamberlain, whose magnificent collection at Highbury near Birmingham kept him s supplied with buttonholes (*Odontoglossum crispum* for preference) that were as much a trademark of the British statesman as his supercilious monocle. In 1903 London's Gaiety Theatre found it had a hit on its hands when it burlesqued Chamberlain's hobby, in *The Orchid*, a musical comedy about a plant hunter's struggle to deliver a

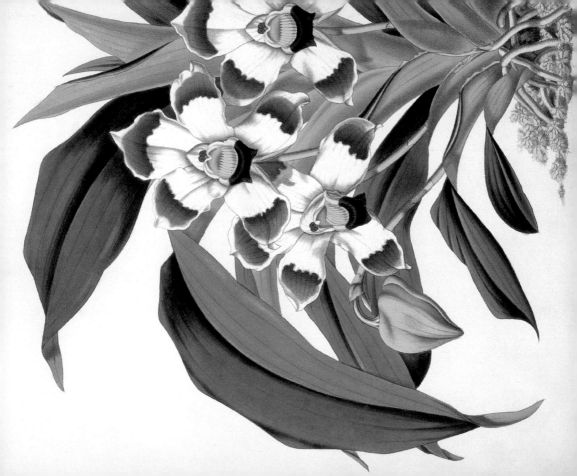

BOLLEA LAWRENCEANA

A denizen of the western Andes, *Bollea lawrenceana* belongs to a distinctive group of South American orchids with waxy flowers carried on fans of foliage. This species and the related *B. coelestis* are among the so-called 'blue' orchids, their flowers suffused with lilac, opal and amethyst tones. They are also heavily scented with accents of hyacinth. The name *lawrenceana* commemorates Sir Trevor Lawrence (1831–1913). Serving as president of the Royal Horticultural Society for twenty-eight years, Sir Trevor built up a world-famous collection of orchids at his home, Burford Lodge in Surrey.

LAELIA PURPURATA (syn. LAELIA CRISPA VAR. PURPUREA) *Laelia purpurata* is one of the larger, *Cattleya*-like laelias, together with the white-tepalled and purple-lipped *L. crispa* and the bronze and rosy-purple *L. tenebrosa* – all of them native to Brazil. In the mid-nineteenth century, gardeners came to understand *Laelia purpurata*'s needs for brilliant light and a fast-draining, well-aerated compost, and so the plants were grown in terracotta 'baskets' hung high in the glasshouse with their potting medium of coarse peat renewed every two years.

particularly choice specimen to one Aubrey Chesterton, Minister for Commerce. Reactions to the orchid's elitist ethos were not always so good-humoured. In 1900, Chamberlain's own gardener, H.A. Burberry grumbled:

Why are orchids generally supposed to be an expensive luxury and out of reach of all save the most wealthy? I think these notions have arisen from the fact that when orchids are written about in newspapers and periodicals, they are invariably associated with the name of some well-known and wealthy individual.

Thirteen years later, Suffragettes stormed Kew's orchid house smashing glass, pots and plants. As if to confirm Burberry's suspicions, the press summoned all its outrage on behalf of orchids and the Establishment – 'Mad Women Raid Kew' (*Daily Express*); 'Orchids At Kew Ruined' (*Evening Standard*). But the women's actions struck a chord with some who were beginning to identify orchids with a privileged and passé patriarchy.

Orchid hunting dwindled in the 1910s as a result of several factors. Two of these were welcome: we were beginning to master the art (if not yet the science) of propagation; hybrids were beginning to match species in popularity. Both relieved the pressure on wild orchid populations, and both were trends that continued throughout the twentieth century, giving rise to many of the beautiful plants featured here.

The other factors contributing to the demise, not only of orchid hunting as a profession but of Orchidmania itself, were less happy. Many of the habitats that orchid hunters had plundered with such determination only decades before were now denuded. In rainforests, on cloudy mountain tops, in mangrove swamps and savannah the world over, the cupboard was bare. Had Nature's supply been undiminished, Orchidmania would still have ended with the outbreak of World War I. Hothouses were abandoned when fuel prices rose as a result of the war, and the legions of gardeners needed to maintain them became horticulture's new and tragic rarities as they went to the Front. The last throe of gardening's grandest craze came in 1920, when another Duke of Devonshire, despairing of the state of his collection, ordered Chatsworth's Great Stove, Paxton's first masterpiece, to be demolished.

Over the century that followed, the orchid has risen phoenix-like from the Great Stove's shattered panes and twisted girders. We have perfected the skills of growing, increasing and crossing them, and all genuinely within the means and capabilities of millions. New species have been discovered and lost species have been rediscovered. These too have taken their place in our collections. But they have arrived there, in recent years at least, largely by ethical routes as we have sought to protect the well-being of orchids in the wild – a pressing priority that would have baffled the heroes (and villains) of Orchidmania. Despite their new-found familiarity and availability, orchids have lost none of their mystique. It is, perhaps, a mystique that derives not from the nineteenth century and all its tales of expense, rarity and, derring-do, but from the plants themselves and our millennia of interaction with them.

The cult of the orchid first took root thousands of years and miles away from the hothouses of Europe and North America. Far in spirit from our own ravening Orchidmania, it was rather a thing of the mind, intimately associated with philosophy and the arts. The oldest surviving mention of orchids was made in China around 800BC. It consists of a series of allusions to a graceful, highly perfumed plant – possibly *Spiranthes sinensis* or a *Cymbidium* species – and appears in the *Shih Ching*, a book of poems. But it was Confucius who, three hundred years later, elevated the orchid

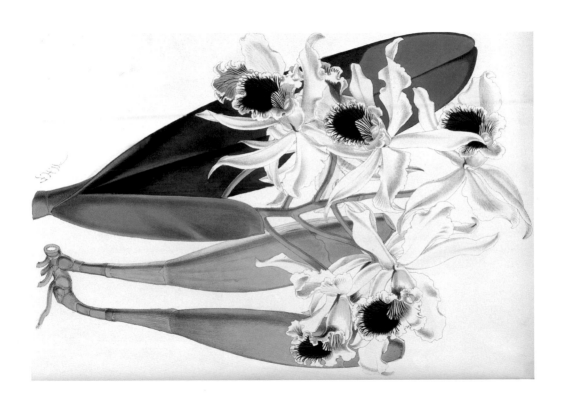

Plate XI

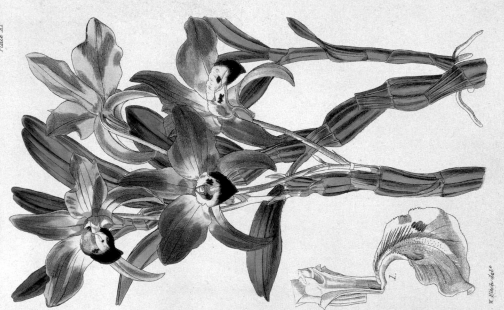

W. Fitch del.

Dendrobium moniliforme

DENDROBIUM MONILIFORME In its native Japan, *sekkoku* (*Dendrobium moniliforme*) has been a well-loved garden plant since the sixteenth century at least, when it was grown as a form of living air freshener, its flowers perfuming the houses of the aristocracy. While the typical plant is white-flowered, numerous forms of *m.* have been developed, some of them brilliantly coloured in shades of yellow, pink and rosy-mauve.

to the exalted position in the Chinese floral hierarchy that it has enjoyed ever since. For Confucius, orchids (*lan*), and especially *Cymbidium goeringii*, symbolised simple elegance. They were the living embodiment of the type of austere refinement he offered as one ideal of human development. The orchid was the top plant and the top person's plant, but, importantly, nobody was talking about the sort of exuberantly colourful equatorial extravagances that would deck the hothouses of Europe more than two millennia later. Confucius's orchids were quiet, unassuming; their superiority, like that of the persons who praised and grew them, was a thing best left unstated. While the slender arching leaves of *lan* and their bowing, subtly beautiful blooms were a model for scholarly and decorous behaviour, their fragrance earned far more extrovert praise. Indeed, theirs is a strangely mutable perfume, varying in intensity throughout the day from scarcely noticeable at dawn to sharply strident in the afternoon and seductively pervasive at dusk, and shifting through many notes from jasmine-like to spicy, from scapy to citrus. Accordingly the odour of *lan* was many things – an emblem of virtue, the 'king of perfumes', a perfume fit for kings, an augury of successful lovemaking, and, as can be seen in this quote from the *I-Ching*, a metaphor for friendship:

Words spoken between true friends
are as sweet as the perfume of orchids.

So positive was the power of the orchid and all associated with it that *lan* came to be used in philosophical and poetical texts as a highly affirming prefix. For example, *lan-yu* meant 'close friend'; *lan-chang*, 'bountiful harvest'; and *lan-hsin*, 'elegant woman'.

Two orchids, *Cymbidium ensifolium* and *Dendrobium moniliforme*, appear in the earliest surviving Chinese work devoted to botany, *Nan-fang T'sao-mu Chuang*, written by Ki Han, an imperial minister of state circa 300AD. By this time *lan* (in the sense of *Cymbidium*) was firmly established as the premier icon of Confucian culture, the subject of poems, ethical treatises, paintings and calligraphy. When, some time in the fourth century, Wang Xizhi, the celebrated Chinese calligrapher, decided to hold a contest to test the skills of his fellow poets and calligraphers, he did so at the Ran-tei ('The Orchid House'). His brushwork describing the occasion remains a model for calligraphers to this day.

Its cultural ethos aside, the orchid was also of great horticultural interest. Plants with especially fine or distinctive scent, foliage and flower colour were carefully selected and lovingly cultivated. Their descendants (essentially the very same plants) are still cherished as family heirlooms. The earliest works devoted to orchids and their cultivation were composed around the turn of the first millennium. During the Sung Dynasty (960–1279), orchid growing burgeoned in China, leading to the discovery of new species, the development of new cultivars, the refinement of growing techniques and the publication of a wealth of horticultural literature, one example of which was *Lan Pu*. A treatise on orchids produced by Wang Kuei-hsueh in 1247; it accounts for thirty-seven different orchid species and cultivars. It is also refreshingly matter-of-fact or, the subject of the orchid's superiority:

CYPRIPEDIUM MACRANTHOS VAR. SPECIOSUM In Japan *Cypripedium macranthos* var. *speciosum* is known as *Atsumoriso*, after the historical figure of Taïra Atsumori, a youthful warrior of the Heike clan who was killed at the battle of Ichinotani in 1184.

Bamboo has elegant stems but no flowers; the plum has flowers but ugly leaves; but the orchid, it has an elegant stem, fine leaves and flowers that are both beautiful and fragrant.

After the Sung, the orchid in art continued to acquire ever-greater delicacy of depiction and an ever-greater burden of symbolism – as can be seen in a famous painting of *Cymbidium goeringii* made in 1306. The image consists of a handful of scimitar-like strokes in sage-green ink representing the orchid's leaves with, at their centre, a solitary flower. Its lip is picked out in black to echo a text which explains that the plant is a symbol of classical Chinese values – values which survive only with difficulty, their proponents having been deracinated by Mongol incursions. (The orchid has no roots and no roothold.) The pessimism of the rootless orchid notwithstanding, *lan* continued to dominate Chinese traditional horticulture. In the sixteenth century, when the English were making their first major forays into botanical and horticultural literature, the Chinese were into their fifth century of producing popular orchid-growing manuals, some of whose titles (*A Monthly Cultivation Guide for Orchids*, *Orchid Talks*) would not be out of place today. Throughout wars, invasions and cultural revolutions, *lan* has remained China's pre-eminent plant. Neither the orchids themselves nor the methods of growing them have changed greatly in nearly three thousand years.

In 1999 the Japanese orchid expert Takaki Kamiya launched Ojako-no ko-rankai, a society for the appreciation of *Cymbidium* species that are native to China and which have been grown there since antiquity. The society takes its name from 'ojako', Confucius's famous description of *Cymbidium goeringii*, which means 'king of fragrance'. Its foundation is the most recent flowering of Japan's centuries-old fascination with China's orchids.

In all likelihood Japan first gathered the idea of the orchid as a plant of great aesthetic and spiritual value from the Chinese. Some of China's orchids – cymbidiums especially – enjoy a privileged position in Japanese horticulture, while also manifesting themselves in painting and poetry much as they do in their native country. One would be wrong, however, to assume that Japan's orchid growing tradition (the second oldest in the world) follows China's example slavishly. Japan's *ran* is not the same as China's *lan*. While China's orchids are appreciated in Japan, several of the best-loved among them (*Cymbidium goeringii*, *Dendrobium moniliforme* and *Bletilla striata* to name but three) are also native there. Inevitably this gives rise to a certain degree of overlap in the subjects of the two horticultural traditions, if not in the actual practice. But Japan also has a rich orchid flora entirely of its own, native mythic and social conventions surrounding the plants, and home-grown methods of cultivation and display that are no less than an art form. As a result of their nation's centuries of seclusion, Japanese growers focused on native orchids, mastering their upkeep, employing exquisite connoisseurship in the selecting of cultivars, and even breeding the first artificial hybrids (an achievement to which the British like to lay claim). When the first exotic orchids (*yoran*, the orchid equivalent of *gaijin*, or foreigners) were introduced to Japan in the late nineteenth century, the cultivation of native orchids using traditional methods continued unchallenged. Today it remains the pinnacle of classical Japanese horticulture.

Unlike China's, Japan's orchid culture was not especially well-documented until the eighteenth century. Legend offers an explanation of *Jusan taiho*, the vernacular name of *Cymbidium ensifolium*, meaning 'thirteen great treasures' – an Emperor's wife, long thought barren, conceived the first of her thirteen children after breathing in its ravishing scent. Orchids flourish in such fables, and spring up from time to time in poetry and painting. They also feature in *De Materia Medica*, a reminder that, in the Orient, orchids were and still are sometimes of greater medicinal than ornamental value. That the Japanese had been growing orchids for something like a thousand years can be largely

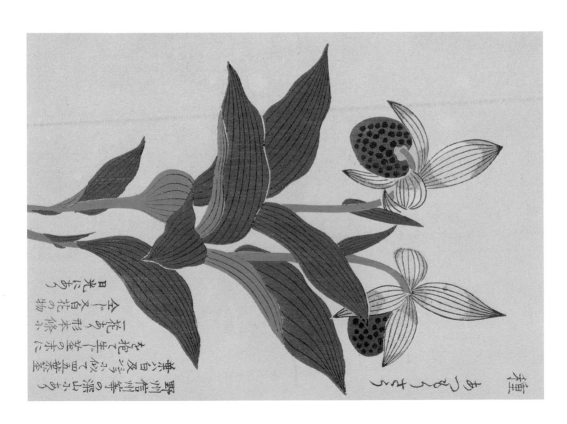

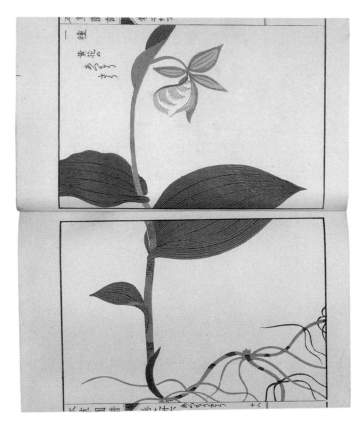

CYPRIPEDIUM GUTTATUM Found from the eastern Russian Federation through China, Korea and Japan, *Cypripedium guttatum* has become highly prized among growers of hardy orchids and alpines. It was named by the Swedish botanist Olof Swartz in 1800, the year in which he became the first Western botanist to publish studies devoted to orchids. Swartz recognised twenty-five genera of orchids in all: twenty-four with one anther; one with two anthers (*Cypripedium*). This fundamental division has continued to underpin orchid classification ever since. In Japan, *Cypripedium* had never been included in the traditional, herbalist's classification of orchids – although they were valued for their beauty and linked with some of the heroic figures of the country's past.

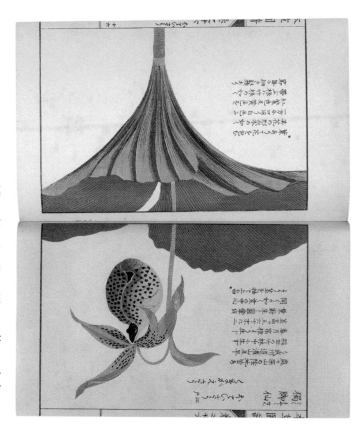

CYPRIPEDIUM JAPONICUM Taira Atsumori's killer at Ichinotani was Kumagai Naozane, older, more battle-hardened and a ferociously effective warrior. He fought on behalf of the Minamoto clan which struggled with the Heike for control of Japan. As he charged into the fray, Kumagai's kit bag (in effect a cloak gathered at his waist) billowed behind him, suggesting the inflated lip of *Cypripedium japonicum*. Accordingly this slipper orchid became known as *Kumagaisō*, in contrast to the smaller and more blushingly coloured *Atsumoriso* (*Cypripedium macranthos* var. *speciosum*), which was named in memory of Kumagai's young victim.

deduced from such clues, and from the fact that, by the time it was decided to give orchids a comprehensive treatment of their own, it was abundantly clear that they had long enjoyed prime position in the plant lovers' pantheon – they were not only named, understood and bred, they were exclusively grown in purpose-made *ran* pots.

Japanese herbalist Gentatsu (Joan) Matsuoka (1668–1746) produced the first account of his country's orchids, *Igansai-ranhin*, published in 1728. Matsuoka's text is full of practical advice – on growing cymbidiums, for example:

Shelter them in spring
Shade them in summer
Keep them moist in autumn
Keep them on the dry side in winter

The text describes each of the most highly prized *ran* – *ebine* (prawn-rooted orchid), namely *Calanthe*; *kanran* (winter orchid), namely *Cymbidium kanran*; *shunran* (spring orchid), meaning *Cymbidium goeringii*; *nagoran* (Orchid from Mount Nago), *Sedirea japonica*; *furan* (wind orchid), meaning *Neofinetia falcata*; *iwagusuri*, or the corruption, *sekkoku*, of its Chinese name ('medicine from the rock', referring to the plant's lithophytic habit and reputation for prolonging life), i.e. *Dendrobium moniliforme*, and so on. During the Edo era (1603–867), growing these plants was sometimes a social indicator. *Cymbidium* was bred by merchants. *Calanthe* was beloved of artists and intellectuals. *Dendrobium moniliforme* was the preserve of the imperial aristocracy. Samurai and warlords forgot themselves with the diminutive, virginal white and fragrant *Neofinetia*, nursing their plants all the way to Edo (Tokyo) when required to attend on the Shogun there.

Warriors had already furnished Japan's slipper orchids with vernacular names. Spectacular overblown *Cypripedium japonicum* is known as *Kumagaiso*, after Kumagai Naozane, a ferocious warrior of the Minamoto clan. The smaller, more blushingly coloured *Cypripedium macranthos* var. *speciosum* is known as *Atsumorisō*, after Taira Atsumori, a youthful warrior of the opposing Heike clan, whom Kumagai slew at the battle of Ichinotani in 1184.

Igansai-ranhin went through several editions, each more detailed and beautifully produced than the last. It was one of a number of floristic works produced from the middle of the Edo era onwards which describe, Japan's native plants and illustrate them with woodcuts. Orchids tend to occupy a special place in each. But, four decades before Matsuoka put brush to paper, the closed world of Japanese orchids had already been penetrated.

Working for the Dutch East India Company, German physician and natural historian Engelbert Kaempfer arrived in Nagasaki in 1689. During his two-year sojourn there he encountered *Neofinetia*, *Calanthe* and *Dendrobium*. Published in his *Amoenitatum Exoticarum* ('Foreign Delights') of 1712, Kaempfer's descriptions and drawings of these orchids are the West's first glimpse of one of gardening's oldest and most closely guarded secrets. The early phase of the West's own orchid heritage was not nearly so high-minded, although it did claim to hold the secrets of breeding – not just for orchids but human beings, too. Turn to book nine, chapter eighteen, section three of Sir Arthur Hort's translation of Theophrastus' *Enquiry into Plants* in the Loeb Classical Library and you will find the following:

And in relation to our own persons, apart from their effects in regard to health, disease and death, it is said that herbs have also other properties affecting not only the bodily but also the mental powers …

The dots are his not mine, and what follows them is a rather large hole where there ought to be an account of Greek orchids and their medicinal properties. Sir Arthur was moved to this fit of bowdlerism by the appearance and reputed effects of the orchids. The missing passage matters to us, however, because it marks the moment at which these supposedly pornographic plants formally received the name by which we have known them ever since.

TESTICULUS LATIFOLIUS & TESTICULUS Two European native orchids featured in the work of the Heidelberg herbalist Jacob Theodore of Bergzabern (*Tabernaemontanus*) in the year of his death (1590). While the illustrations themselves are clearly becoming more accurate and readily identifiable, compared with some earlier depictions the names applied to the plants continue to echo their ancient association with the male genitalia and potency.

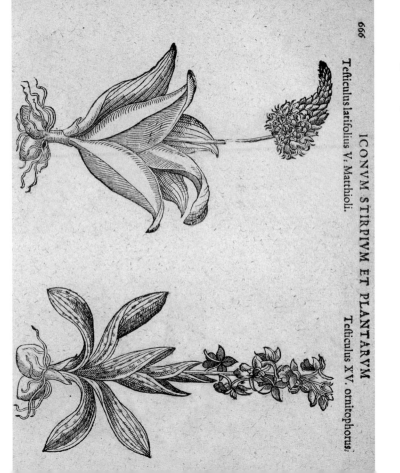

666

ICONVM STIRPIVM ET PLANTARVM

Testiculus latifolius V; Matthioli.

Testiculus XV. ornitophorus.

HVc potißimum spectant palmæ Chrisi vocatæ, hermodactyli, &
vulgaris ischæmi, sine dactyli Pliniani plantæ, digitatis manus 14
notantes, vt in superiore sede videntur; in ima vero manus cum suis
digitis spectatur.

nis, & Pauli monitu vim habent ad articulorum defluxum
præcipuam. Sunt etetliculorum genere digiti curm appellati

PALMA CHRISTI Although standards of description and illustration were coming ever closer to some semblance of scientific accuracy and objectivity, even at the end of the sixteenth century there were still throwbacks to old and fanciful doctrines. For example, in 1588 Giovanni Battista della Porta produced *Phytognomonica*, which explored the doctrine of signatures, a theory of physick that posited herbal remedies on the basis of similarities between parts of the human body and plants. Featured left is the orchid *Palma Christi* ('Christ's hand'), now known as *Dactylorhiza* ('finger root').

Theophrastus was born circa 370BC, about a century after Confucius died. He was a student and close companion of Aristotle and succeeded him as head of the Lyceum in Athens, a role he executed with brilliance for thirty-five years until his death in 287. He wrote on many subjects, from the satirical gallery of the *Characters* to treatises on stones, fire, the winds and scent. But he is best remembered as the Father of Botany, having composed the two great founding texts of Western plant science, the *Enquiry into Plants* and *On the Causes of Plants* – texts which continued, for good or ill, as the ultimate authority on matters botanical into the renaissance. At his botanic garden in the Athens Lyceum (possibly the world's first such institution), Theophrastus received plants and plant lore from across the Hellenic world and from the campaigns initiated by Alexander as they pushed further eastwards. The orchids that fell under his gaze were not exotic, however. They were specimens of what we would recognise as *Ophrys* and *Orchis*, genera widespread in the Mediterranean and Aegean regions.

Two original aspects of Theophrastus' study were scientific in the modern sense: he attempted to describe the plants, their behaviour and their habitats objectively; he gave them names. These were intended to be official, in effect, the beginnings of a standard plant nomenclature; but they were based on the vernacular names used by the people most familiar with them (herb gatherers, herdsmen etc). One such name was *orkis*. In the passage from the *Enquiry into Plants* that Sir Arthur Hort chose not to translate, Theophrastus identifies two *orkis* – *orkis megas*, probably the species we call *Orchis papilionacea*, and *orkis mikros*, which is almost certainly *Orchis italica*.

Hort's problem with the name *orkis* is that it means, literally, 'testicle' – a graphic and apt description of the tubers of many European terrestrial orchids. These are more or less spherical and occur in pairs, one partner of which is larger and suspended slightly lower than the other. A large part of plant lore from antiquity to the early modern period was fashioned by the doctrine of signatures. This dictated that the form of plants indicated their particular usefulness to man. *Hepatica*, with a liver-shaped leaf, was judged good for liver complaints. *Aristolochia*, with flowers shaped like the birth canal, was favoured by midwives and abortionists. This 'science' was practised by medics and codified by herbalists like Theophrastus, but it was essentially folkloric in origin. With its testicular tubers, *orkis* was only too obviously an aphrodisiac and a promoter of fertility. Centuries after the Chinese had first praised orchids for their perfume and grace, the Greeks had a word for them which reflected an altogether more pragmatic view of their value, as a sort of vegetable Viagra. *Orkis* has been with us ever since, as the root of *Orchis*, orchid and Orchidaceae, a very earthy etymology for these most rarefied of plants.

Theophrastus attributes powers to orchids that would have placed anyone using them very high indeed in a sexual olympiad. Their reputation went before them into the Roman world. Petronius has prostitutes put them to good use in *Satyricon*. In his *Natural History*, Pliny the Elder (23–79AD) discusses the extraordinary efficacy of *orchis herba* in generating vigour and fecundity. He also mentions another ancient name for orchids – *serapias*, after the Egyptian bull deity Serapis. Not long after Pliny's death, Dioscorides, a Greek herbalist and physician working for the Roman army, took up the theme in his *De Materia Medica*, describing four orchid species and giving them names, in addition to *orkis*, like *priápiskos* and *saturion* which also trumpet their legendary potency. Dioscorides' account of *orkis* from John Goodyer's 1655 translation:

GALEANDRA BAUERI Although its distribution extends from Mexico to Surinam, *Galeandra baueri* had a reputation for rarity among orchid hunters. This example was painted in 1839 by Sarah Anne Drake (1803–1857), who between 1830 and 1847 lived with John Lindley's family at Turnham Green in London and prepared a magnificent series of orchid paintings for Lindley's publications. Its name commemorates another of Lindley's artist colleagues, Franz Bauer, whose *Illustrations of Orchidaceous Plants* (1830–1838) is an outstanding work of orchid anatomy.

> ... it is said that if the greater root is eaten by men, it makes them beget males, and the lesser, being eaten by women, to conceive females. It is further storied that ye women in Thessalia do give to drink with goates milk ye tenderer root to provoke venerie, and the dry root for ye suppressing, dissolving of venerie ...

The classical world's view of orchids as wild plants of racy medicinal value rather than any ornamental or intrinsically botanical interest predominated in Europe until the sixteenth century. Like their Mediterranean relations, many orchids native to Western and Northern Europe also exhibit pairs of spherical tubers. The roll-call of lurid names given to orchids referred mostly to their similarity to the male genitalia and to their purported ability to incite yearnings that were far from horticultural. Quite understandably such names captured the attention of the founding fathers of our own botanical tradition. In his *New Herbal* of 1561, for example, William Turner applied Dioscorides' model to British native orchids, colouring his account with vernacular names gathered from around the country:

> There are divers kinds of orchis which are called in Latin *testiculus, that is stone [i.e. testicle]. One kind of them hath many spots on the leaf, and is called adder grasse in Northumberland; the other kinds are in other countries called fox stones or hare stones, and they may, after the Greek, be called dog stones ... Satyrion ... may be named in English white Satyrion, or white hare's coddes, or, in other more unmannerly speech, hare's bullocks ... It is supposed to steer men to lust of the body.

Similarly indelicate sobriquets included standergrass, doggis cods, sweet cullions and, in a by then customary dig at the supposed fragility of the celibate life, preestes pyntel. The orchid's fleshly associations were not all below the belt, however. As late as 1588, Giovanni Battista della Porta was pursuing the doctrine of signatures. In *Phytognomonica*, a remarkable work that shows fancied correspondences between plants and parts of the human body, della Porta illustrates not only the usual testicles and tubers, but also the tubers of such orchids as *Dactylorhiza* which resemble the human hand. These too were a theme in the naming and mythology of European orchids, with the finger-like tubers imagined to be the metamorphosed hands of a variety of personnel from forsaken maidens to executed criminals and Christ himself. Names of both types figure in *Hamlet* when Queen Gertrude names the wildflowers that Ophelia picks:

> There with fantastic garlands did she come,
> Of crowflowers, nettles, daisies, and long purples,
> That liberal shepherds give a grosser name,
> But our cold maids do dead men's fingers call them

There is a puzzle here. Did this, the most famous orchid in English literature, have spherical tubers, thereby earning the 'grosser name', or finger-like tubers? Did Shakespeare mean *Orchis* or *Dactylorhiza*? It is a question that cannot be answered. But the next chapter in the story of orchids tells the tale of our attempts to avoid such confusions as, through science and exploration, we saw orchids proliferate from the fifty or so species known in Europe in Shakespeare's time to become known as the largest family in the plant kingdom. One of Shakespeare's likely sources

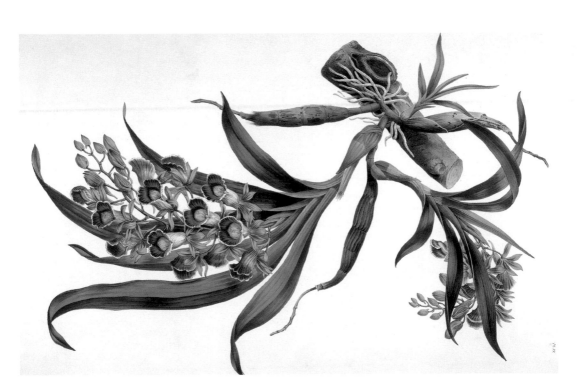

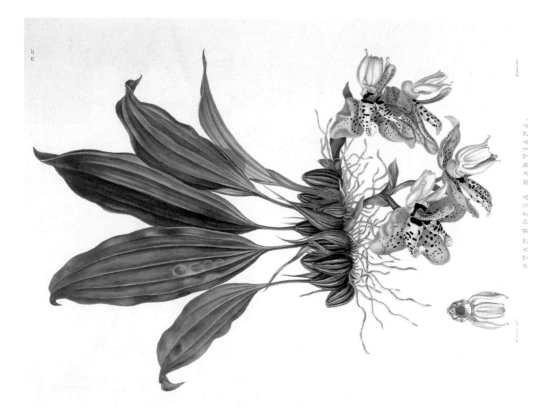

STANHOPEA MARTIANA.

STANHOPEA MARTIANA Found by the botanist Karwinski in western Mexico in 1827, *Stanhopea martiana* flowered in James Bateman's collection in 1840. Soon after, he named it in honour of Carl Friedrich Phillip von Martius, Professor of Botany at Munich. Bateman tended to grow stanhopeas on decaying boughs and tree trunks, while others tried unsuccessfully to grow them in clay pots. It was not until later that the practice of growing them in slatted baskets began.

for botanical colour was the 1597 *Herball or Generall Historie of Plantes* compiled by the herbalist and gardener John Gerard (1545–1612). By 1633, when Thomas Johnson produced a revised second edition of Gerard's *Herball*, some fifty species of orchids had been recorded by modern botanical and horticultural authors. On the Continent, several of these commentators had already produced works that look forward to the discipline of modern botany. Otto Brunfels in his *Contrafayt Kreuterbuch* (1537), Fuchs in his *De Historia Stirpium* (1542), Mattioli in *Commentarii ... de Materia Medica* (1554), and Dodoens in *Florum* (1569), all depicted Europe's native orchids with exquisite clarity. As befits a Shakespearean source, however, Gerard's orchids appear roughly rendered and garlanded with a variety of names Latin and vernacular, formal and obscene, while his text is a vivid admixture of classical authorities, personal observation and old wives' tales. For example, the description of *Cynosorchis major*:

The small floures are like an open hood or helmet, having hanging out of every one as it were the body of a little man without a head, with arms stretched out, and thighs straddling abroad, after the same manner almost that little boys are wont to be pictured hang'ng out of Saturnes mouth.

Herbalism had not yet given place to botany: not had the orchid evolved in European eyes from local wildflower with peculiarly potent tubers in to peculiarly potent flower from wild and distant places. This can be put down partly to a simple lack of opportunity (we were not quite in the era of frequent and far-reaching explorations), and partly to lack of taxonomic nous. We could just about relate our native orchids to one another and to the *orkis* template handed down to us from Ancient Greece, but an orchid in any of its thousands of other guises would simply have struck us as unorchid-like: flower anatomy had not yet been established as the clue to natural relations in the plant kingdom.

So it was that, by the time Gerard wrote his *Herball*, several very exotic orchids had been known in Europe for nearly fifty years – only not as orchids. These were plants 'discovered' as a result of the Spanish conquest of Mexico in 1519. The most celebrated among them was vanilla. It is difficult to imagine a plant less like Europe's native orchids than *Vanilla planifolia* – a vigorous climber with glossy lancehead leaves and large, waxy trumpet-shaped flowers that range in colour from creamy white to pale gold and which exude an overpowering fragrance. Cortes himself noted the Aztecs' use of *tlilxochitl* – vanilla – as a perfume and flavouring for chocolate. This orchid also appears in the *Badianus Herbal* of 1552. This was the work of two Aztecs, Martin de la Cruz, a physician specialising in native plants and cures, and Juan Badianus, an adept at Latin. Both were teachers at the Colegio de Santa Cruz in Tlaltiluco, where they compiled a magnificent record of a tradition all but extirpated by the conquistadors.

In the *Badianus Herbal* vanilla is recommended for protecting travellers, perfuming chocolate, dispelling fear, strengthening the heart, and relieving the weariness customarily experienced by workers in government departments. Another orchid, *tsacouhxochitl* (from *Izacouh*, 'glue', and *xochitl*, 'flower', and probably either *Bletia campanulata* or *Catasetum maculatum*) is used in a mixture prescribed as '*timoris microspsychiae remedium*' – a cure for shyness.

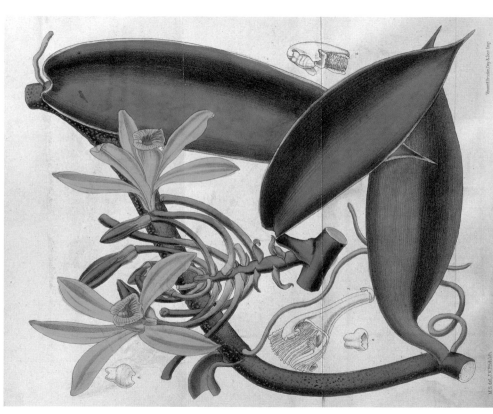

VANILLA PLANIFOLIA Perhaps the last remaining orchid of economic (rather than purely ornamental) value, *Vanilla* arrived in Europe from Central America in the early sixteenth century. Although we think of it today as a source of food flavouring, in its native lands and throughout Europe for three centuries vanilla was a herb of manifold and near-magical properties, believed to cure melancholy, impotence and hysteria, rheumatism, menstrual problems and epilepsy.

Intrigued by reports of such wonders, Philip II of Spain appointed his own physician, Francisco Hernandez, 'Protomedico' (First Medical Officer) of the Indies and sent him to Mexico to catalogue its *materia medica*. Between 1571 and 1577, Hernandez produced *Rerum Medicarum Novae Hispaniae Thesaurus*, 'The Mexican Treasure', a vast compilation of writings and drawings. Philip had them lavishly bound, but did nothing more with them before Hernandez died in 1587. He then ordered summaries and fragments to be published in Mexico and Rome where, in 1651 and long after both players were dead, a fully illustrated edition finally appeared. It contained an illustrated account of vanilla with both its Aztec name and that first given it by Europeans, *Arico aromatico* ('aromatic bean').

A few years later, the name vaynilla or vanilla became current. A diminutive of *vaina*, and meaning 'small pod', 'vanilla' enjoys the distinction of being the only orchid in the Western world of economic value and, not long after its discovery, attempts began to cultivate it intensively for the spice trade. Unlike *Vanilla*, two further orchids that appear in 'The Mexican Treasure' have no strict economic value. But, as ornamentals, *Coatzonte coxochitl* and *Chichiltic tepetlauhxochitl* were considered pearls beyond price when they burst upon the British horticultural scene as *Stanhopea tigrina* and *Laelia speciosa* over two centuries later.

We must thank the Dutch for introducing us to the orchids of the Old World Tropics. In the second half of the seventeenth century, H.A. van Rheede tot Draakestein, Governor of their colonies in Malabar, Southern India, devoted himself to documenting the rich flora of his domains. The result was the twelve-volume *Hortus Indicus Malabaricus* (1678-1703), a magnificent catalogue of over eight hundred species, each illustrated with remarkable accuracy. Among them are six orchids, including the plants we know as *Vanda spathulata*, *Rhyncostylis retusa* and *Cymbidium aloifolium*, none of which would enter Western cultivation until nearly two centuries later. Like the other plants figured in *Hortus Indicus Malabaricus*, these orchids appear with their vernacular names. *Rhynchostylis*, for example, is Biti-Maram-Maravara: *Vanda* is Ponnampou-Maravara. Rheede explains that the suffix 'Maravara' applies to plants that are found on the branches of trees, a primitive but accurate classification for epiphytes.

Our first glimpse of Indonesian orchids came courtesy of Georg Eberhard Rumphius, who, having enjoyed careers as a mercenary for the Venetian Republic, a sailor in the Dutch West India Company, and a soldier in the Portuguese army, came to rest in 1653 at Ambon in the Dutch East Indies. Rumphius conceived a passion for the plants of the region, collecting, describing and growing them. His existence was hit, however, by waves of disaster: his wife and daughter died in an earthquake; he became blind; and, finally, in 1687, his garden, herbarium and papers were destroyed in a fire. Despite all, he persevered, bringing his great flora, *Herbarium Amboinense*, close to completion at the time of his death in 1702. Published posthumously between 1741 and 1755, it describes 1200 species and contains two volumes devoted to orchids. One of his discoveries, *Angraecum album majus*, was the plant known today as *Phalaenopsis amabilis*, a name it did not receive until its rediscovery in 1825 by Karl Ludwig Blume. This orchid has since become the darling of collectors, hybridisers and, more recently, florists and interior designers. Still more prescient was Rumphius basic but revolutionary understanding of the orchid's reproductive anatomy.

Insights like his and Rheede's enshrined in such great illustrated works as *Hortus Malabaricus* and *Herbarium Amboinense*) were vital source material for the great Swedish botanist Linnaeus (Carl von Linne 1707-1778). The view from the herbarium no longer took in Europe alone. It now ranged over a whole world of plants. Linnaeus provided easy, failsafe access to this new world of flora by devising a system of classification based on the numbers and ratios

DISA UNIFLORA (syn. DISA GRANDIFLORA) In 1767, the hooded and intricately veined dorsal sepal of this South African orchid led the botanist Bergius to name it *Disa* after a mythical Queen of Sweden who came to the King of the Sweas wrapped in a fishing net. Of the 130 or so species of *Disa* found in Africa and Madagascar, *D. uniflora* is the most famous – a signature plant of Cape Province.

of any given plant's sexual organs. More enduringly, he pioneered the binomial method of naming plants, which, with a few modifications, we use to this day. It involves two terms – genus and species – replacing, for example, the unwieldy name *Angraecum album majus* with *Phalaenopsis amabilis*. Linnaeus instituted the binomial method in *Species Plantarum* (1753). This landmark work has the added distinction of containing more orchids than any other before it – sixty species from across the globe. Little did Linnaeus suspect that this was only a minute sample. Less than a century later, in his *Genera and Species of Orchidaceous Plants* (1830–1840), John Lindley described all the orchids then known, a total of 1980 species. In time, this figure, too, would prove conservative – by a factor of thirteen.

Despite their reputation for rarity, orchids belong to what is possibly the largest and most diverse of all plant families. The Orchidaceae contains nearly 1000 genera comprising over 25,000 species – nearly a tenth of the world's flowering plants. In terms of numbers, they are challenged only by the daisy family, *Compositae* or *Asteraceae*, which is often cited as the plant kingdom's most populous, with some 1550 genera and 25,000 species. These two families, the orchids and the daisies, owe their success to differing evolutionary dynamics. Members of the *Compositae* such as thistles, dandelions and ragworts are botany's great broadcasters, peddling a narrow but successful formula across a vast geographical range with minimal alteration. Orchids, conversely, are niche marketeers, protean opportunists that have evolved, are still evolving, to exploit the nuances and extremes of a multitude of habitats, and to attract the pollinating insects that are found in them. Orchids are specialists.

They can be found growing wild in almost every land environment that is even halfway hospitable to plant life. *Arethusa*, *Calopogon* and *Disa* will grow with their 'feet' in fresh (or stagnant) water; several species of *Epipactis* inhabit sand dunes and brackish burrows. Some genera dwell in forests so deep that light scarcely reaches them (not, as we shall see, that they need light). While the most exposed of mountain crags and open of alpine plains, from the Rockies to the Himalayas, will usually boast its own orchid flora. In areas of Australia and Southern Africa that experience deep seasonal drought, orchids can be among the most ephemeral of wildflowers, making the briefest of appearances in the wet season before disappearing below ground once more to rest as dormant tubers. In even the driest regions of Mexico, *Encyclia* and *Oncidium* will colonise the boughs of cacti; and *Eulophia* thrives in the semi-desert regions of Africa. They can even survive in cooler regions (*Calypso bulbosa*, for example, thrives in the Arctic Circle, *Chiloglottis cornuta* touches Tierra del Fuego); but around ninety percent of orchids are found in the Subtropics and Tropics and it is these species that have earned by far the widest following among collectors and breeders.

In the way in which it grows, each orchid species presents an adaptive solution to the challenges posed by its environment. At the crudest level, these solutions fall into one of four broad categories of growth habit: terrestrial, epiphyte, lithophyte and saprophyte. Like most higher plants, terrestrial orchids grow with their roots in the ground. This one feature aside, terrestrials are a disparate group, distributed throughout the world's climates and in habitats that range from marsh to mountainside and from rainforest to arid lands. They exhibit a wide variety of growth patterns: tufted, leafy growths (as in *Paphiopedilum*), pseudobulbs (*Calanthe*), tubers (*Orchis*), thick-rooted, buried rhizomes

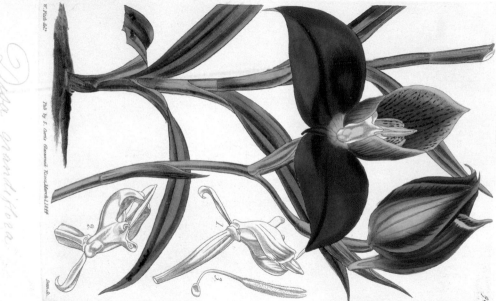

MASDEVALLIA COCCINEA

(Left) Named for the Spanish botanist and physician Jose Masdevall, the genus *Masdevallia* consists of some 350 species found in Central and South America. They are mostly small or dwarf plants found growing on trees and rocks at high altitudes. Their flowers consist of a tricorn-like shield composed of three showy, pointed sepals with inconspicuous petals and lip at their centre. *Masdevallia coccinea* is found in Colombia and Peru at elevations of 2400 to 2800 metres. In addition to its typical but spectacular crimson form, there are ruby, magenta, pale rose, white, creamy yellow, peach and scarlet variants – for example, *M. coccinea* var. *harryana*, named for the great orchid grower Sir Harry Veitch.

MASDEVALLIA MACRURA

(Opposite) A native of Colombia and Ecuador, the *Masdevallia macrura* plant is somewhat less conventional in its appeal. However, its combination of antenna-like tails, glistening ochre ribs and translucent maroon warts conveys exactly the type of sinister charm that would commend it to the legion of *Masdevallia* devotees.

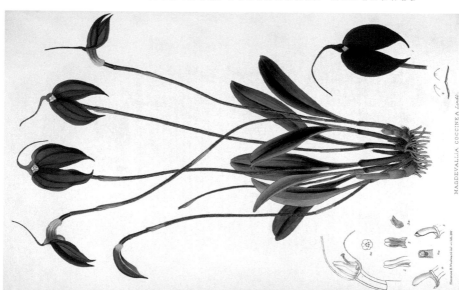

MASDEVALLIA COCCINEA Lindl.

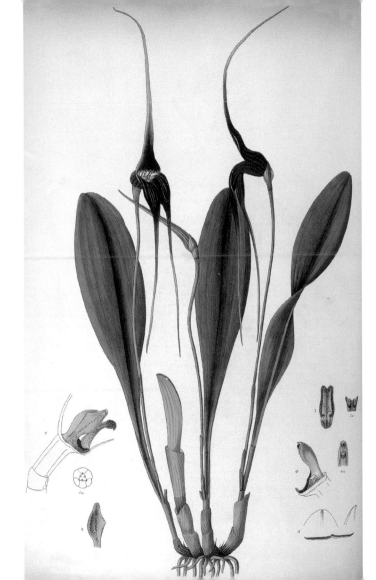

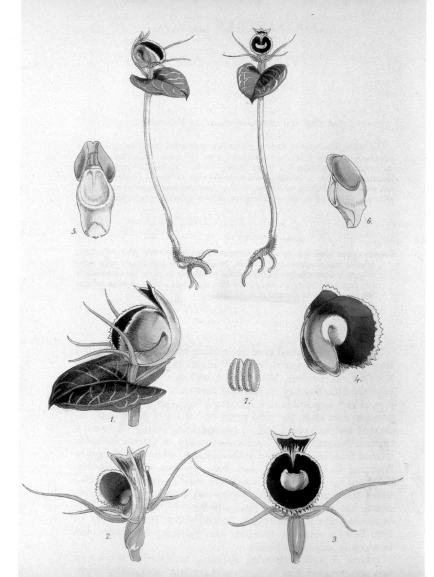

CORYBAS LIMBATUS Named after the dancing priests of the goddess Cybele in Phrygia, the genus *Corybas* occupies a wide distribution, from Southern China to New Zealand. One species, found on Macquarie Island, is the southernmost orchid of all. They are small plants, with heart-shaped leaves that sit on the soil surface as collars to curiously hooded and fringed flowers. This example of *Corybas limbatus* was the first member of the genus to flower in British cultivation, having journeyed from Java to William Bull's nursery in the King's Road, Chelsea in 1862.

(*Cypripedium* and *Cephalanthera*), fleshy creeping rhizomes (*Goodyera*), clumped and cane-like (*Sobralia*, *Thunia*), and scrambling or climbing stems that, at least at first, are anchored in the ground (*Vanilla*). Although there are numerous subtropical and tropical terrestrials, this growth habit is most common among orchids at higher latitudes. Britain's fifty or so native orchids, for example, are all terrestrials, unless we count the bog orchid, *Hammarbya paludosa*, as an epiphyte. This diminutive, green-flowered species, named after Linnaeus's beloved home and garden, grows not in but upon sphagnum moss. Most epiphytes pick larger hosts, usually trees.

An epiphtye (from Greek *epi*, 'upon', and *phyton*, 'plant') is a plant that grows on another. It does so without deriving any nourishment from its host – an epiphyte is not a parasite, merely a plant looking for a lift up in life. Nevertheless, the harmlessness of epiphytes was lost on so illustrious a botanist as Sir Hans Sloane, who in the early eighteenth century classified the Jamaican epiphytic orchids *Brassavola cordata*, *Broughtonia sanguinea* and *Oncidium luridum* under *Viscum* (mistletoe). Nearly three hundred years later, the orchid collector Hugh Laird could still recall the bafflement of his native guides at his delight in what, to them, were mere 'parasitos'.

Epiphytes have taken to the trees in the search for light, water and nutrients, all of which would otherwise be denied them by the forest's dense, shielding canopy and understorey. Clinging to the bark of their hosts with adhesive roots or clasping stems and rhizomes, they benefit from exposure to optimum sunlight and rainfall – the latter providing not only water but also food in the form of dissolved minerals leached from vegetable detritus and animal droppings.

A phenomenon largely of the humid Tropics and Subtropics, epiphytism is exhibited by a variety of plants including ferns, aroids and figs. For two families in particular it is an essential strategy for survival in the competitive forest – the bromeliads (*Bromeliaceae*), and the orchids, of which more than half are epiphytes. In the forests of Central and South America, members of both these families can be found together, decking the boughs of their support trees in dense communities which amount to arboreal gardens. Although most have a preference for abundant atmospheric moisture, epiphytic orchids are by no means confined to rain and cloud forests. They can be found colonising timber-framed buildings in tropical towns, adorning fence posts and telegraph poles, festooning the crowns and stilt roots of coastal mangrove, and greening gaunt trees and cacti on even the most exposed of plains. Exploring the Gavea or Topsail Mountain near Rio de Janeiro in 1836, the orchid hunter George Gardner spotted a colony of a species which had been thought lost since 1818: 'On the face of the mountain, at an elevation of several hundred feet we observed some large patches of one of those beautiful large-flowered orchidaceous plants which are so common in Brazil. Its large rose-coloured flowers were very conspicuous, but we could not reach them. A few days later we found it on a neighbouring mountain, and ascertained it to be *Cattleya labiata*. Those on the Gavea will long continue to vegetate, far from the reach of the greedy collector.' Gardner had discovered a lithophyte. Like epiphytes, lithophytes (from Greek *lithos*, 'stone', and *phyton*, 'plant') avoid the pressures of life on the ground in densely wooded or otherwise hostile environments by seeking higher perches – not trees, but rocks. For some orchids, this strategy offers very distinct advantages, as in the case of the Thai slipper orchid, *Paphiopedilum bellatulum*, which grows on limestone bluffs and has a marked preference for an alkaline substrate. For many other species, the 'choice' of roothold is not so narrow; they can be found growing epiphytically and lithophytically. Nor are lithophytes confined to natural rock faces and crevices. In 1870, for example, the collector Benedikt Roezl found another celebrated *Cattleya*, *C. skinneri* var. *alba*,

PERISTERIA PENDULA Found in Venezuela, Peru, Brazil and Surinam, *Peristeria pendula* is a spectacular epiphyte with thick, waxy flowers. The name *Peristeria* derives from the Greek *peristerion*, meaning 'little dove', and refers to the flower's column and the lateral lobes of the lip, which resemble a dove in flight. The similarity was more apparent in the first species that Hooker named: *P. elata* of 1831 has snowy white flowers. *P. pendula* of 1836 is rather more pantherine.

flourishing on the roof of a chapel in Totonicapán, Guatemala. It had probably been placed there by Indians looking to hedge their bets by attaching a plant emblematic of their own gods to the house of an imported deity. Lithophytes have also been known to thrive on more aboriginal masonry – for example, the Inca ruins at Machu Picchu, which were home to large colonies of the fluorescent vermilion-flowered *Masdevallia veitchiana*; while another Peruvian native, the slipper orchid *Phragmipedium pearcei*, favours stream-washed boulders.

These last two lithophytes – the *Masdevallia* shrouded by mists and clouds, the *Phragmipedium* slaked by spray and eddies – have few problems with moisture. Many epiphytic and lithophytic orchids, however, suffer the obvious disadvantage of life with their roots in the air: the lack, at least for some months of the year, of ready water either as rainfall or humidity. As we shall see, it is a challenge they have met through a number of special adaptations.

The last major category of growth habit among the orchids sidesteps the need for light and mineral nutrition altogether. All orchids rely, in the wild at least, on symbiotic relationships with fungi. Fungi assist in the germination of orchid seeds by providing the minute, impoverished and unprotected orchid embryo with the nutrients necessary for life. Later, the adult orchid benefits from mycorrhizal symbiosis, where root fungi break down organic matter, supplying the plant with nutrients. In turn, the fungi receive sugars produced by the orchid during photosynthesis. The seedlings of many species of terrestrial orchids spend part of their early lives as subterranean protocorms – buried blobs of life lacking chlorophyll (the means of manufacturing their own food) and reliant on symbiotic fungi. In most cases, these protocorms break their total dependency on fungi by producing aerial, leafy growths which photosynthesise. But for some orchids this etiolated, underground freeloading is not so much a phase as a lifelong career.

Saprophytes (from Greek *sapros*, 'rotten', and *phyton*, 'plant') draw nourishment exclusively from dead and decaying organic matter. Usually through symbiosis with fungi, organisms which these orchids crudely resemble in some respects: lacking chlorophyll, consisting of fleshy, eerily coloured tissues, passing much of their lives in darkness, and revealing themselves only in order to reproduce. The best-known saprophytic orchids are European and North American denizens of the leaf litter floors of dense forest. The coralroot (*Corallorhiza*) and the bird's nest orchid (*Neottia*) both take their popular names from the odd appearance of their clustered, succulent 'roots' (in fact, masses of slender tissues permeated with symbionts). The ghost orchid (*Epipogium*) lacks any semblance of roots, owing its name to its hood-like, translucent white flowers which arise deep amid the beechwoods. Unlike these northern temperate saprophytes, the Western Australian *Rhizanthella gardneri* prefers a more open and arid site, nested among the roots of the tea tree *Melaleuca uncinata*; but then *Rhizanthella* shuns the light altogether, spending its entire life (flowering and fruiting included) just below the soil surface. Not all saprophytes are so cryptic. *Galeola*, a genus from East Asia, produces writhing, tawny yellow stems that clamber, like a leafless poison-stricken vine, high into the surrounding trees. These stems are hung with waxy flowers and, later, with bean-like, coral-red fruits. Achieving heights of as much as twenty metres in as many days, *Galeola* qualifies for the title of the world's largest and fastest-growing orchid (the prize for being the world's bulkiest going to the non-saprophytic *Grammatophyllum speciosum* from Southeast Asia).

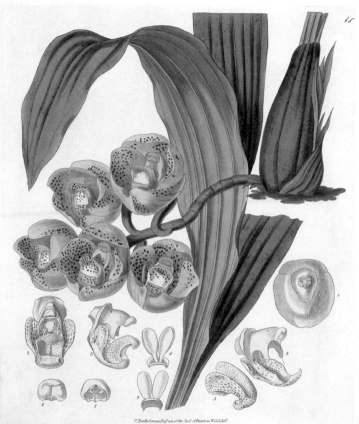

V. Bartholomew, Esq.ʳᵉ one of the Soc.ᵗ of Paint in W.Col.del.ᵗ
Pub. by J. Curtis, Glasswood Essex, Ap.ˡ 1836.

Peristeria pendula

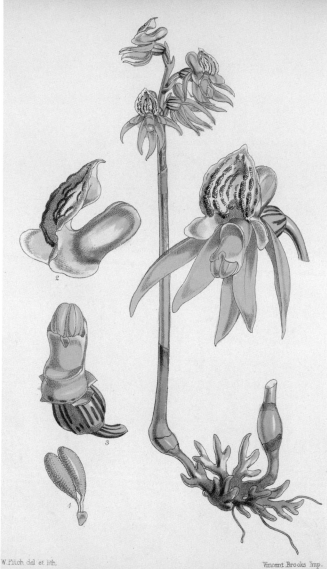

EPIPOGIUM APHYLLUM Saprophytic orchids lack chlorophyll and manufacture their food not by photosynthesis but by symbiotic association with fungi that live on decaying vegetable matter. The colouring of saprophytes tends to be waxy and translucent; their haunts are dark and secluded and their appearances in the world above ground fleeting and unpredictable. As a result, this saprophyte, *Epipogium aphyllum*, is known almost throughout its northern Eurasian range as the ghost orchid and variations on that theme. Its eerie beauty is impossible to foster in cultivation and difficult to glimpse in the wild.

Because of the inimitable nature of the ecosystems in which they grow, and the fragile complexity of the symbiotic relationships on which they depend, saprophytes are almost impossible to cultivate. Plants dug from the wild may live for a short time in gardens; but attempts to grow them artificially usually end in failure. Recently, however, Japanese growers have succeeded in cultivating one of their native saprophytes, *Gastrodia*, in pots. The answer, it seems, is to replace the food supplies that would normally be secured through symbiosis with sucrose feed and sterile conditions.

Each orchid species also conforms to one of two growth patterns. Sympodial orchids have two types of stem: the rhizome which extends laterally and bears roots, and aerial stems which arise at intervals along the rhizome and bear leaves and flowers. Rhizomes can be buried, as in such genera as *Epipactis*; partially buried, as in the wandering stems of *Ludisia* which act as both aerial shoot and rhizome; or exposed, as in epiphytes and lithophytes like *Cattleya*. The aerial stem can be so short as to appear non-existent, and the rhizome can be similarly compressed – for example, the clumped, leafy fans of the genera *Bollea*, *Huntleya* and *Oberonia*, and the slipper orchids *Paphiopedilum* and *Phragmipedium*. In *Masdevallia* and *Dracula*, the stems are a little longer and clumped, each bearing a single thinly fleshy leaf and, at its junction with the stem, an inflorescence. In other genera the aerial stems are more conspicuous, bearing leaves throughout and blooms at their summits – for example, *Arundina* and *Sobralia*. But the commonest model by far for the aerial stems of sympodial orchids is a water-saving device entirely their own, the pseudobulb.

Although they resemble bulbs in their swollen appearance and usefulness as reservoirs, pseudobulbs are thickened aerial stems capable of photosynthesis and of bearing leaves and flowers. They vary greatly in shape – pear-shaped, egg-like, cylindrical, spherical, grape-shaped, disc-like or flask-shaped –and also in size. In *Bulbophyllum odoardii*, the barrel-shaped pseudobulbs are a mere 1.5mm long, making this species from Borneo one of the world's smallest orchids. Meanwhile, the cane-like pseudobulbs of *Grammatophyllum papuanum* from New Guinea have been recorded as nearly five metres long. In genera like *Cymbidium* and *Phaius*, the pseudobulbs can be concealed altogether by closely overlapping leaf bases. Given the exigencies of a life spent high in the trees or on a rock face, an orchid's pseudobulbs are a remarkably efficient way of maximising all available water, and of continuing the process of food manufacture should it become necessary for the plant to jettison its leaves. At the base of each pseudobulb one or two vegetative buds can be found. In the case of the leading pseudobulb (the last one produced), one of these will develop into the next growth. If the species bears its flowers basally or laterally (from near the base of the pseudobulb), there may be further buds destined to develop into inflorescences. In the case of older pseudobulbs, one of the vegetative buds remains as an insurance policy, to be activated only should the leading growth die out. Known as 'backbulbs', these dormant pseudobulbs can be detached and triggered into growth as a method of propagation.

More conventional types of types of water-storage vessel can be found among the terrestrial sympodial orchids, such as the testicle-shaped tuberoids that gave *Orchis* and hence the whole family its name, and the fleshy clustered roots of *Cypripedium*. Masters of mimicry, some orchids such as *Bletia* and *Calanthe* produce subterranean pseudobulbs that are not unlike the corms of members of the *Iris* family. Monopodial orchids produce only one type of stem – this is aerial and, in theory at least, capable of extending itself indefinitely by producing new growth at its apex. Usually the stems of monopodial orchids are narrow with tough, fibrous inner tissues. Their bases may become slightly 'woody' with

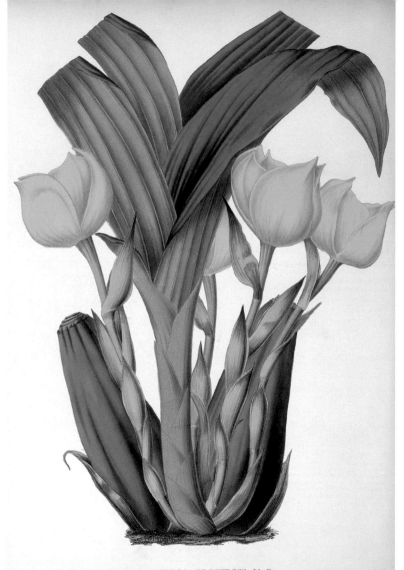

ANGULOA CLOWESII Lindl.

**PAPHIOPEDILUM VENUSTUM
(syn. CYPRIPEDIUM VENUSTUM)**
(Right) In the 1860s Robert Warner wrote
of this superb slipper orchid: 'The type of
the present plant is a very old inhabitant
of our hothouses having been introduced
from Nepal in the year 1816, and
was indeed the first of the Indian species
brought to Europe ... it will stand unharmed
in an ordinary warm conservatory or as
an ornament to the drawing room, in which
it will produce a charming effect, with its
curious marbled leaves and pouched or
slipper-like labellum.'

ANGULOA CLOWESII
(Opposite) The Luxembourg-born plant
hunter Jean Linden was commissioned
in 1841 by a consortium of English orchid
growers to collect for them in Venezuela
and Colombia. Among the plants he sent
back was a specimen with large, golden
waxy flowers richly scented of chocolate
and wintergreen. It flowered in the
collection of Linden's sponsor, the Reverend
John Clowes of Manchester, earning itself
the name *Anguloa clowesii*. The upright,
cupped attitude of the plant's flowers have
caused it to be known as 'the tulip orchid',
while the incurved tepals have also brought
it the sobriquet 'cradle orchid'.

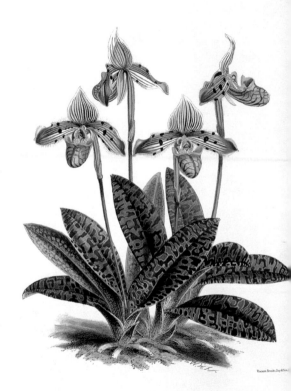

Cypripedium venustum

SCUTICARIA STEELEI *Scuticaria steelei* belongs to a genus comprising five epiphytic species and found in South America. The best known among them exhibit a strongly pendulous habit with vibrantly colourful flowers clustering at the crown of a veil of slender leaves. The latter characteristic gives the genus its name – from the Latin word *scutica*, which means 'whiplash'.

age. Their leaves are often arranged in two ranks running the length of the stems. In some monopodial genera the stems are reduced to the point of vanishing, as in *Phalaenopsis*, which has only the shortest of growth axes enveloped by leaf bases. In the leafless genus *Chiloschista*, the stem is a mere junction for the photosynthetic roots.

The monopodial habit is the forte of the orchid family tribe *Vandeae*, which includes *Aerangis*, *Angraecum*, *Neofinetia*, *Phalaenopsis* and *Vanda*. In all of these the stems may branch only at their bases or leaf axils, and the roots are produced for the most part adventitiously from root axils near the base of the plant and along the stems. The flowers, too, develop laterally from the leaf axils, whereas sympodial orchids may produce theirs laterally from the base or axils of their stems, or terminally, at the tips of their stems or pseudobulbs. As with the other organs of these non-conformist plants, orchid roots exhibit a number of unique adaptations. The most remarkable of these can be found in the thick, aerial roots of many epiphytic and lithophytic genera. These are covered in a coating of pale spongy tissue called velamen. Understandably, most botanists used to think that the purpose of this seemingly porous root-sleeve was to absorb moisture in the form of rainfall and atmospheric humidity. It now appears that the opposite is true – that the role of velamen is primarily protective, insulating the thread-like root core with its corky inner tissues and preventing sun scorch and desiccation with its nacreous outer coating. In fact, among species that exhibit pronounced velamen, only the root tip itself is capable of absorbing water in sufficient quantities to keep the orchid alive.

When active, the root tips of many epiphytic and lithophytic orchids are bright green, an indicator of their photosynthetic function. They are also exploratory and adhesive, seeking out suitable surfaces for the orchid to colonise and attaching it to them. As the root tip progresses its hindmost toughens, flattens and becomes encased in velamen, which also acts as a kind of cement, securing the plant to its perch. The leaves of most orchids have one or two things in common with each other. Many exhibit a slight notch at their tips. In a large number of epiphytic and lithophytic species, the leaves have a waxy coating of cells whose function is to conserve water. The leaves of such orchids are commonly succulent and, like the leaves of many succulents in other plant families, save water by keeping their pores closed in the heat of the day and open for evotranspiration in the cool of the night.

These observations aside, it is no easier to make generalisations about the leaves of orchids than it is to make generalisations about their flowers. Orchids can be deciduous, evergreen or, as we have seen, have no foliage at all. Those that do have foliage (the great majority) produce leaves that range in size from 1mm to 2m, and in texture from thick and succulent, or tough and leathery, to transparently thin, and as fragile as crepe de Chine. They can vary in form from gherkin- to quill-like by way of heart-, strap- and parasol-shaped, and in texture from smooth to silky, and from puckered to warty or hairy. We do not usually place an orchid's leaves high among its attractions, but several species have strikingly handsome foliage. The leaves of slipper orchids like *Paphiopedilum venustum* and *P. wardii* have a snakeskin patterning of deep sea green and leaden grey. In *Paphiopedilum bellatulum* and its allies *P. godefroyae* and *P. niveum*, the foliage is overlaid with a moss green tracery. Also from Southeast Asia, some of the finest moth orchids (*Phalaenopsis*) would be worth cultivating for their leaves alone – most notably *Phalaenopsis schilleriana* and *P. stuartiana*, both with verdigris foliage tessellated with shimmering silver.

An uncommon coloniser of mossy twigs in the cloud forests of Ecuador and Colombia, the miniature epiphyte *Lepanthes calodictyon* balances plate-like leaves on delicate stalks. These are velvety aquamarine imprinted with a network of dissolving, chocolate-brown veins. The leaf colouring of one Malaysian species is similarly nebulous –

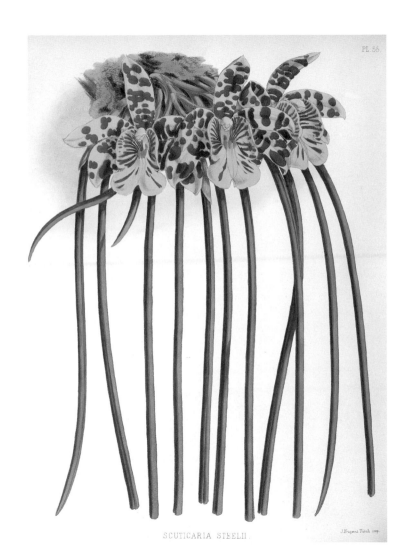

SCUTICARIA STEELII.

J. Nugent Fitch imp.

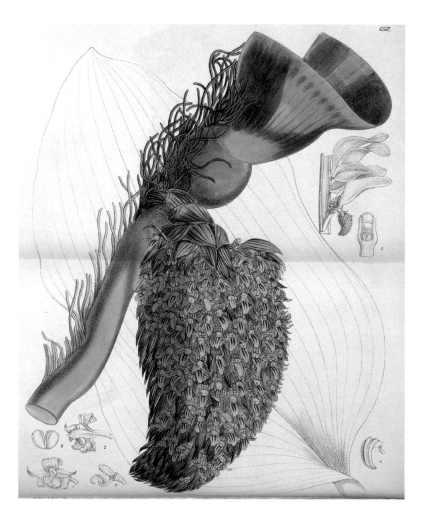

BULBOPHYLLUM BECCARII Writing in 1881, Joseph Dalton Hooker observed: 'In one character *Bulbophyllum beccarii* transcends all other orchids, if not all other vegetables, and that is the foetor of its flowers, which is loathsome beyond description ... Although the drawing here was executed in an airy room, close to a large open window, the artist [Matilda Smith] was repeatedly overpowered by it, and finally made for a time really ill.' At over 1200 species, *Bulbophyllum* is one of the largest genera of orchids and this species from Borneo is one of the largest and strangest of all. It was discovered by Thomas Lobb in 1853.

bronze-pink reticulated with slatey grey; hence its botanical name *Nephelaphyllum pulchrum*, which means 'pretty cloudleaf'. *Phaius tankervilleae* is famed for being one of the first exotic orchids to be grown in Europe, but *P. flavus* is equally well-known in its native East Asia. And rightly so – not only does it bear tall spikes of scented, sulphur-yellow flowers, but its handsomely shaped and pleated leaves are racing green with chrome yellow blotches. Related to *Phaius*, the southern Japanese *Tainia laxiflora* has pleated, malachite-green foliage obscurely spattered with purple-bronze like the not-entirely-successful camouflage of some gorgeous game bird. The leaves of several European species in the genera *Orchis* and *Dactylorhiza* are spotted with deep maroon – markings fancied long ago to have been made by Christ's blood shed on the cross. Several Far Eastern representatives of *Malaxis* (another genus familiar to North European naturalists) have uncannily colourful leaves. In *Malaxis metallica*, for example, they are an iridescent Tyrian purple. This last species is especially popular in Japan, whose indigenous horticultural tradition values orchids with distinctive foliage even more highly than those with beautiful flowers. Aberrant forms of *Cymbidium kanran*, *C. goeringii*, *Dendrobium moniliforme* and *Spiranthes sinensis* with variegated, mottled and oddly textured or shaped leaves are grown in their thousands and command prices of one hundred thousand yen and upwards. But none is so highly prized as *Fukiran*, the collective term for variegated and other mutant forms of the Japanese native *Neofinetia falcata*. Priced at ten million yen (roughly £58,000), one such *Fukiran* is currently the world's most highly valued orchid. Named 'Higuma' ('Brown Bear'), it is a mere 8cm tall with bronze-stained olive leaves and ruby root tips.

For variety and beauty of foliage *Fukiran* are outdone by an even more unassuming genus of orchids, *Goodyera*. These are small plants with creeping, succulent rhizomes and slender spikes of flowers which tend to be undersized and dull in colour. In this the flowers contrast markedly with the leaves, which are oval, thinly fleshy and usually patterned with silver or white veins. In *Goodyera* and its relations, the leaf surfaces are covered in myriad papillate cells which give them a shimmering appearance – hence their Japanese name, *shusu-ran* ('satin orchids'). There are even variegated forms of these already naturally 'variegated' plants. Known in Japan as *nishiki-ran* ('brocade orchids'), these are mutations of such species as *Goodyera schlechtendaliana* (which would typically have lustrous eau-de-Nil leaves chased with pewter veins) that are marbled with snowy white, suffused with gold and splashed with fluorescent lime. *Goodyera* represents the northernmost constituents of the jewel orchids, a group of genera renowned for their exquisite foliage and whose flowers, when they do appear, tend to be nipped in the bud by orchid growers, who find them tiresome to look at and fear them tiring for the plant. The most spectacular examples of this alliance are found in Subtropical and Tropical Asia and islands in the Indian and Pacific Oceans, where they grow in conditions of deep shade and high humidity.

As with *Goodyera*, the leaves of *Anoectochilus*, *Ludisia* and *Macodes* are thinly fleshy, oval to heart-shaped and satin-textured. They range in colour from sooty black to chestnut brown, copper and bronze and from lime to jade green and blood red. They are also embroidered with intricate patterns of gold, silver or ruby veining. Their rich and seemingly artful colouring, combined with their ability to spring up in the forest's most inhospitable places (and to disappear from them just as quickly), have at times given the jewel orchids something close to supernatural status in their native lands. In Southern India and Sri Lanka, for example, it was once believed that the leaves of *Anoectochilus regalis* were the meta-morphosed tatters of wood nymphs' saris – these had been snagged on the undergrowth as the nymphs fled intruding men.

BRASSIA VERRUCOSA (syn. BRASSIA BRACHIATA) The British botanist Robert Brown named the genus *Brassia* after William Brass, (who circa 1782) collected plants in West Africa for Sir Joseph Banks and others. Brass's explorations notwithstanding, these spectacular plants, commonly known as spider orchids because of their slender tepals, hail exclusively from the American Tropics. *Brassia verrucosa* (syn. *B. brachiata*) is one of the most popular species.

Variations on this myth can be found throughout the distribution of *Anoectochilus*, usually associating these elusive orchids with wood spirits or ghosts and elaborating on their habit of vanishing at the first sign of humans. To the great vexation of generations of orchid growers, most jewel orchids (the unkillable *Ludisia* excepted) are similarly fugitive in cultivation.

One of the showiest jewel orchids, however, was associated more positively with humans. This is *Macodes petola*, whose leaves are netted with luminous veins and figures that so closely resemble one of the scripts of its native Java that its name in the local tongue means 'writing paper plant' or 'text plant'. When he first recorded this orchid on the island of Amboina in the (then) Dutch East Indies, the botanist Georg Eberhard Rumphius (1628–1702) noted its vernacular name, *daun petola*, part of which survives in the plant's botanical epithet. In a literal reading of the doctrine of signatures, an eyewash made from leaves of *Macodes* was given to help those learning to read. Stronger solutions of the decoction were recommended for would-be authors and for students of literature.

These then are some basic features, growth habits and survival strategies to be found in the orchid family. They reveal something of the startling evolutionary flexibility of orchids. Some of these distinctions, like epiphyte and terrestrial or pseudobulbous and non-pseudobulbous, also hold the key to successful orchid growing. But these are not taxonomic distinctions and if anything we are left asking with even greater justification than before, 'Why should all these disparate plants be treated as orchids?' Their vast numbers, protean variety and global penetration having been established, the question remains: 'What exactly makes an orchid?' In broadest-possible terms, orchids are perennial herbs belonging to the *Monocotyledonae* (monocots), which comprise one of the two great subclasses of flowering plants, the other being the *Dicotyledonae* (dicots). Monocots can be crudely characterised as having a single cotyledon (seed leaf), leaves with mostly parallel veins, the absence of vascular cambium, vascular bundles scattered or in two or more rings and floral parts in threes or, rarely, fours and fives. The monocots include such groups as the aroids (arums), palms, grasses, irises, amaryllises and lilies. It is to the last three of these that the orchids are probably most closely related and they tend to be grouped in the superorder *Liliiflorae*.

The orchids themselves belong to the order *Orchidales*, which contains the single family *Orchidaceae*. Among the lily-like plants, they are seen to be the most rapidly evolving group and the one that has assumed its multitude of present guises most recently. Not all orchids are neophytes, however. Fossil evidence (always scant for organisms with soft tissues like orchids) has revealed such extinct orchid ancestors as *Protorchis* and *Palaeorchis* which date back to the mid Tertiary period some forty million years ago. The pantropical and transoceanic distribution patterns of such primitive but extant orchid genera as *Vanilla* and *Corymborkis* also suggest that true orchids were around in the early Tertiary when the continents they now inhabit were not so far-flung. As John Lindley commented in 1858, orchids 'assume as many guises as an actor'. Nonetheless, they do have some telltale characteristics – especially in respect of their flowers, and it is here that the shortest answer to the question 'What makes an orchid?' can be found.

The orchid flower consists of two whorls of segments – an outer whorl of three sepals, and an inner whorl of three petals. In some genera, like *Paphiopedilum* and *Dracula*, evolution has rationalised this formula by fusing some or all

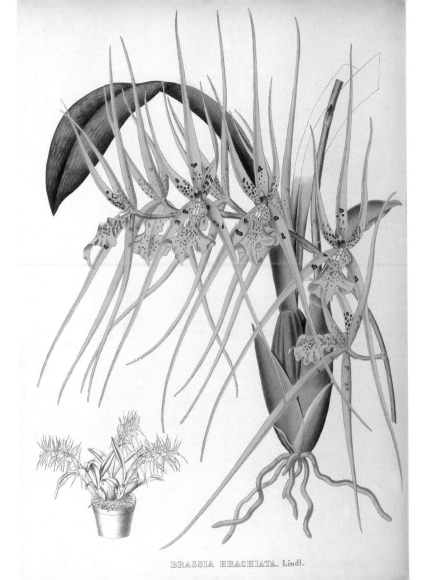

BRASSIA BRACHIATA. Lindl.

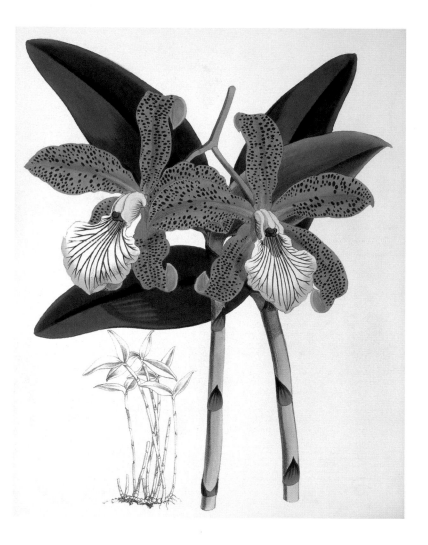

BULBOPHYLLUM BARBIGERUM
(Right) Collected in Sierra Leone and
imported by Loddiges Nursery of Hackney,
London in 1836, *Bulbophyllum barbigerum*
is one of the most bizarre orchids of all.
Adorned with tufts of silky sensitive hairs
and a precision-engineered hinge, the
flower's lip prompted John Lindley to
remark: 'to breathe upon it is sufficient
to produce a rocking movement, so
conspicuous and protracted, that one is
really tempted to believe that there must
be something of an animal nature infused
into this most unplant-like production'.

CATTLEYA VELUTINA
(Opposite) The Brazilian *Cattleya velutina*
is one of a group of cattleyas that includes
C. bicolor and *C. aclandiae*, whose colouring
is rich and intriguing rather than blousy
and prima donna-ish. In recent years,
they have grown in popularity and are
used with increasing frequency in breeding
programmes. The specific epithet 'velutina'
means 'velvety'.

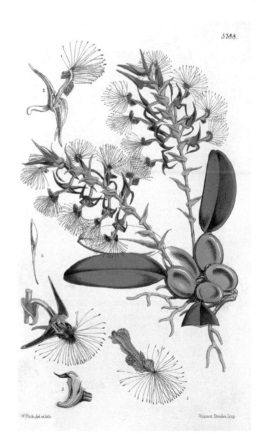

5288.

W Fitch, del et lith. Vincent Brooks, Imp.

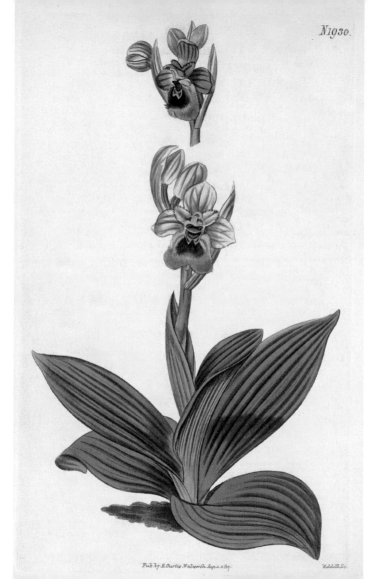

Pub. by S. Curtis Walworth Sep. 1 1819.

OPHRYS TENTHREDINIFERA Members of the genus *Ophrys* are masters of mimicry: the flowers are adapted to resemble female insects. Male insects in search of a mate land on them and, in their fruitless frenzy, detach pollen and take it on to the next floral liaison. This specimen of the sawfly orchid, *Ophrys tenthredinifera*, was collected in Sicily by William Swainson, who later discovered a very different but equally extraordinary orchid in Brazil, *Cattleya labiata*.

of the sepals together. But in most orchids these parts are free. Five of them are so similar in colour and form that they are treated collectively as 'tepals'. The sixth part (in fact the third and lowermost petal) differs sharply in shape, size and colour. Known as the lip or labellum, this distinctive feature of orchid flowers is a highly modified landing platform for pollinating insects. From the centre of the flower and, usually, arching over the lip, projects the column – a single structure that combines the stamen and the stigma. The stamen consists of large pollen masses (pollinia), which are housed beneath a detachable anther cap at the summit of the column. Directly below the anther cap on the facing surface of the column is a small, beak-like protrusion called the rostellum. This serves to brush pollinia carried from other orchid flowers from the heads and backs of visiting pollinators. These newly expropriated pollen masses then become stuck to the stigmatic surface, a groove or cavity situated beneath the rostellum, and the mechanical transfer side of pollination is complete. If pollination has been successful, the sepals and petals of the orchid flower fade and wither (except in the case of some *Lycaste* species, where the petals have actually been observed to fold inwards, covering the plant's sexual organs as if to say 'no more'). The column remains, however, and begins to swell as the pollen masses become drawn flat against the stigmatic surface. Navigating the sticky exudate produced by the stigma, minute individual pollen grains next grow in tubular form and begin their long descent within the column to the ovary, an ovary that also doubles up as the flower stalk – another telltale characteristic of orchids.

The secret business of fertilisation is straightforward by comparison with the lengths to which orchids will go to ensure their pollination. It is the intricate and seductive ruses involved in their ceaselessly inventive fertility dance that give the orchid flower its multiplicity of forms. The dance is usually undertaken with insects, which orchids have evolved a vast range of blandishments to attract, entrap and manipulate. Most simply, the orchid attracts its pollinators by means of colour, scent and the promise of nectar. The insect alights on the lip and is 'guided', usually by lines of special pigmentation, hairs or protuberances and ridges, toward the heart of the flower. The insect then finds itself wedged between the lip and the column. Its only escape is to reverse out of the flower. In the course of entry or exit, the visitor will inadvertently have detached the pollinia which it carries on its body hairs to the next flower. There are as many variations on this theme as there are orchid species. With a kind of anthropomorphism that is hard to resist when describing orchids, Charles Darwin called them 'contrivances'. They are indeed miniature masterpieces of evolutionary engineering. One of the best known of these strategies is the phenomenon of pseudocopulation, where the flower assumes the appearance, attitude and even the odour of the female of its pollinating species. The European genus *Ophrys*, for example, bears small, velvety flowers, each of which is adapted to entice a particular bee, wasp or hoverfly pollinator. The male insect believes he has arrived in a remarkably ductile seraglio and sets about the work of procreation con brio but in vain. The result is successful fertilisation for the orchid and zero population increase for the bug. In the tropical and subtropical genus *Bulbophyllum*, one of the largest and most highly adapted in the orchid family, these feats of mimicry are taken even further – several species have lips that are not only disguised as insects but also simulate their movements, rocking gently on exquisitely balanced hinges.

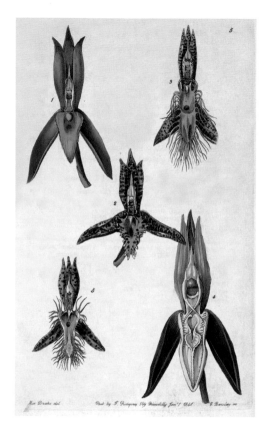

Min Drake del. Print by S. Ridgway 169 Piccadilly Jan.ᵗ 1 1848. G. Barclay sc.

CATASETUM Seventy or so species of *Catasetum* are scattered throughout Central and South America. Their flowers are among the strangest in the orchid family. Male, female or hermaphrodite flowers may be produced. Even though they may appear on the same plant and at the same time, flowers of different sex differ greatly in size, shape and colouring (males are usually gaudier). Male flowers are capable of hurling their pollen masses on to insect pollinators should they touch two horns or bristles on the column that act as a trigger. Illustrated here are (opposite) *Catasetum sanguineum* and (above) details from (1) *Catasetum callosum*, (2) *Catasetum cristatum*, (3 & 5) *Catasetum barbatum* and (4) *Catasetum laminatum*.

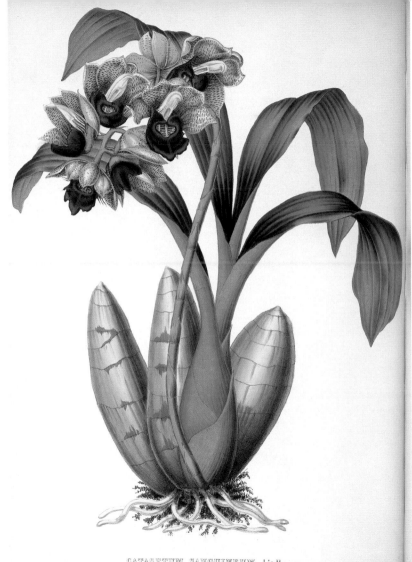

CATASETUM SANGUINEUM Lindl.

PAPHIOPEDILUM HIRSUTISSIMUM (syn. CYPRIPEDIUM HIRSUTISSIMUM) The year 1857 was a good one for slipper orchids. Not only did *Paphiopedilum fairrieanum* arrive in London from Assam but Northeast India yielded another spectacular newcomer. It made its debut in a sale of Asian orchids at Stevens's Auction Rooms. When the slipper orchid flowered a year later, John Lindley seems to have been more intrigued by its bristly pelt than by its colouring, and named it *Paphiopedilum hirsutissimum*.

The African *Bulbophyllum barbigerum* lures flies with a lip that is densely covered in slender ruby-coloured hairs. These tremble in the slightest breeze, setting the whole flower in motion and convincing would-be mates that their attentions will be met with enthusiasm. Africa is also home to another group of orchids that secures its line through deceit. These have evolved to resemble not their pollinators but wholly unrelated plants (usually in the *Iris* family and altogether more popular with insects), among which they grow and whose pollinators they quite simply poach.

The slipper orchids (*Paphiopedilum*, *Phragmipedium*, *Cypripedium* and *Selenipedium*) take a more aggressive approach to pollination. In these genera the lip has developed as a pouch or inflated sac whose rim and inner surface bear glands that attract insects. Entering the lip, the insect finds itself driven downwards by a combination of slippery surface cells and hairs. Reaching the 'toe' of the slipper – its only chance of escape is to crawl up the rear interior of the lip, whose outer edges are inrolled, forming a tunnel of sorts. Reaching the aperture of this tunnel, the insect must push past the pollen masses standing in its way, detaching them and carrying them to the next tender and temporary trap, where they will be deposited, unwittingly, on the stigmatic surface.

In the bucket orchids (*Coryanthes*) of South America the lip is divided into three parts. At its base is the hypochile, an inflated or skull-shaped sac. From this projects the mesochile, a slender tube-like structure. This ends in the epichile, which resembles a water-filled bucket. Male bees are attracted to the bucket orchid's musky odour, which contains pheromones that may help the bees in attracting mates of their own. To gather this substance, the bees massage glands found on the hypochile and mesochile, but they do so with such vigour that they fall exhausted (or intoxicated) into the bucket-like epichile. Their only chance of escape is to crawl through a narrow 'spout' in the rim of the bucket. This runs closely parallel to the flower's column, and is a route that forces the insects either to remove or deposit the orchid's pollen masses.

The aptly named *Arthrochilus irritabilis* from Southeast Australia is pollinated by male wasps whose would-be brides its flowers resemble. The amorous wasp alights on the lip to find its frenzy rudely interrupted: the lip is set like a trap, balanced on a hinge of uncanny sensitivity. The wasp's combined weight and movement set off the trap, bringing it and the lip down upon the column like a hammer on an anvil. Dazed but decked with pollen, the wasp disentangles itself and flies off to try its luck elsewhere. In the South American genus *Catasetum*, the lip bears 'antennae' that are linked, like hair triggers, to the column. When a pollinator lands on the lip t, its activity sets off the triggers causing the column to spring free. On its release, the column hurls its load of pollinia onto the insect, which duly proceeds to the next flower. The relationship between orchids and their pollinators is not always so one-sided. In the forests of Madagascar grows a species with large, waxy white flowers that exude a delicious night fragrance. Its name, comet orchid, refers to the fact that these blooms have long tails. Its botanical name, *Angraecum sesquipedale*, tells us just how long these tails are – up to 'a foot and a half'. They are in fact slender tubular spurs with a reservoir of sweet nectar at their tip.

Charles Darwin saw in this orchid a miracle of co-evolution. Its white, night-scented blooms were evidently 'designed' to attract moths; but its long spurs puts nectar beyond reach of any known moth. So convinced was Darwin of the orchid's 'ingenuity' that he conjectured a moth capable of pollinating the *Angraecum* must exist. For four decades the mystery of the comet orchid went unsolved until a moth was discovered in Madagascar with a proboscis long enough to drink from the orchid's 30cm spurs. Posthumously Darwin was vindicated, and the moth was named *Xanthopan morganii praedicta*, in honour of a guess that proved correct, one inspired by orchids. Darwin's subject was

Plate XV

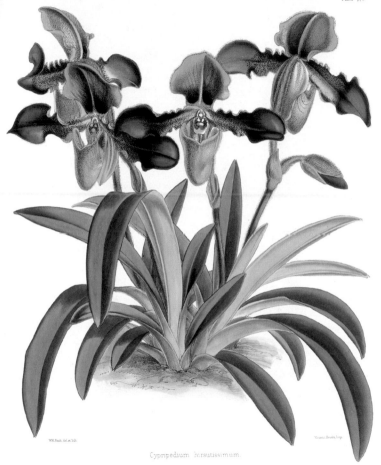

W.H. Fitch, del. et lith.

Vincent Brooks, Imp.

Cypripedium hirsutissimum.

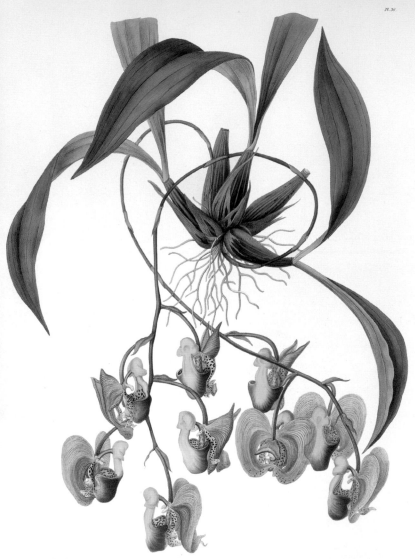

Pl. 36.

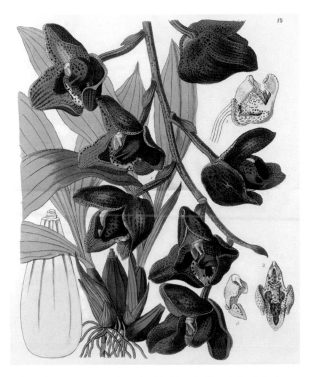

ACINETA SUPERBA (Above) The genus *Acineta* can be distinguished from its close relation *Peristeria* by its lip, which is not hinged but fused to the lip – hence its name, from the Greek *akinetos* ('immobile'). When it was first named (by Karl Sigismund Kunth in 1815), this magnificent orchid enjoyed a wild distribution that extended from Panama to Peru. Today, it is rare in nature, although large specimens are cherished in the plantations and gardens of South American farming and ranching families.

CORYANTHES SPECIOSA (Opposite) The flowers of the helmet or bucket orchids, Coryanthes, are among the most complex in the orchid family – a system of lures, pitfalls, traps and concealed exits arranged to dupe insects into facilitating pollination. Although it remains rare in cultivation, C. speciosa is found from Guatemala to Peru and, in gardens, flowered first for Sigismund Rucker of Wandsworth, South London, in 1842.

Tab. IV

Gez. v. J. G. Beer

K. K. a. pr. art. lith. Anstalt v Ant. Hartinger & Sohn in Wien

SEED DETAILS Orchid seeds are minute and, lacking food reserves of their own, seem ill-prepared for life. There is nonetheless as much variety in this quintessence of dust as there is in the flowers that issue from it. The seeds in this magnified selection from different genera range in size from 0.3mm to 2mm.

the *Dactylorhiza maculata*, an orchid rather closer to his Kentish home, when he ventured that if each of the 6200 seeds produced by one of its flower-spikes were to germinate, the offspring of this single orchid plant would cover the earth's landmass in three generations. Orchids produce seed in greater abundance than any other flowering plants. A single, 12cm-long pod of the Venezuelan swan orchid *Cycnoches chlorochilon*, for example, can contain as many as 3.7 million. Henry Oakeley described what happens when such a seedpod splits: 'In a small wood in Costa Rica, with a light breeze rocking the tops of the trees and the sunlight filtering through them, the seedpods of Lycaste macrophylla were dehiscing. Millions upon millions of seeds, forming dusty golden 'sunbeams' in the afternoon light, slowly descended covering the rocks, the moss, the leaves, my hair and my clothes with their cream-brown dust.'

What is to prevent Darwin's nightmare from materialising, the ultimate *embarras de richesses*, a world engulfed by orchids? As we have seen, orchids are not among the plant kingdom's most polyphiloprogenitive colonisers. They could rarely be said to occur in superabundance, and they tend to exploit ecological niches. Finding a suitable berth other than that already occupied by their parents is a gamble. Produced in vast quantity and capable of long-distance travel, orchid seeds are an acknowledgment of this risk, more bet-spreading than blanket bombing: in the wild, only very few of their millions ever germinate. To facilitate transportation by wind, and to gain a purchase on inhospitable perches, orchid seeds are very small – 5mm long at most, usually more in the region of 0.3–0.5mm. But they pay a price for their prodigality and this, even more than the problems of finding the right roothold, keeps down the rate of germination and saves the planet from a plague of orchids. Unlike most other plants, the orchid seed has no food reserves on which to draw. It consists merely of a cluster of embryo cells contained by a loose and often fragile membrane. With the exception of a few primitive genera like *Apostasia* and *Vanilla*, which have tougher seed coatings, and epiphytes like *Chiloschista*, whose seeds produce spiralling outgrowths that act as holdfasts on their prospective host trees, orchid seeds are a study in ill-preparedness and poor resources.

To secure the nutrition necessary for germination and growth, the seed must enter into a compact with microscopic fungi. Mycorrhizal symbiosis, as this relationship is known (from the Greek *mykos*, 'fungus' and *rhizon*, 'root') is engaged in to varying degrees by a wide range of plants; but for orchids the arrangement is vital. Hyphae, thread-like strands of fungus, penetrate the orchid seed and trigger its germination by supplying the embryo with nutrients. Unlike those of many other higher plants, the orchid embryo is not differentiated into organs such as radicle, plumule and seed leaves. It is, rather, a lump of tissue (the protocorm) that enlarges and sorts itself into roots and shoots only when nourished externally. With germination underway, the fungal hyphae permeate the substrate surrounding the protocorm, breaking down organic matter and freeing minerals and nutrients which can then be assimilated by their hatchling orchid host. Once the protocorm is capable of photosynthesis, the orchid and the fungus establish a life-sustaining and lifelong reciprocity. The orchid provides the fungus with sugars it manufactures during photosynthesis, while the fungus supplies nutrients in greater concentration than the orchid's roots (if unassisted) could ever wring from its hostile habitat. Henry Oakeley captures the powerful impulse of orchids to survive and reproduce, when he writes of an encounter 'in the clouds and fogs of the Sierra de las Minas of Guatemala, with a seedpod of *Lycaste skinneri*: 'Tapping it as it hung from a tree, the seeds tumbled out, not to fall to the ground but to stay suspended in the mist, no lighter, no heavier than droplets of mist, dancing to the tune of Brownian Motion to be carried in the next breeze to their distant rendezvous with some symbiotic fungus, germination, and the continuation of the cycle of life.'

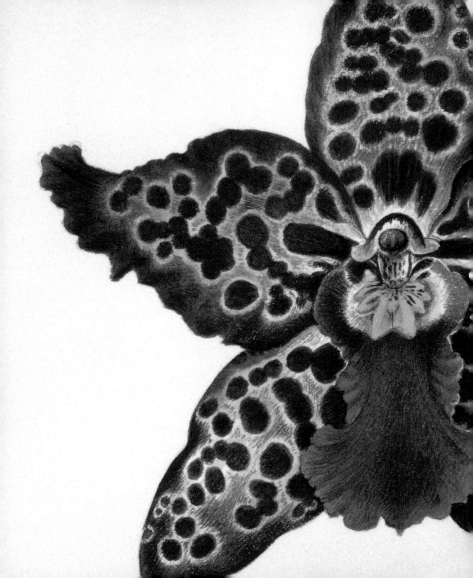

ODONTIODA BECQUET VINCENT 'SAINT HELIER'

PRIZE ORCHIDS

PRIZE ORCHIDS

A S THE NINETEENTH CENTURY PROGRESSED, botanists and gardeners began to penetrate the mysteries of orchid reproduction, setting the stage for Orchidmania's second phase – the hybrid revolution that continues to this day. Japanese horticulturists were growing hybrid orchids centuries before their Western counterparts, but we cannot tell whether those hybrids were artificial (made by hand cross-pollination), or whether they were happy accidents produced by confused insect pollinators. Oddly enough, the first certifiable artificial orchid hybrid did involve two East Asian species; but credit for the achievement must go to an Englishman.

On 25 October 1856, James Veitch Jr, proprietor of the Exotic Nursery in Chelsea, visited John Lindley, orchidologist and Secretary of the Horticultural Society. to show him an orchid flower of a rich rosy purple. It was clearly a Calanthe, but Lindley could not quite say which Calanthe. The flower's forked, downy spur reminded him of the white-flowered Calanthe triplicata while its colour and the broad midlobe of the lip recalled Calanthe masuca. Lindley speculated that this new plant might be intermediate between the two species, effectively a living link between them. James Veitch then revealed that the new plant was in fact a hybrid, manufactured in his own glasshouses. Now hybrids – both naturally occurring and artificially made – had been known for centuries, if not millennia. Humankind depends on them for essential needs that range from cereals to beasts of burden. As one of the foremost English botanists of his generation, Lindley knew the dynamics of hybridisation better than most. What he had never countenanced before that October day was the notion that orchids – those superbly adapted, specialised plants – might be capable of crossing with each other.

For three decades Lindley had spearheaded the campaign to name and classify the thousands of new orchid species that were pouring into cultivation. Now a single flower was casting doubt on his efforts: 'You'll drive the botanists mad,' he told Veitch. In the event, much of Lindley's work was safe. With a few exceptions, he had not been naming as species what were in fact hybrids (which he termed 'mules'). But Veitch's Calanthe planted seeds of doubt.

Its likely impact on orchid taxonomy aside, the new plant was revolutionary in two other important respects. It proved that some understanding had at last been gained of the mechanism of orchid pollination, thus clearing the way for further crosses. The new plant had been raised successfully from seed, a horticultural feat which, owing to the size of orchid seeds and their peculiar germination requirements, had only before been accomplished haltingly and unsystematically.

The man responsible for this miraculous plant was not James Veitch himself but his nursery foreman John Dominy. While working at the Veitch family's Exeter nursery, Dominy had struck up a friendship with John Harris, a local surgeon and gifted amateur biologist. Harris explained to Dominy the basic anatomy of the orchid flower and the process by which it was pollinated. Dominy took the matter into his own hands and, in 1853, began to cross-pollinate Cattleya species at the nursery. When these first attempts at hybridisation proved unsuccessful, Dominy turned to Calanthe instead, crossing C. triplicata with C. masuca. He sowed the resulting fertile seed in 1854 and the seedlings grew with astonishing speed, flowering only two years later. In recognition of his pioneering work, Lindley named this first recorded 'orchidaceous mule' Calanthe Dominyi. Meanwhile, Dominy's attention had turned again to Cattleya, this time with success. Five flowering plants of Cattleya Hybrida, a cross between the maroon-spotted, olive-flowered C. guttata and the lilac-pink C. loddigesii, were exhibited at the Horticultural Society in August 1859. Dominy's adventures in orchid breeding soon took even more daring turns as he began to cross species belonging to different genera. June 1861 saw the advent of the intergeneric hybrid Dossinimaria Dominyi, a cross between Ludisia discolor and Dossinia marmorata, two of the 'jewel orchids' that Victorians valued so highly for their beautifully patterned

leaves. Sadly such plants have long fallen from cultivation, but not all Dominy's innovations were so ephemeral.

In September 1863, Dominy recorded the flowering of the first crosses between Laelia and Cattleya, among them Laeliocattleya Exoniensis (Cattleya mossiae x Laelia crispa): these would set the trend in orchid breeding for generations to come. In the twenty-two years before his retirement in 1880, John Dominy produced at least twenty-five orchid hybrids which guaranteed Messrs Veitch a monopoly of orchid cross-breeding for over a decade. Of all his output, few plants can have given Dominy greater pleasure than Paphiopedilum Harrisianum, a cross made between P. villosum and P. barbatum that was named in honour of his mentor, John Harris, in 1869.

It was no longer necessary to plunder nature for new and exciting orchids. John Dominy had shown that it was possible to 'invent' orchids of one's own. Many followed his example – most famously his successor at the Veitch nursery, John Seden, who had produced no fewer then 500 hybrids by 1905, and is commemorated in the rosy-pink slipper orchid Phragmipedium Sedenii. Various attempts were made to keep track of the flood of new orchid crosses.

From the 1870s onwards, The Gardeners' Chronicle printed lists of new hybrids and their parents. Published in London in 1895 and with subsequent supplements and revisions, George Hansen's The Orchid Hybrids was the most comprehensive catalogue until the appearance in 1909 of The Orchid Stud Book by Hurst and Rolfe. Appropriately enough, the last word went to Frederick Sander. Sander began publishing hybrid listings in 1901. In the years that followed, he and his descendants augmented these lists, registering all known hybrids until, in 1946, they were able to produce Sander's Complete List of Orchid Hybrids. In the 1960s, responsibility for the registration of orchid hybrids and for revising and publishing Sander's List fell to the Royal Horticultural Society (RHS). Less than 150 years since James Veitch Jr presented John Lindley with the first orchid cross to be made in the Western world, more than 100,000 hybrids have been registered.

The Royal Horticultural Society not only sponsored the introduction and cultivation of orchids and took charge of the registration of hybrids, it also provided growers and breeders with a forum for presenting new plants. This was the Society's Orchid Committee. Formed in 1889, it still meets on the first day of the Society's flower shows to assess plants and recommend awards where deserved. In rising order of importance, these are Preliminary Commendation, Award of Merit and First Class Certificate. Especially well-grown plants can also be recommended for a Cultural Commendation. We have this curia of nurserymen, botanists and gifted amateurs to thank for the images featured in the chapters that follow. In 1897, the committee resolved that all orchids that receive an award should be painted in watercolour to uniform standards and specifications, and that these paintings should remain with the RHS as a permanent and expanding record.

The first RHS official orchid artist was Nellie Roberts, who, as a 17-year-old girl, had been bewitched when she beheld a vase of orchids in the shop window of a South London florist. Sixty years later, she was still painting them. Her huge industry is celebrated in the name of the satiny pink Cattleya 'Nellie Roberts'. Even in its most recent and sophisticated manifestations, colour photography cannot challenge the value of these watercolours. An artist can present a flower in ways that reveal its most distinguishing characteristics more ingeniously than the camera. Above all, watercolour and the painter's eye combined can reproduce flower colour far more faithfully. The artist alone can do it justice and, as we shall see in the pages that follow, RHS orchid artists from Nellie Roberts to Cherry-Anne Lavrih have succeeded in doing so brilliantly.

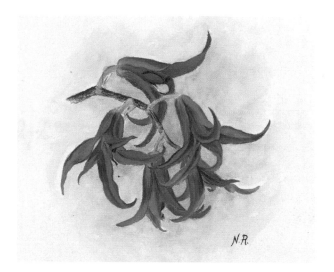

ADA AURANTIACA
(Above) The genus *Ada* was named by John Lindley to commemorate the queen of
the ancient kingdom of Caria. Its natural distribution is far from Asia Minor, however,
extending from the Colombian Andes to Grenada. This plant of *Ada aurantiaca* received its
Award of Merit in March 1900. Just over a century later, this species remains one of the
most popular cool-growing orchids, valued for its cinnabar-red flowers and ease of culture.

ADA OCANENSIS 'BEVERSTEN CASTLE'
(Opposite) Not all of the fifteen or so species of *Ada* are as cheerily colourful as *Ada
aurantiaca*. In 1998, this dramatic-looking plant came before the Royal Horticultural
Society's Orchid Committee – it is *Ada ocanensis* 'Beversten Castle', a striking clone with
spidery, chestnut-painted blooms.

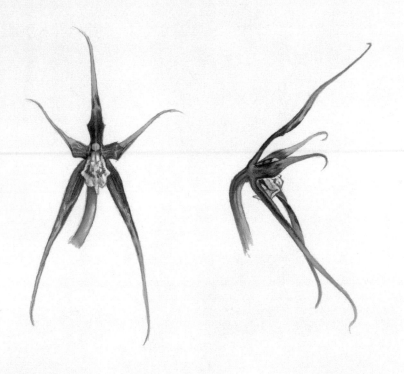

CA Labih

AERANGIS DISTINCTA
(Right) This *Aerangis* species was
named by renowned orchidologist
and RHS Director of Horticulture,
Joyce Stewart, together with the well-
known specialist in African orchids
Isobyl LaCroix. *Aerangis distincta* from
Malawi has starry white flowers that
are sometimes tinted shell pink at
their tips. Typical of the genus are
the exceptionally long floral spurs,
rich in nectar and exuding a delectable
nocturnal scent. This award-winning
example bears the well-deserved name
'Kew Elegance'.

AERANGIS CONFUSA 'WOTTON'
(Opposite) Another *Aerangis* species
named by Joyce Stewart, in this case
from Kenya and Tanzania. It received
an Award of Merit in January 1987.
This species is, like almost all other
members of the genus *Aerangis*,
white-flowered, although it often
flushes rosy pink, especially with age.

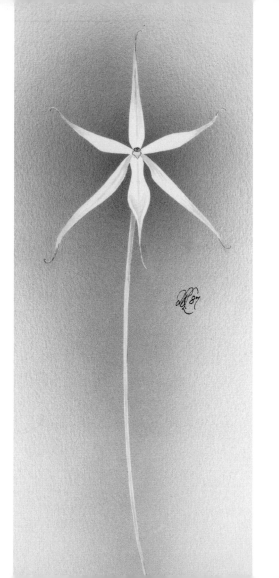

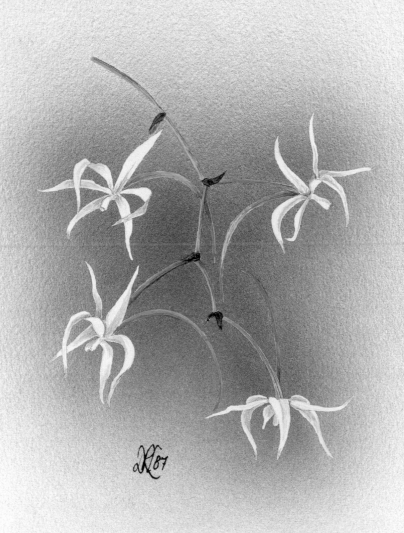

AERANGIS ARTICULATA 'MARCEL'
(Opposite) In 1997, the celebrated French orchid
grower Marcel Lecoufle won an Award of Merit for this
clone, *Aerangis articulata* 'Marcel'. After two centuries
of questing for colour and flamboyance, orchid growers
have more recently turned to species with elegant form
and pure tones – a trend that has sparked new interest
in the angraecoid orchids (genera such as *Aerangis* and
Angraecum), many of which have white, butterfly-like
blooms and, like this species, hail from Madagascar.

AERANGIS SPICUSTICTA 'SANDHURST'
(Above) In March 1993, this hybrid between *Aerangis
spiculata* and *Aerangis luteo-alba var. rhodosticta* was
shown by Plested Orchids of Camberley in Surrey,
England. Named *Aerangis Spicusticta* 'Sandhurst',
it exhibits (in somewhat diluted form) the creamy
tepals and remarkable red column of *Aerangis
luteo-alba* var. *rhodosticta*.

**AERANTHES
GRANDIFLORA 'FINCHAM'**
(Left) The genus *Aeranthes* takes
its name from the Greek *aer*, 'air',
and *anthos*, 'flower'. They are striking
epiphytes from Africa and Madagascar
with pendulous sprays of ghostly flowers
in shades of white, cream, green and
brown. This clone *Aeranthes grandiflora*
'Fincham' was exhibited in 1968,
although it had first been collected in
Madagascar over a century before.

AERANTHES HENRICI 'PEYROT'
(Opposite) The following year, in
February 1969, the French orchid
grower Marcel Lecoufle astonished
the RHS Orchid Committee when
he presented, for the first time
in England, the extraordinary
Aeranthes henrici 'Peyrot'. Adding
to this orchid's general air of
strangeness is the fact that its flower
spikes remain in bloom for a year
or two at a stretch, although only
one or two flowers will be open at any
one time.

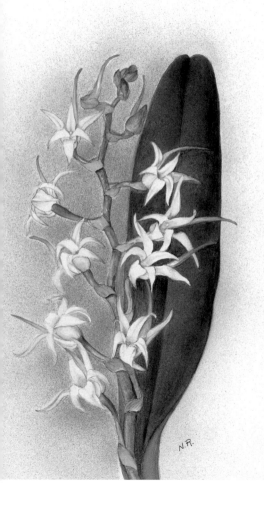

ANGRAECUM O'BRIENIANUM
(Left) A genus of 150 species from
Africa and the adjacent islands of
the Indian Ocean, *Angraecum* takes
its name from *angurek*, a Malay word
for epiphytic orchids. They are mostly
robust plants whose strap-shaped,
dark-green leaves contrast strongly
with ethereal sprays of waxy, pure white
flowers. *Angraecum O'Brienianum* was
first introduced in 1912 by the celebrated
nursery Sander & Co of St Albans,
Hertfordshire.

**ANGRAECUM SUPERBUM
Á'PINE CLOSE'**
(Opposite) One of the most striking
features of *Angraecum* is the floral spur,
a long, nectar-containing tube that has
evolved to a specific length and shape in
each species to attract and accommodate
a particular type of moth. When it
was shown in 1968, this example of
a Central African species, *Angraecum
superbum* 'Pine Close' was noted to
have spurs over 30cm long.

ANGULOA CLIFTONII 'PALE THOMAS'

(Left) Confusion reigned among the cradle or tulip orchids, members of the genus *Anguloa*, until Henry Oakeley began to collect and research them: yellow-flowered species were muddled one with another, likewise those with white or pale pink flowers, and those with ochre blooms that are mottled with maroon. His selected clone *Anguloa cliftonii* 'Pale Thomas' won an Award of Merit in June 1996. A native of Colombia, it bears massive, waxy flowers of a pale primrose yellow, their interiors marbled with red.

ANGULOA ROLFEI

(Opposite) Sixty-six years earlier, Sir Jeremiah Colman brought this specimen to London from his celebrated orchid collection at Gatton Park in Surrey. Named *Anguloa* Rolfei, it is a naturally occurring hybrid between the yellow *Anguloa cliftonii* and the maroon and olive *Anguloa brevilabris*. The existence of such plants, although a bonus for horticulture, has, as John Lindley predicted, frequently perplexed the botanists. (Overleaf, left) Another example of the natural hybrid *Anguloa* Rolfei 'Saint Thomas' was exhibited at the Royal Horticultural Society by Henry Oakeley in July 1993.

ANGULOA VIRGINALIS 'SAINT THOMAS'

(Overleaf, right) Unlike *Anguloa* Rolfei, *Anguloa virginalis* 'Saint Thomas' is a demure species with delicately poised flowers of the palest lilac-pink. The true plant was reintroduced to horticulture by Henry Oakeley in 1990 having been lost for over a century. Like most *Anguloa* species, it is native to Colombia, and its flowers are heavily perfumed of chocolate and oil of wintergreen.

N.R.

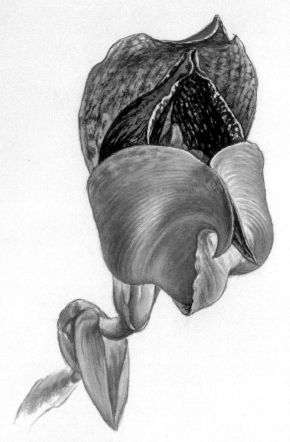

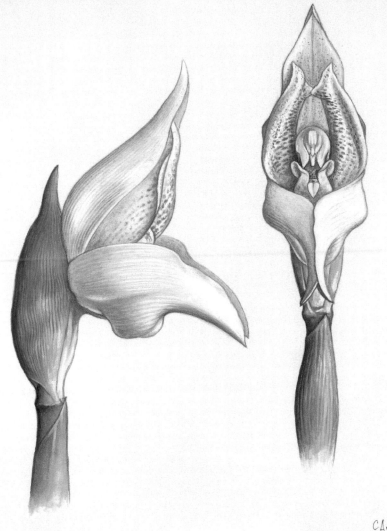

CALavich

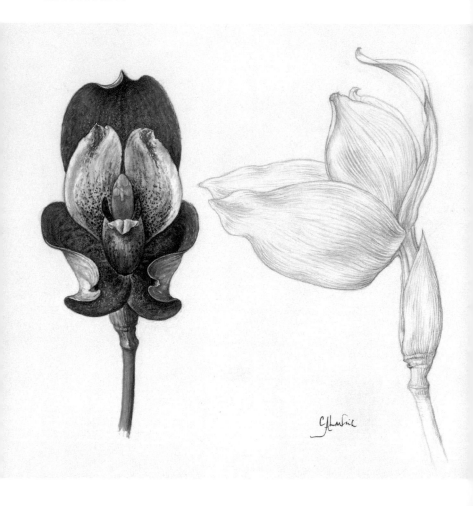

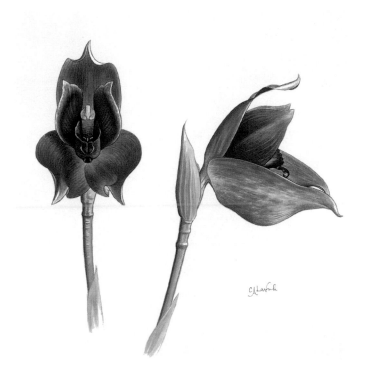

ANGULOCASTE PINK CHARM 'SAINT THOMAS'
& ANGULOCASTE MAUREEN 'SAINT HELIER'
Crossed with *Lycaste*, *Anguloa* gives *Angulocaste*. These are large plants
with massive waxy flowers usually in shades of ivory, pink, buff, tan,
maroon and brown. *Angulocaste* Pink Charm 'Saint Thomas' (above) is
a cross between *Anguloa virginalis* and *Lycaste* Balliae. Raised by
Dr Henry Oakeley of Beckenham, Kent, it gained an Award of Merit in
1991. A cross between *Anguloa eburnea* and *Lycaste* Jackpot, *Angulocaste*
Maureen 'Saint Helier' (opposite) was exhibited by the Eric Young Orchid
Foundation of Jersey in 1991, winning an Award of Merit.

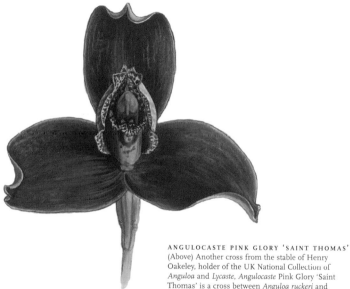

ANGULOCASTE PINK GLORY 'SAINT THOMAS'
(Above) Another cross from the stable of Henry
Oakeley, holder of the UK National Collection of
Anguloa and *Lycaste*, *Angulocaste* Pink Glory 'Saint
Thomas' is a cross between *Anguloa ruckeri* and
Lycaste Balliae. It was shown in 1989.

ANGULOCASTE MAUREEN 'FOXDALE'
(Opposite) In the year 2000, Foxdale Orchids of
Stoke-on-Trent received an Award of Merit for their
beautifully delicate clone, called 'Foxdale', of the
well-loved grex *Angulocaste* Maureen, which is a cross
between *Anguloa eburnea* and *Lycaste* Jackpot.

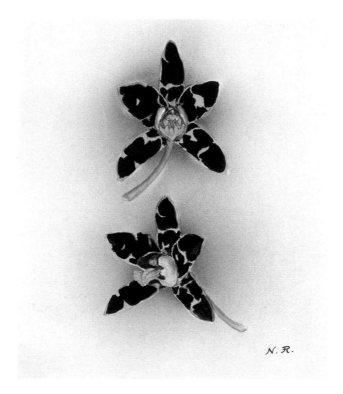

ANSELLIA CONGOENSIS

The genus *Ansellia* commemorates the English gardener
and plant hunter John Ansell (d 1847), who collected the
first specimen in Fernando Po. In 1935, this example of
Ansellia congoensis (*Ansellia africana*) won an Award of
Merit. Its flowers are typical of the genus – yellow petals
mottled with chestnut brown – and earn it the popular
name of leopard orchid.

ANSELLIA AFRICANA 'MONT MILLAIS'
Leopard orchids are widespread in Tropical and Southern Africa,
growing in a wide range of habitats, from rainforest to dry grasslands.
Their flowers vary greatly, from pure yellow to near-black, but most
conform to the pattern shown by this clone, *Ansellia africana* 'Mont
Millais', which was collected in Sierra Leone and exhibited in 1975 by
the Jersey orchid grower Eric Young. Despite their wide distribution
and variation in flower colour, the many types of *Ansellia* follow the
same basic anatomical outline, causing them to be lumped together
by botanists in a single species, *Ansellia africana*.

ARACHNANTHE ANNAMENSIS
(Right) In 1906, Ireland's National
(then Royal) Botanic Garden at
Glasnevin presented this remarkable
Southeast Asian orchid. It had been
collected in Annam by Micholitz,
a plant hunter working for the great
orchid nursery of Sander and Company.
It was named *Arachnanthe annamensis*
('the spider flower from Annam'),
and it keeps the spidery element even
in the name by which it is better known
today, *Arachnis*. It is one of the showiest
members of a group of orchids that
has become important to the Malaysian
cut-flower industry, the best known of
which is *Arachnis flos-aeris*, a species
that can be found in supermarkets and
in vases in restaurants the world over.

ARACHNANTHE ROHANIANA
(Opposite) A related species named
Arachnanthe rohaniana was shown
the following year. It differs from other
Arachnanthe (in the sense of *Arachnis*),
however, in having flowers of two
distinct types on the same spray (both
are shown here). A few lowermost
blooms are broad-petalled, while the
remainder are narrower, differently
coloured and cascade in their dozens
or hundreds in magnificent, weeping
racemes. This double sex life led the
botanist Rolfe to place this and one
other similar species in a genus of their
own, named *Dimorphorchis*.

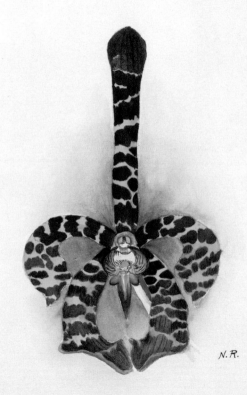

N. R.

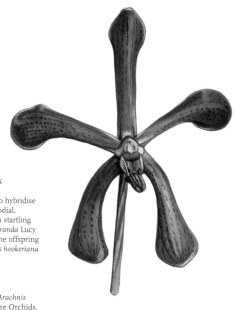

ARANDA LUCY LAYCOCK 'MANDAI BEAUTY'

(Right) *Arachnis* was found to hybridise with other genera of monopodial, Southeast Asian orchids with startling results. First seen in 1963, *Aranda* Lucy Laycock 'Mandai Beauty' is the offspring of the primary cross *Arachnis hookeriana* x *Vanda tricolor*.

ARANDA WENDY SCOTT 'BLUE BIRD'

(Opposite) Another *Vanda/Arachnis* primary cross from Singapore Orchids, *Aranda* Wendy Scott 'Blue Bird' was shown to the Royal Horticultural Society Orchid Committee in 1960. It combines *Vanda hookeriana*, with *Arachnis Rothschildiana*.

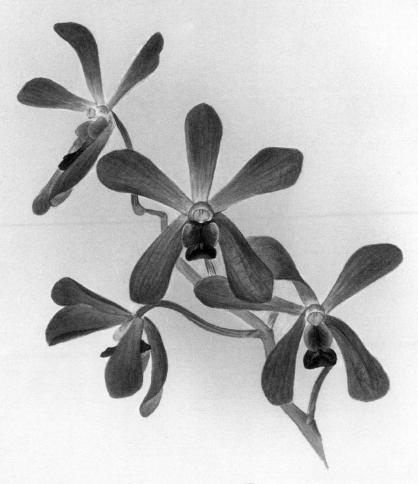

ASCOCENDA HYBRIDS

Two Asian genera combine in the orchid hybrids grouped as *Ascocenda: Ascocentrum*, which are primarily miniatures with sparkling, fluorescent flowers, and *Vanda*, which are more robust with large, butterfly-like blooms. The combination gives plants of a manageable size from the first parent, and spectacularly showy flowers from the second. Here is a selection of the some of the most striking of these jewel-like plants.

(Clockwise from top left) *Ascocenda* Thonglor 'Truman Muggison' (*Ascocenda* Medasand x *Ascocenda sanderiana*); *Ascocenda* Tan Chai Beng 'Tilgates Amethyst' (*Ascocenda* Meda Arnold x *Vanda* Rothschildiana); *Ascocenda* Prima Belle 'Bulawayo' (*Ascocenda* Tan Chai Beng 'Tilgates Amethyst' x *Vanda* Rothschildiana 'Tilgates'); *Ascocenda* Amelita Ramos 'Robert' (*Ascocenda* Pokai Victory x *Vanda sanderiana* var. *alba*); *Ascocenda* Bonanza 'Tilgates' (*Vanda* Pukele x *Ascocenda* Meda Arnold); and *Ascocenda* Phushara 'Tilgates' (*Vanda* Onomea x *Ascocenda* Medasand).

(Overleaf, from left) *Ascocenda* 'Madame Panni 'Malibu' (*Vanda* Onomea x *Ascocentrum curvifolium*) and *Ascocenda* Fiftieth State Beauty 'Jersey' (*Ascocenda* Yip Sum Wah x *Ascocenda* Meda Arnold).

M.I.H.

**BRASSIA ARACHNOIDES
'SELSFIELD'**
(Right) A fine example of the
South American spider orchid,
Brassia arachnoides 'Selsfield' earned
David Sander's Orchids of East
Grinstead an Award of Merit in 1967.

BRASSIA VERRUCOSA 'BURNHAM'
(Opposite) Although orchid
hybridisation deepened in complexity
and ingenuity toward the end of the
twentieth century, and numerous newly
discovered or newly introduced species
also gained favour, there was still
room for some old favourites. In 1983,
for example, Burnham Nurseries of
Newton Abbot in Devon showed this
magnificent clone of the tropical
American spider orchid, *Brassia
verrucosa* 'Burnham'.

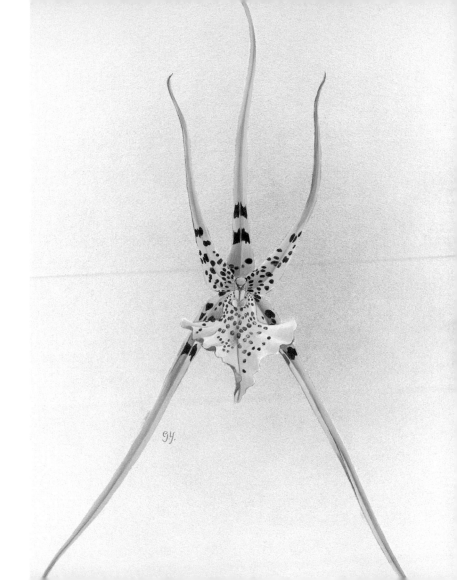

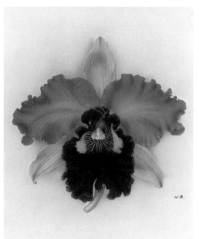
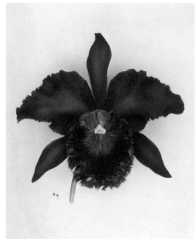

BRASSOCATTLEYA JOHN LINFORD

(Above left) One member of the Central and South American genus *Brassavola*,
B. digbyana (now more properly known as *Rhyncholaelia digbyana*) produces flowers
whose cool, ivory colouring is belied by a magnificently showy, ruffled and dissected lip.
Early on in orchid hybridisation, this characteristic was combined with the large and
more vividly coloured *Cattleya* to produce *Brassocattleyas* in intense tones and with lacy
edges to their flowers. In the 1930, the celebrated orchid growers Black & Flory of Slough
in Berkshire presented *Brassocattleya* John Linford, a hybrid between *Cattleya* Prince
Shimadzu and *Brassocattleya* Rosita. It was a magnificent achievement, but one typical
of a nursery that was the lineal descendant of the famous Veitch nursery where British
orchid hybridisation first began.

BRASSOCATTLEYA LISETTE & BRASSOCATTLEYA
DIGBYANO-TRIANAEI 'HEATON'

Ten years earlier, W.R. Fasey of Snaresbrook in London won an Award of Merit for
Brassocattleya Lisette (above right), a cross between *Brassocattleya* Digbyano-warneri
and *Cattleya dowiana* 'Aurea'. More typical of these lavish flowers, *Brassocattleya* Digbyano-
Trianaei 'Heaton' (opposite) is a clone of the primary cross *Brassavola digbyana* x *Cattleya
trianaei*. It was produced by the nursery Charlesworth & Co of Bradford, Yorkshire and
exhibited in 1905.

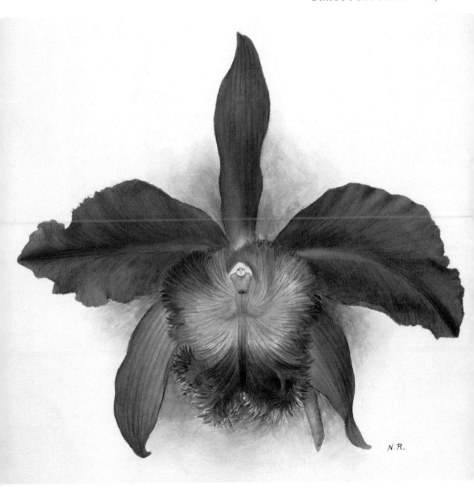

N.R.

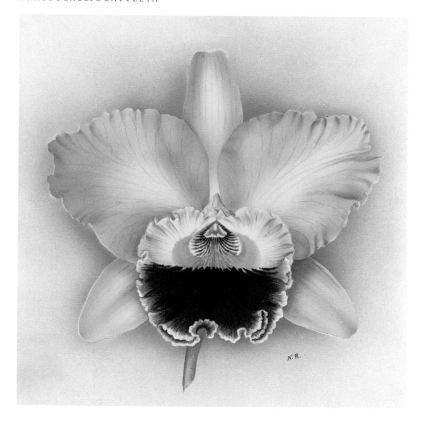

BRASSOLAELIOCATTLEYA JUPITER 'MAJESTICA'
Produced in 1921 by Hassall & Co of Southgate, Middlesex,
Brassolaeliocattleya Jupiter 'Majestica' combines *Brassolaeliocattleya* Veitchii
with *Cattleya* Armainvillierense to produce a flower that fuses the typical
colouring of *Cattleya* and *Leilia* with the broad, frilly outline of *Brassavola*.

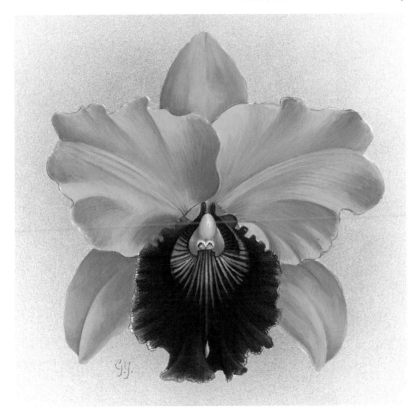

BRASSOLAELIOCATTLEYA GOLDEN OF TAINAN 'SOUTH GREEN'
The genus *Laelia* is allied to both *Brassavola* and *Cattleya* but tends to
bear smaller flowers in softer tones. The three genera were united by
orchid breeders in *Brassolaeliocattleya*, an excellent example of which
is *Brassolaeliocattleya* Golden of Tainan 'South Green', a cross between
Brassolaeliocattleya Golden Ember and *Brassolaeliocattleya* Dana that
appeared comparatively late in the orchid breeding story, in 1984.

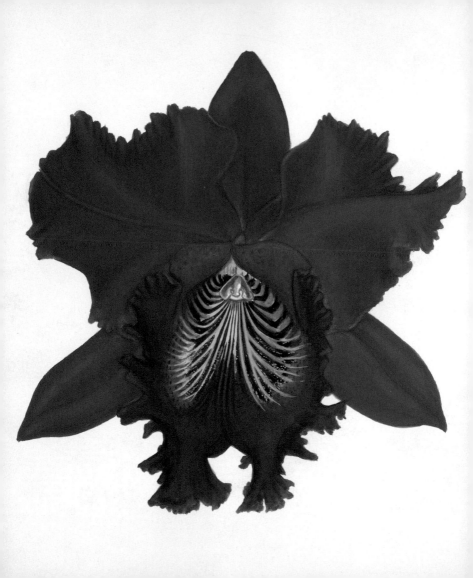

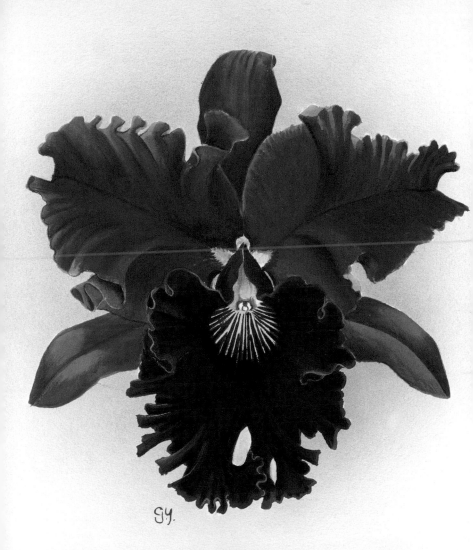

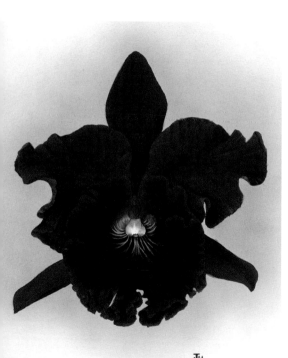

JH

BRASSOLAELIOCATTLEYA HYBRIDS
(Previous page, from left to right)
These two *Brassolaelio-cattleya*s conform
perfectly to the type of the luxurious
corsage-wearer's orchid. *Brassolaelio-
cattleya* Norman's Bay 'Gothic' is a
cross between *Laeliocattleya* Ishtar and
Brassocattleya Hartland shown by Stuart
Low & Co of Sussex in 1953. *Brassolaelio-
cattleya* Amy Wakasugi 'La Tuilerie'
combines *Laeliocattleya* Bonanza with
Brassolaeliocattleya Herons Ghyll and
was shown by the French orchid
breeders Vacherot & Lecoufle in 1985.

**BRASSOLAELIOCATTLEYA
HERONS GHYLL 'NIGRESCENS'**
(Left) *Nigrescens*, meaning 'blackish',
aptly describes the sultry ruby-magenta
of the *Brassolaeliocattleya* Herons Ghyll
'Nigrescens' orchid, a cross between
Brassolaeliocattleya Norman's Bay and
Laeliocattleya Ishtar 'Low's' that earned
the growers Stuart Low & Co of Sussex
an Award of Merit in 1960.

**BRASSOLAELIOCATTLEYA KEOWEE
'HILLSIDE'**
(Opposite) Toward the end of the
twentieth century, increased interest in
species (and in crosses that resembled
them) resulted in the introduction of
smaller-flowered *Brassavola* species to
the heady hybrid mix. *Brassolaeliocattleya*
Keowee 'Hillside', for example, combines
genes from the flashy *Laeliocattleya*
Lorraine Shirai with *Brassavola nodosa*,
the ghostly flowered 'lady of the night'
orchid from the Tropical Americas.

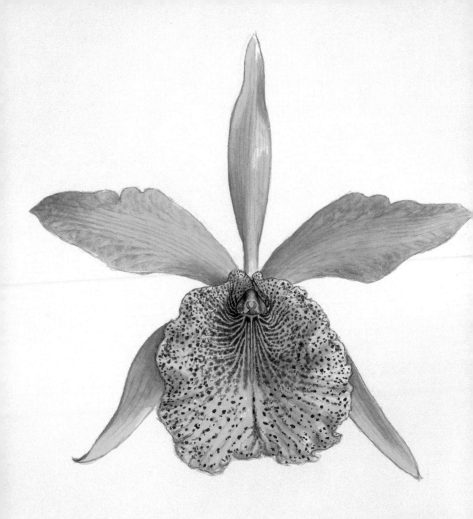

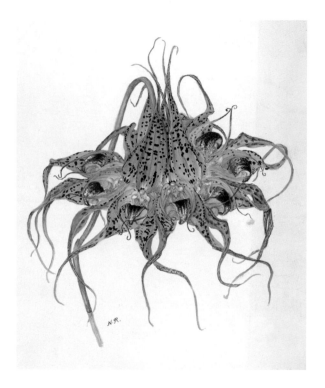

BULBOPHYLLUM BINNENDIJKII
& BULBOPHYLLUM JERSEY 'MONT MILLAIS'

The genus *Bulbophyllum* is one of the orchid family's largest and contains over 1200 species. Today it also encompasses the many plants formerly classified as *Cirrhopetalum*, and hybrids between the two genera (known as *Cirrhophyllum*). For orchid registration, however, these names are still retained. In 1997, the Eric Young Orchid Foundation in Jersey won an Award of Merit for its hybrid *Bulbophyllum* Jersey 'Mont Millais' (opposite), a cross between *Bulbophyllum lobbii* and *B. echinolabium*.

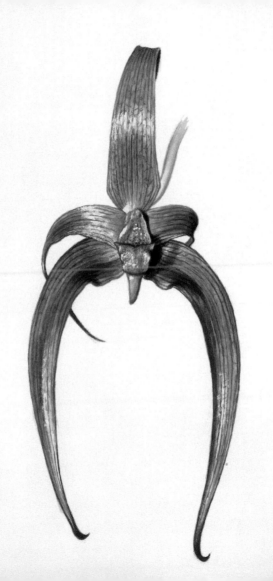

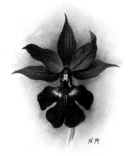

CALANTHE HYBRIDS
The first orchid hybrid to be made in the West involved two *Calanthe* species, and this genus remained at the forefront of orchid breeding until the early decades of the twentieth century. Why it then fell from fashion is hard to explain: these are relatively easy plants to grow, producing elegant sprays of butterfly-like flowers in winter. The award-winners on these pages are typical of the plants that found such favour. For the most part, they involve *Calanthe vestita*, a showy species from Southeast Asia, in their parentage: (from left to right) *Calanthe* Angela (*Calanthe* Sedenii 'Burfordiensis' x *Calanthe* Chapmanii); *Calanthe* Splendens (*Calanthe rosea* x *Calanthe* Bryan); and *Calanthe* Chapmanii (*Calanthe* Sedenii 'Burfordiensis' x *Calanthe* Oakwood Ruby).

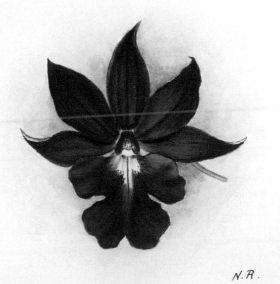

N.R.

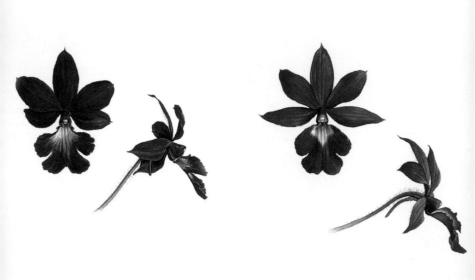

CALANTHE HYBRIDS
While the cool-growing and semi-hardy calanthes of Japan and China had scarcely waned in popularity in four centuries, the warmth-loving species and hybrids that had adorned Western conservatories in the Edwardian era were in deep recession by the end of the twentieth century. Then Jersey's Eric Young Orchid Foundation addressed itself to the problem, producing a magnificent series of new selections, among them (from left to right) *Calanthe* Five Oaks 'Saint Martins' (*Calanthe* Gorey x Calanthe Corbiere), *Calanthe* Rozel 'Trinity' (*Calanthe* Grouville x *Calanthe* Saint Aubin) and *Calanthe* Grouville 'Trinity' (*Calanthe* Diana Broughton x *Calanthe* Bryan).

**CATASETUM PILEATUM
'IMPERIAL PIERRE COURET'**
(Opposite) *Catasetum* is one of the
most remarkable of all orchid genera.
Not only are the flowers strangely
shaped and coloured, but they are also
capable of changing shape, colour and
gender according to the environment
in which the plants find themselves.
When John Lindley examined different
types of flowers from what he did not
realise was the same plant, he placed
the several states of *Catasetum* in
different genera. By 1987, when
Catasetum pileatum 'Imperial Pierre
Couret' gained Vacherot & Lecoufle
an Award of Merit, the confusion
had been cleared up; but the plants
had lost none of their mystique.

CATASETUM TENEBROSUM
(Right) That mystique is perhaps
nowhere more evident than in
Catasetum tenebrosum, a species from
Ecuador whose very name reflects its
sombre colouring, shadowy past and
love of impenetrable forest haunts.

CATASETUM FANFAIR 'BARABEL'
(Left) Possibly because of their odd
habits, catasetums have enjoyed
fluctuating fortunes among orchid
fanciers. In 1991, however, *Catasetum*
Fanfair 'Barabel' received the fullest
endorsement from the RHS Orchid
Committee. A primary hybrid between
C. expansum x *C. saccatum*, it marked
a new direction in orchid breeding
and signified a sea change in the
tastes of orchid growers – from the
conventionally beautiful to the bizarre.

CATASETUM NASO
(Opposite) As is so often the case
in plant breeding, however, the new
departure was also something of
a revival, as *Catasetum Naso*,
a hybrid produced by the Sussex firm
of Charlesworth & Co as long ago as
1928, bears witness.

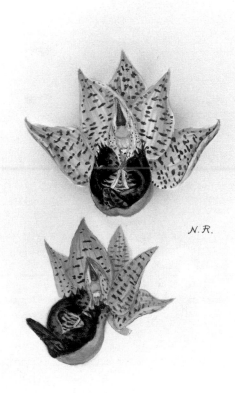

N.R.

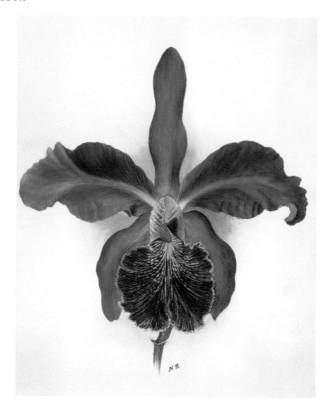

CATTLEYA CLAUDIAN & CATTLEYA BICOLOR 'GROSSII'

Ever since *Cattleya labiata* sparked orchid fever in the early years of the nineteenth century, cattleyas have been seen as the most 'orchid-like' orchids of all. Produced by the firm of Charlesworth & Co in Yorkshire, *Cattleya* Claudian (above) won a First Class Certificate in 1906. It is a cross between the fragrant, lavender-flowered *Cattleya* lueddemanniana, and *Cattleya schilleriana,* a Brazilian species with maroon-mottled, olive-green flowers. Not all cattleyas are such grandes dames. Several species produce smaller flowers that are as rich in character as they are in colouring. First shown in 1902, *Cattleya bicolor* 'Grossii' (opposite) is remarkable for its deep mahogany tepals and a cerise lip.

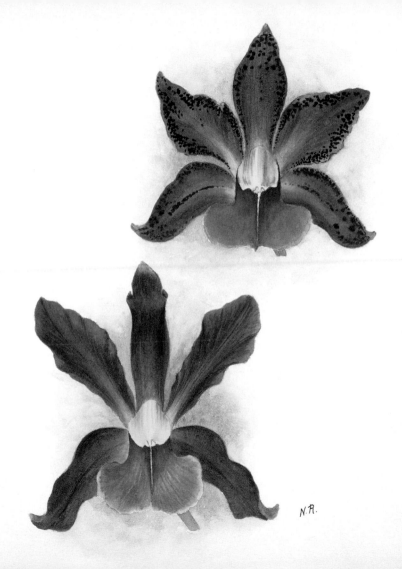

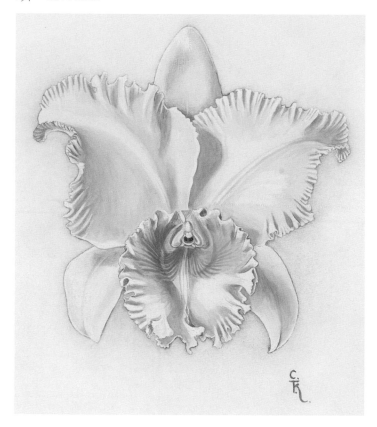

CATTLEYA BOB BETTS 'SNOWDON'
One of the most famous white-flowered orchid hybrids of all, *Cattleya* Bob Betts 'Snowdon' gained an Award of Merit for the Kent growers Armstrong & Brown in 1954. A cross between *Cattleya* Bow Bells x *C. mossiae* 'Wageneri', its blooms are crystalline white and powerfully fragrant, making it popular for winter wedding bouquets.

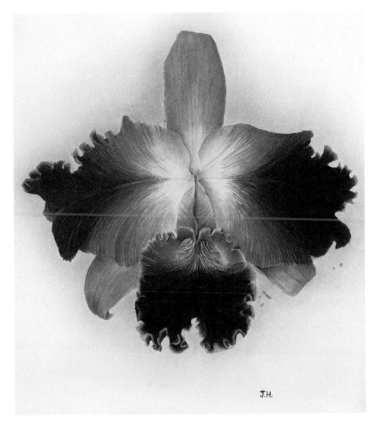

CATTLEYA LADY MOXHAM 'SOUTHERN CROSS'
Bridal purity is not usually associated with these most flamboyant
flowers. Produced by Stuart Low & Co of Sussex in 1955, *Cattleya* Lady
Moxham 'Southern Cross' draws on *Cattleya* Evelyn 'Carrie' and *Cattleya*
'Cokeham' to give an overpowering blend of magenta, burgundy and
glowing orange.

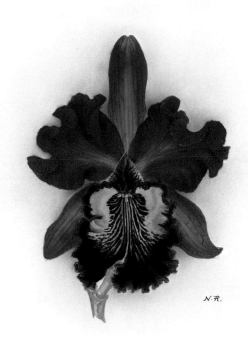

CATTLEYA GLADIATOR & CATTLEYA GERMANIA
One of the most important parents in *Cattleya* breeding is *C. dowiana*, a species from
Costa Rica, Panama and Colombia with rich golden tepals and a velvety ruby lip.
Its influence is apparent in *Cattleya* Gladiator (above), a cross shown by F.J. Hanbury
of Sussex in 1929. A hybrid dating from 1901, *Cattleya* Germania (opposite) shows
the influence of another of the smaller-flowered and intriguingly coloured species
(*C. granulosa* 'Schofieldiana'), which combines here with the more conventionally
buxom *C. Hardyana* to give a flower that is elegant in form and muted in tone.

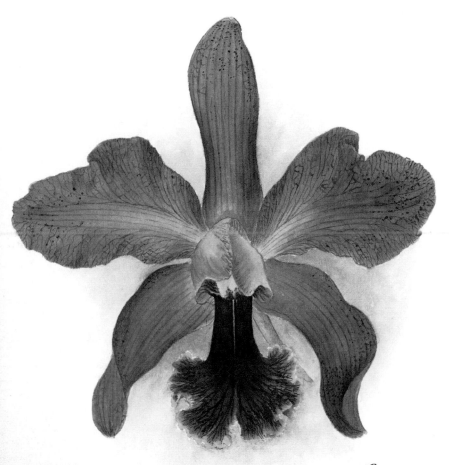

N.R.

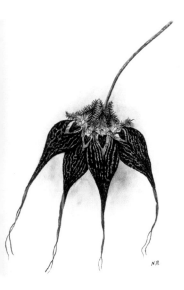

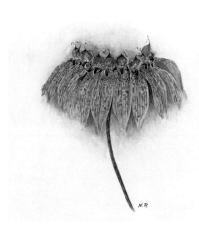

CIRRHOPETALUM ELIZABETH ANN 'BUCKLEBURY'

'Hybrid vigour' is a phenomenon commonly observable in orchid crosses, many of which are larger, fastergrowing and more resilient than their parents. Few plants exhibit it more clearly, however, than *Cirrhopetalum* Elizabeth Ann 'Bucklebury' (opposite). This cross between *Cirrhopetalum longissimum* and *Cirrhopetalum rothschildianum* was raised by Stuart Low & Co. In 1972, it gained an Award of Merit for the great orchid amateur Lady Sainsbury and it has been growing irrepressibly in baskets in the greenhouses of orchid lovers ever since. In 1895, one of the parents of *Cirrhopetalum* Elizabeth Ann 'Bucklebury', *Cirrhopetalum rothschildianum* (above left) received a First Class Certificate from the RHS. This Indian species is one of several cirrhopetalums (*Bulbophyllum*) that attract their pollinators by simulating the movements of female insects.

CIRRHOPETALUM PULCHRUM

(Above right) Their relatively small proportions and strange appearance notwithstanding, cirrhopetalums have tended to steal the hearts of orchid grandees no less than operatic cattleyas and soignée slipper orchids. This specimen of *Cirrhopetalum pulchrum* was shown by Sir Jeremiah Colman of Gatton Park in 1908. It is native to Papua New Guinea and its name, meaning 'pretty', reflects its blend of creamy primrose and rosy purple.

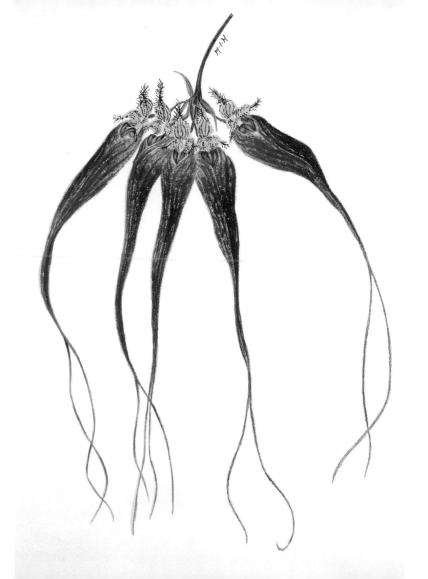

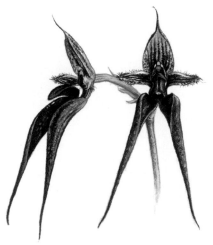

CIRRHOPHYLLUM HANS' DELIGHT 'BLACKWATER'

(Above) The late 1900s saw renewed interest in orchids, especially small (or miniature) species that bore flowers that were disproportionately big in character. Orchid breeders embarked on a quest for hybrids that resembled wild species. *Cirrhophyllum* Hans' Delight 'Blackwater', shown in 1997 by Plested Orchids of Sandhurst, Berkshire, is a cross between two Southeast Asian species, *Cirrhopetalum putidum* and *Bulbophyllum cruentum*. The name *Cirrhophyllum* reflects the fact that two genera, *Cirrhopetalum* and *Bulbophyllum*, are involved in its parentage. Since *Cirrhopetalum* is now considered to be part of *Bulbophyllum*, however, this hybrid should strictly be styled *Bulbophyllum* Hans' Delight 'Blackwater'.

CYMBIDIELLA PARDALINA 'COOKSBRIDGE'

(Opposite) *Cymbidiella* takes its name from the well-known genus *Cymbidium*, which it resembles. These are, heat-loving plants from the forests of Madagascar where they often grow in association with giant, epiphytic stag's horn ferns – a habit that affords them a moist, humus-rich foothold and the chance of a beneficial relationship with colonising ants. In 1972, McBean's Orchids showed this richly patterned specimen of *Cymbidiella pardalina* (syn *C. rhodocheila*), named 'Cooksbridge' after the location of their nursery.

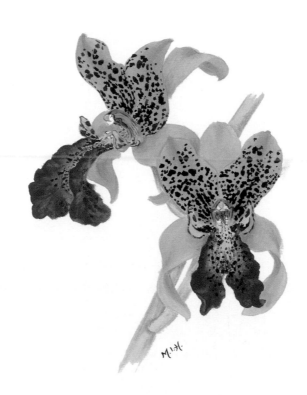

CYMBIDIUM ATLANTIC CROSSING 'FEATHERHILL'
& CYMBIDIUM MAUFANT 'TRINITY'

In 1981, Featherhill Exotic Plants of Goleta, California received an Award of Merit
for *Cymbidium* Atlantic Crossing 'Featherhill' (opposite), a clone of a *Cymbidium*
Claude Pepper and *Cymbidium* Coraki 'Margaret' cross. California has established
itself as a centre for *Cymbidium* breeding: its equable climate allows the plants to be
grown outdoors with little more than lath protection to screen them from scorching
sun and burning heat. But the ancestors of hybrids like this one are found far
from the Sunshine State, in the cooler areas of Asia from India east to Japan.
Modern *Cymbidium* hybrids have been subject to such intensive breeding and have
such complex ancestry that is scarcely possible to discern the lineaments of their
wild forebears. A cross between *Cymbidium* Thurso and *Cymbidium* Red Beauty,
Cymbidium Maufant 'Trinity' (above) was shown by the Eric Young Orchid
Foundation of Jersey in 1992.

N.R.

CYMBIDIUM ERICA 'ORBIS' &
CYMBIDIUM INSIGNE 'SUPERBUM'
In 1927, Sanders of St Albans received an Award of Merit for
Cymbidium Erica 'Orbis'. The cross involves *Cymbidium hookerianum*
(syn. *C. grandiflorum*) and *Cymbidium* Pauwelsii, and the influence of
the wild species can clearly be seen in the flower's apple-green tepals.
Nearly two decades earlier, the same company showed *Cymbidium*
insigne 'Superbum' (above), a large-flowered example of a species
that is native to Vietnam, China and Thailand. Sanders had come
to world prominence by sponsoring orchid collectors and dealing
in wild-collected plants; but, as the twentieth century progressed,
they would take a lead in nursery-bred superior clones of species
(like this one) and hybrids.

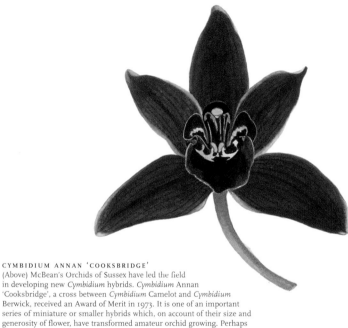

CYMBIDIUM ANNAN 'COOKSBRIDGE'
(Above) McBean's Orchids of Sussex have led the field
in developing new *Cymbidium* hybrids. *Cymbidium* Annan
'Cooksbridge', a cross between *Cymbidium* Camelot and *Cymbidium*
Berwick, received an Award of Merit in 1973. It is one of an important
series of miniature or smaller hybrids which, on account of their size and
generosity of flower, have transformed amateur orchid growing. Perhaps
more than any other orchid, the miniature *Cymbidium* has placed the
cultivation of what were once thought of as elite plants within the compass
of everyone's means and abilities.

CYMBIDIUM CANALICULATUM' VAR. SPARKSII
(Opposite) Species, rather than hybrids of *Cymbidium* have still been
capable of galvanising the arbiters of orchid fashion. In 1976, for example,
Eric Young of Jersey received an Award of Merit for 'Mont Millais', a selected
form of *Cymbidium canaliculatum* var. *sparksii*, a species from Australia that
produces sprays of hundreds of small, blood-red flowers.

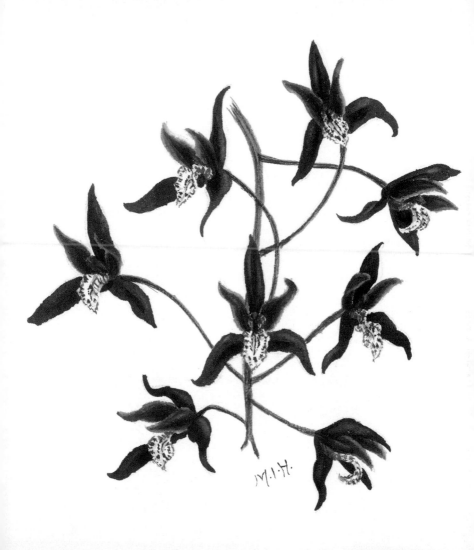

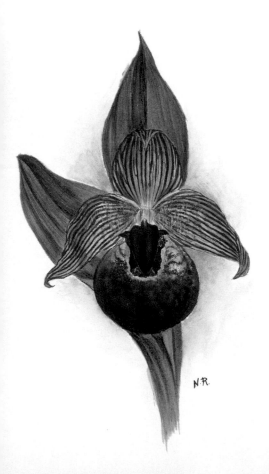

N·R·

CYPRIPEDIUM TIBETICUM
(Left) The Tibetan *Cypripedium tibeticum*
is a spectacular species with sombrely
coloured and strongly inflated floral
lips. Although better known for their
expertise in tropical and subtropical
plants, James Veitch & Sons of Chelsea
won much praise for this specimen
when they exhibited it in 1907.

CYPRIPEDIUM SEGAWAI 'JESSICA'
(Opposite) In the last two decades of
the twentieth century, a fashion spread
for growing hardy orchids. Among
these, one of the most challenging and
rewarding genera is *Cypripedium*,
the slipper orchids. In 1998, Hardy
Orchids of Dorset exhibited *Cypripedium
segawai* 'Jessica', a clone of a Far Eastern
species that was unfamiliar to Western
gardeners at the time. Despite its
diminutive size, it soon grew in
popularity because of its reliable
performance in shady, sheltered gardens
and cold greenhouses.

CYRTOPODIUM PUNCTATUM 'MONT MILLAIS'
(Above) Perhaps because of their sheer bulk, and their liking for soaring temperatures and strong sunlight, *Cyrtopodium* is rather neglected by orchid growers. But in 1986, the formidable resources and talents of the Eric Young Orchid Foundation in Jersey produced this magnificent specimen, *Cyrtopodium punctatum* 'Mont Millais'.

CYRTOPODIUM PUNCTATUM 'FINCHAM'
(Opposite) Around thirty species of *Cyrtopodium* are found in South America andthe West Indies. They are robust plants with stout, cane-like pseudobulbs. Exhibited in 1968 by Maurice Mason, the celebrated orchid amateur from Norfolk, *Cyrtopodium punctatum* 'Fincham' is a clone of a species native to Guyana. These flowers were painted from over 150 that were carried on a single spike.

DENDROBIUM HYBRIDS

Dendrobium is one of the largest genera of orchids, with between 900 and 1400 species, a total challenged only by *Bulbophyllum*. They are found throughout Asia, the Pacific Islands and Australasia, and exhibit a vast range of growth habits and flower shape. Most, however, are epiphytic – hence their name, which is derived from the Greek *dendron*, 'tree', and *bios*, 'life'. Despite the staggering diversity of *Dendrobium*, orchid breeders have often been tempted to improve on nature. In 1890, James Veitch & Sons presented *Dendrobium Aspasia* (above left), a hybrid that draws on the Indian and Chinese *Dendrobium nobile*, one of the most popular species. The influence of this same parent can be discerned in *Dendrobium* Angel Flower (above right), a complex hybrid shown in 1969 by Yamamoto Dendrobium Farm of Okayama, Japan. In Southeast Asia, Japan and Hawaii, *Dendrobium* breeding has assumed industrial proportions, with plants grown to supply the world's flower trade. Behind many of the hybrids and cultivars used is the influence of one very important parent, *Dendrobium bigibbum* (syn *D. Phalaenopsis*) from Papua New Guinea and Australia. Bred by H. Kushima of Oahu, Hawaii, *Dendrobium* Lady Fay 'Ess' (opposite) is typical of the *phalaenopsis*-type hybrids, as they are known, and can be found in florists everywhere.

DENDROBIUM SPECIES

Their popularity among hybridisers notwithstanding, *Dendrobium* species are also highly prized in their own right. Continuing exploration of Papua New Guinea has yielded an astonishing variety of new or little-known species. For the most part, these are small or miniature plants with jewel-like flowers – the perfect choice for growers with limited space. One of the brightest is *Dendrobium agathodaemonis* 'Pam Hunt' (above), which, in 1999, gained J. Hunt of West Melbury, Dorset an Award of Merit. A little over a century before, the same award was given to a specimen of *Dendrobium nobile* 'Hutchinson's Variety' (opposite), a fine example of a well-known Indian and Chinese species that was shown by Major General Hutchinson of Bournemouth. Seen together, these two plants give a clear impression of the sheer range of this Protean genus, and of the delight with which orchid growers must have greeted the advent of the first New Guinea miniatures.

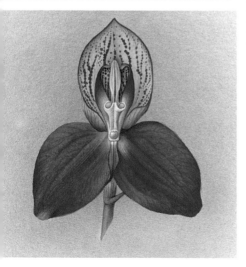

DISA UNIFLORA

The South African *Disa uniflora* is one of the most famous and emblematic orchids of all, closely associated in the popular imagination with its Table Mountain homeland. Like all 130 species of *Disa*, it is terrestrial, growing from clustered tubers that favour a wet but freely oxygenated and cool, acid substrate. Its fame (and thus its rarity), together with its habitat requirements, gave this orchid a reputation for being hard to obtain and even harder to grow. When specimens were successfully flowered in cultivation, they were lauded – for example, the selected clone, *Disa uniflora* 'Sandhurst' (left, below), exhibited in 1966. Hybridisation provided a solution to these twin problems of rarity and difficulty. From the 1980s onwards, new crosses were produced that retained the glory of *Disa uniflora* while seeming to improve on its flower colour. Moreover, hybrids like *Disa Foam* 'Lava Flow' (left, above), which received an Award of Merit in 1991, were robust, fast-growing plants that were capable of thriving in minimally heated greenhouses. The true and unadulterated *Disauniflora*, however, was still considered to be unbeatable, as the award-winning clone 'Johnathon' from 2000 (opposite) so vividly illustrates.

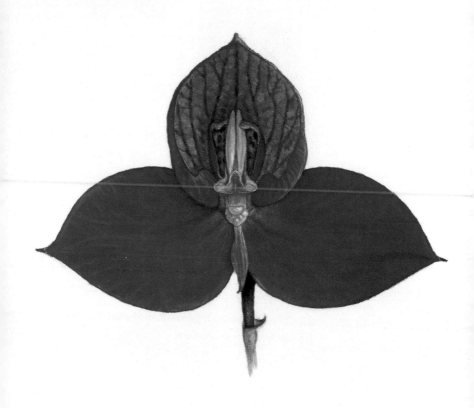

DRACULA

DRACULA SPECIES

Like the Carpathian count, this genus of orchids takes its name, *Dracula*, from Latin, meaning 'a little dragon'. It is a reference to the sinister shape and colouring of the flowers in many of its hundred or so species. Denizens of cool cloud forests in Central and South America, they are relatively small plants with tufted leaves and pendulous long-tailed, tricorn flowers. These differ from the flowers of *Masdevallia* (a genus in which *Dracula* was once included) in their floral lips, which are pouched and resemble an upturned mushroom – a trick to entice pollinating fungus gnats. *Dracula* is an example of an orchid genus that enjoyed great popularity among growers toward the end of the nineteenth century and then fell into neglect for nearly one hundred years. The reasons for their decline are probably to do with their demanding cultural requirements (for shade and a cool, almost chill, buoyant but very moist atmosphere) and the fact that blatantly beautiful hybrids eclipsed fascinating species for the middle years of the twentieth century. By the 1990s, however, *Dracula* had risen again: exciting new species were arriving from Colombia and Ecuador; electronic fans and ventilation systems were making it possible to recreate their favoured environments; pushed for space, amateurs were looking for smaller plants that were nonetheless full of character and interest. One of the most spectacular species is the aptly named *Dracula vampira*. Here we see two Ecuadorean selections of it, 'Night Angel' (right) and 'Morgan le Fay' (opposite), introduced by Johan Hermans of Enfield, Middlesex, in 1997 and 1990 respectively. Also from Hermans are *Dracula simia* 'Meliodas' (overleaf, left), and *Dracula cordobae* 'Lancelot' (overleaf, right).

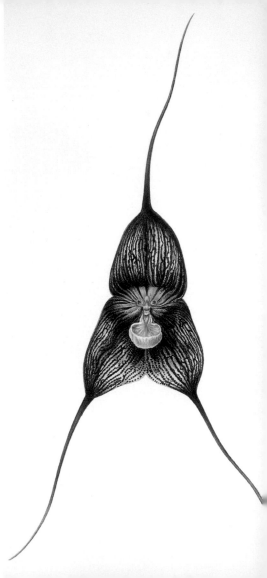

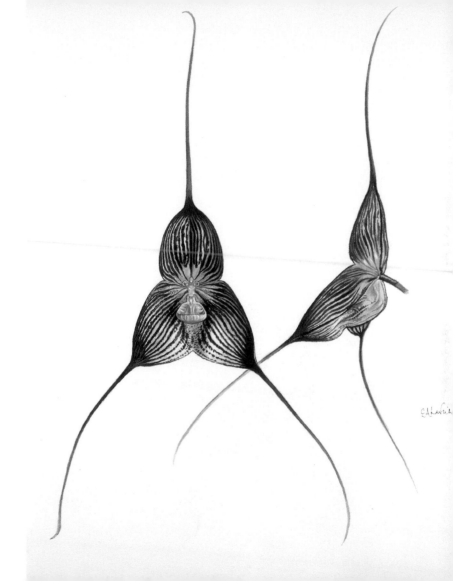

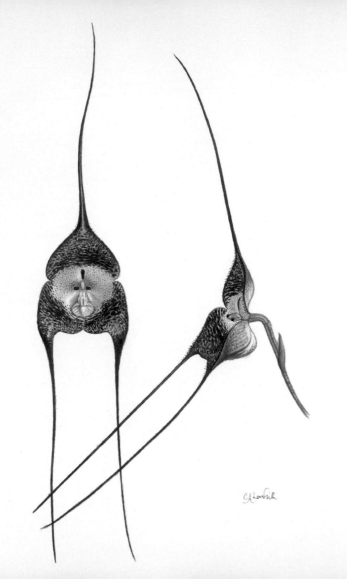

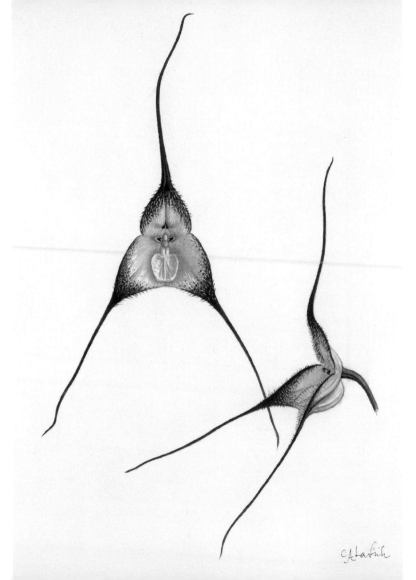

HAMELWELLSARA HYBRIDS
Members of the *Zygopetalum* alliance from South America have combined
to produce some striking hybrids with fragrant, waxy blooms in shades of
purple, violet, lilac-mauve and even black. George Black of Brize Norton
in Oxfordshire had a gift for harnessing their peculiar magic. Two crosses
exhibited by him were *Hamelwellsara* Memoria Edmund Harcourt (above),
which gained an Award of Merit in 1979, and *Hamelwellsara* Margaret
'Harlequin' (opposite), which was shown in 1990.

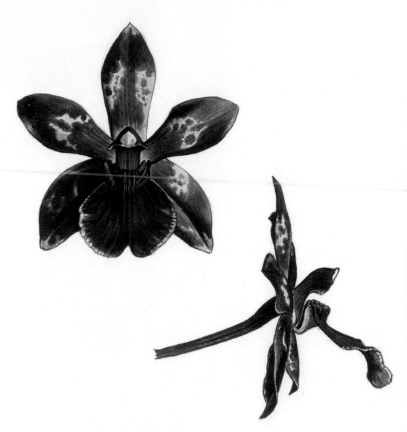

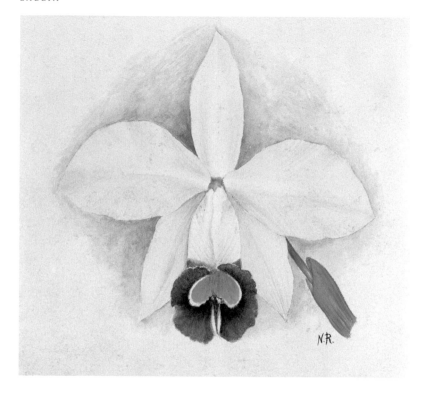

LAELIA PUMILA

John Lindley named the genus *Laelia* for one of the Vestal Virgins –
they are certainly plants of ethereal beauty. Seventy species or so are
scattered through the Tropical and Subtropical Americas. They range in
habit from the tall and willowy, to the robust and stout, to dwarf species.
For the most part, their flowers resemble those of *Cattleya*, a genus to
which they are closely related and with which they hybridise freely. One
of the most coveted species is the Brazilian *Laelia pumila*, a miniature
with disproportionately large and showy flowers. This selection, named
'Gatton Park', was exhibited by Sir Jeremiah Colman in 1897.

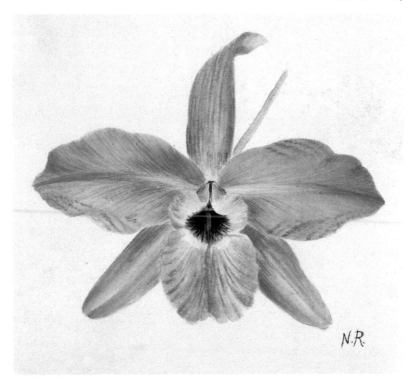

LAELIA RUBESCENS
In late 1897, the great orchid amateur and President of the Royal
Horticultural Society, Sir Trevor Lawrence won an Award of Merit for
a plant of *Laelia rubescens* grown at Burford, his Dorking estate.
Though not so diminutive as *Laelia pumila*, this is another of the smaller
Laelia species, a tough little plant with tall and top-heavy sprays of
large, sweetly scented flowers. It hails from Central America, from
Mexico to Panama.

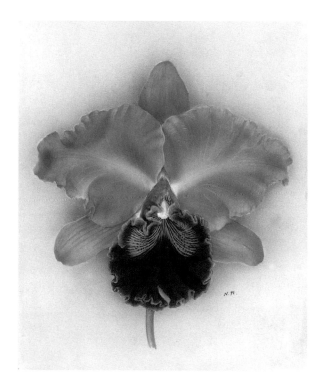

LAELIOCATTLEYA HYBRIDS
Crossed with their allies in the genus *Cattleya*, *Laelia* species impart
their characteristics of neater plants and smaller, shapely flowers,
satiny in texture and with a colour range that extends from brilliant
orange to scarlet, bronze and deep crimson. In 1925, *Laeliocattleya*
Profusion 'Megantic' (above) received an Award of Merit. Produced by
J. & A. McBean of Cooksbridge in Sussex, it is the offspring of *Cattleya*
Hardyana and *Laeliocattleya* Serbia. *Laeliocattleya* Mrs Medo 'The Node'
(opposite) was shown by Mrs Carl Holmes in 1927. It is the result of
Cattleya Venus crossed with *Laeliocattleya* Luminosa Aurea.

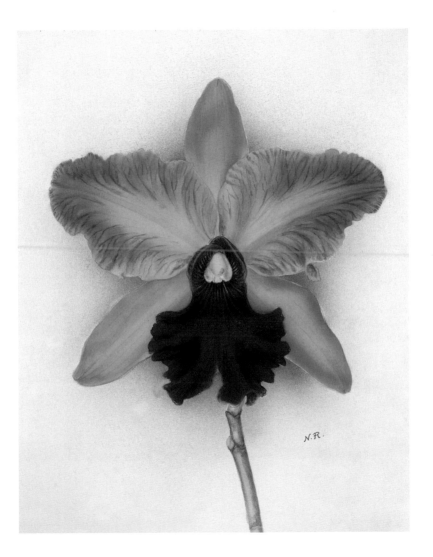

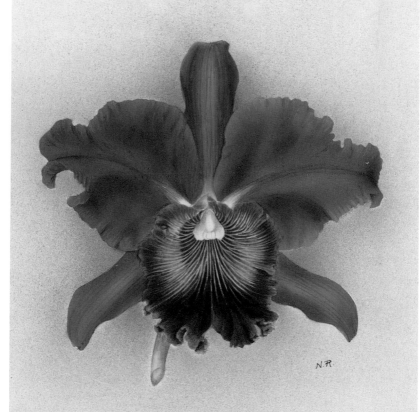

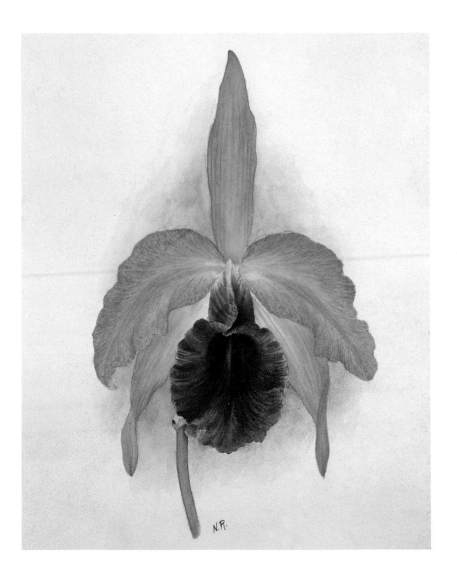

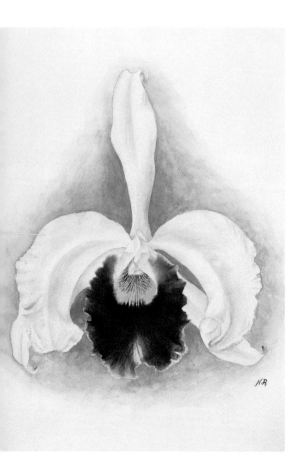

LAELIOCATTLEYA LINDA
(Previous page, left) The glowing golden
tones of *Cattleya dowiana* 'Aurea' meet the
magenta *Laeliocattleya* Arachne to produce
the luminous salmon-pink *Laeliocattleya*
Linda, a plant exhibited by J. & A.
McBean of Cooksbridge, Sussex in 1918.

LAELIOCATTLEYA HAROLDIANA
(Previous page, right) Brazilian *Laelia
tenebrosa* is one of the most arresting
Laelia species – tall and robust with heavy
heads of *Cattleya*-sized blooms, their
spilling tepals topaz to coppery bronze
and their lips deeply stained with wine
red. Here it is crossed with *Cattleya*
Hardyana, resulting in *Laeliocattleya*
Haroldiana, a hybrid exhibited in 1901.

**LAELIOCATTLEYA APHRODITE
'RUTH'**
(Left) *Laelia purpurata* is similar to
L. tenebrosa, differing chiefly in its flower
colour, which is white or palest rose with
a purple-stained lip. In *Laeliocattleya*
Aphrodite 'Ruth', a cross awarded in 1899,
it meets with the Colombian *Cattleya
mendelii*. The parents are close to each
other in colour, but the *Cattleya* brings
greater size, substance and a languorous
fragrance to the hybrid.

**LAELIOCATTLEYA BERTHE
FOURNIER 'SPLENDIDA'**
(Opposite) In 1900, French breeder
Charles Maron gained a First Class
Certificate for the hybrid *Laeliocattleya*
Berthe Fournier 'Splendida'. It is a
splendidly *Belle époque* plant, easily
imagined pinned to the gowns of
fashionable women. Curiously, the
characteristics of one of its parents,
Laeliocattleya Elegans, almost entirely
obscure the form and colouring of the
other, the golden *Cattleya dowiana* 'Aurea'.

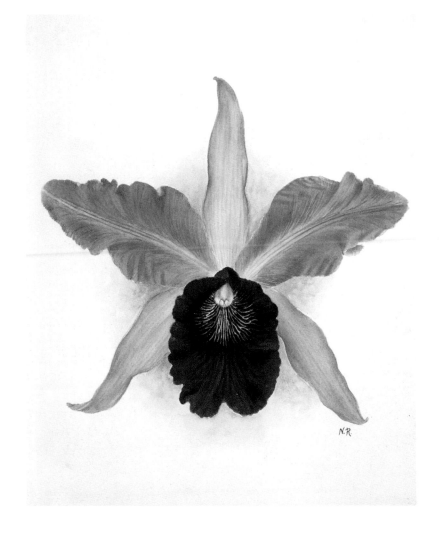

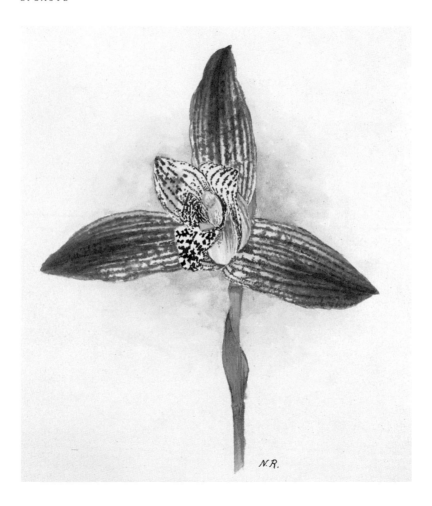

N.R.

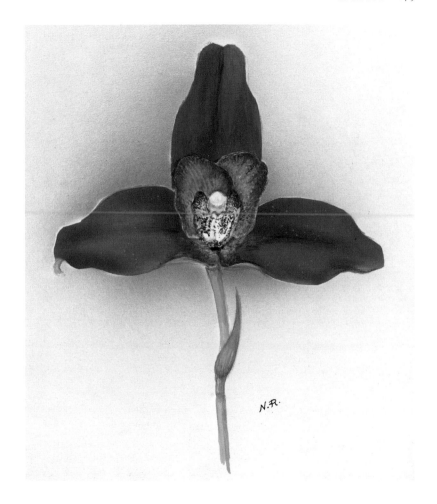

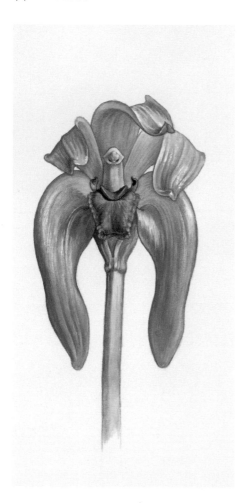

LYCASTE HYBRIDA &
LYCASTE BARBARA SANDER

Natives of the Tropical and Subtropical Americas, lycastes feature stout pseudobulbs and large, pleated leaves. Their size meant a decline in popularity among orchid amateurs once the great hothouse era had ended, but more recently these plants have soared in popularity – they are highly prized in Germany and Japan. In 1902, when they last enjoyed a peak, *Lycaste* Hybrida (previous page, left) gained a well-deserved Award of Merit for Charlesworth & Company. *Lycaste* Barbara Sander (previous page, right), shown by Sander and Company in 1948 is a typical, large-flowered *Lycaste* hybrid with waxy, richly coloured flowers.

LYCASTE LONGIPETALA
'BAILIFF'S COTTAGE'

(Left & opposite) One distinctive group of *Lycaste* species produces flowers in shades of green ranging from jade to apple and olive. In 1994, Laurence Hobbs Orchids of Crawley Down in Sussex gained an Award of Merit for this spectacular plant, *Lycaste longipetala* 'Bailiff's Cottage'. Found in Ecuador, Peru, Colombia and Venezuela, this species produces flower spikes up to 60cm tall with each flower measuring over 16cm across from tip to tip.

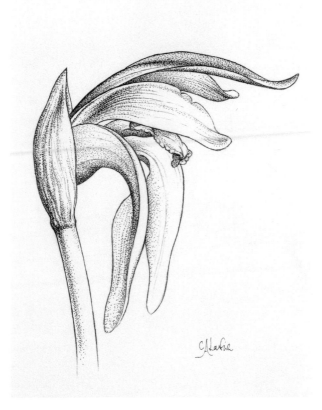

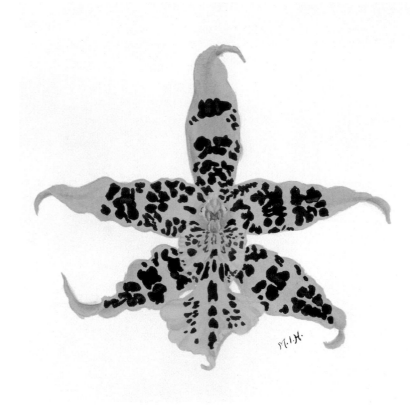

MACLELLANARA PAGAN LOVESONG 'MONT MILLAIS'
Crosses between *Brassia*, *Odontoglossum* and *Oncidium* result in
the hybrid genus *Maclellanara*. The name of the genus celebrates
Ros McLellan, who raised this plant *Maclellanara* Pagan Lovesong
'Mont Millais', a cross between *Odontocidium* Tiger Butter and *Brassia
verrucosa*, exhibited by Eric Young of Jersey in 1980.

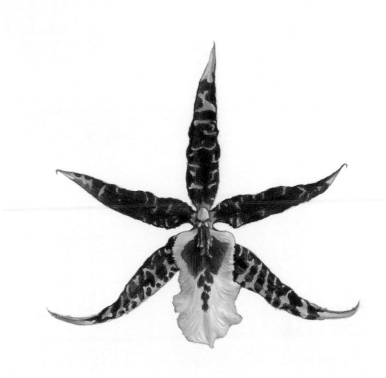

MACLELLANARA MEMORIA ARTUR ELLE 'HAHNWALD'
Maclellanara are mostly vigorous plants with sprays of slender-petalled
flower in shades of cream, yellow and olive, with tigerish stripes and
pantherine mottling – as is evident in *Maclellanara* Memoria Artur Elle
'Hahnwald', awarded a merit in 1988 for R. Frise of Cologne.

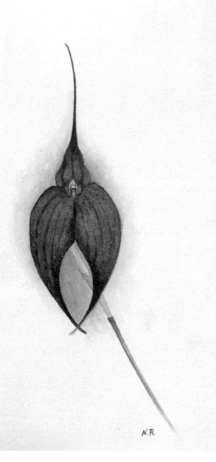

N. R.

MASDEVALLIA

Named for Jose Masdevall (d. 1801),
a Spanish botanist and physician, the
genus *Masdevallia* comprises over 350
species of orchids found in Central and
South America. They are the gems of
the orchid world – small plants, with
neat tufts of paddle-shaped leaves and
flowers whose sepals are drawn out
and fused in a wide range of shapes
and (usually brilliant) colours. In the
nineteenth century, they enjoyed huge
popularity and engaged the hybridiser's
interest, as can be seen from this plant
of *Masdevallia Falcata* (left), a hybrid of
M. veitchiana and *M. coccinea* 'Lindenii'
that was exhibited by Sir Trevor
Lawrence in 1899. Toward the end of
the twentieth century, they boomed
again, as growers looked for plants that
could be grown with ease in a small,
frugally heated greenhouse. One of the
species that captured the orchid-growing
community's imagination at this time
was *Masdevallia mendozae*; this selection
(opposite), named 'Orange Mint',
gained an Award of Merit in 1990.

MASDEVALLIA
Two further masdevallias that illustrate the range of form and colour within the genus – and its ability to surprise even a century after its first heyday. The delicate pink *Masdevallia glandulosa* 'Bromesberrow Place' (below) was exhibited by Miss D. G. Albright in 1987, while eighty years previously *Masdevallia ignea* 'Burford' (opposite) received an Award of Merit when it was shown by Sir Trevor Lawrence in 1906.

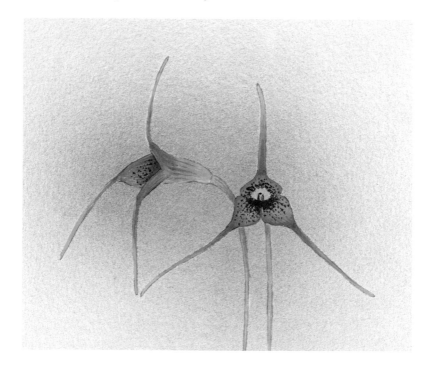

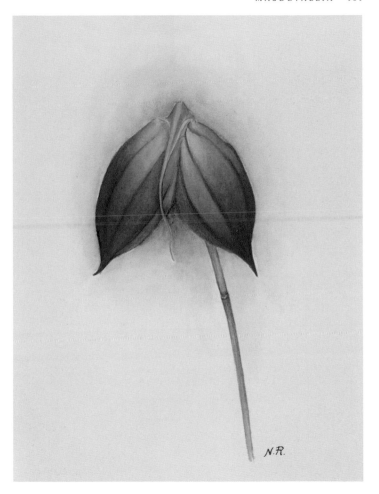

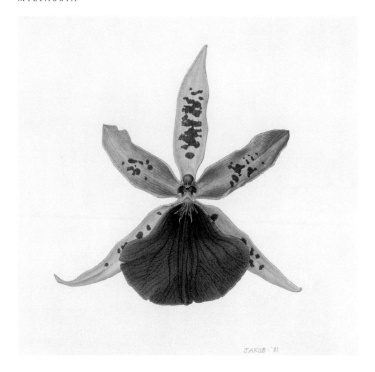

JAKOB · '81

MILTASSIA HYBRIDS

Cross a spider with a pansy and the result is a *Miltassia*. These are hybrids between the spider orchids (*Brassia*) and the pansy orchids (*Miltonia* and *Miltoniopsis*). *Miltassia* Morning Sky 'Ash Trees' (above) made its debut in 1981. The work of the innovative and adventurous orchid hybridist George Black of Brize Norton in Oxfordshire, it combines *Miltassia* J'ouvert with *Miltonia* Matto Grosso. The result is a plant that has the finesse and painterly markings of a *Brassia* and the warm colouring of *Miltonia*. Raised by the Beall Company and shown to the RHS Orchid Committee in 1979, *Miltassia* Mourier Bay 'Mont Millais' (opposite) crosses *Miltassia* Charles M. Fitch with the superb spider orchid grex *Brassia Rex*. The latter's influence is clearly evident in the size of the flowers, their attenuated tepals, and deep chestnut markings.

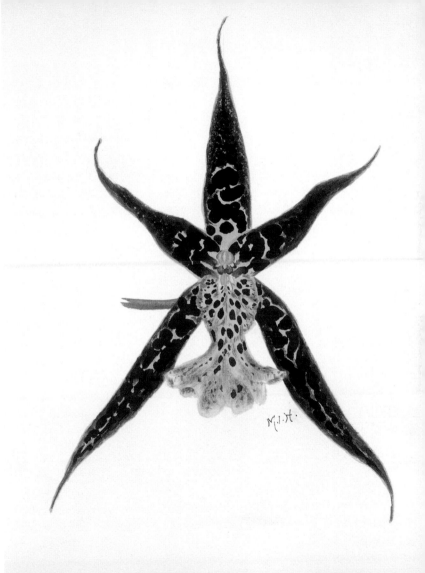

MILTONIA

Named for Lord Fitzwilliam Milton (1786–1857), the genus *Miltonia* and the closely related *Miltoniopsis* (which, for the purposes of registration, is included in *Miltonia*) comprise twenty-five or so spectacular species that hail from cool, cloudy forests in South America. In many of the best-known species, the flowers have rounded tepals and a very broad lip, all of which lie more or less flat – hence the popular name, pansy orchid. In the Edwardian era, they were strong favourites among orchid breeders, but their vogue faded between the world wars, picking up again as orchid growing became a more widespread hobby. Pictured here are three pansy orchids that span the century: (Below left) *Miltonia* Cotil Point 'Jersey' is a cross between *Miltonia* Akagi and *Miltonia* Emotion '4N' and was shown by the Eric Young Orchid Foundation in 1998. (Below right) *Miltonia phalaenopsis* 'McBean's' is a selection of the wild Colombian species *Miltonia phalaenopsis* (*Miltoniopsis phalaenopsis*) made by J. & A. McBean of Cooksbridge, Sussex in 1910. (Opposite) *Miltonia* Baden Baden 'Celle' is a cross between *Miltonia* Robert Paterson and *Miltonia* Kass Erin, shown by H. Wichman of Celle, Germany in 1959.

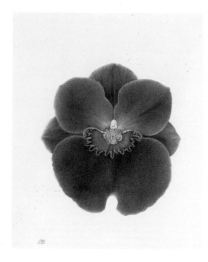

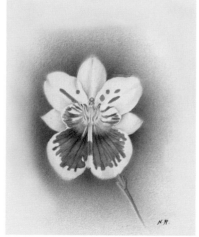

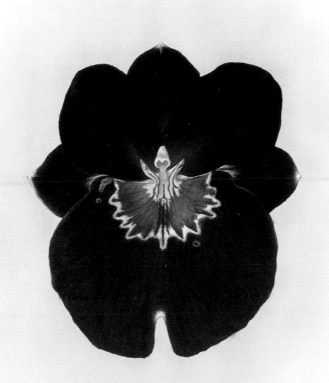

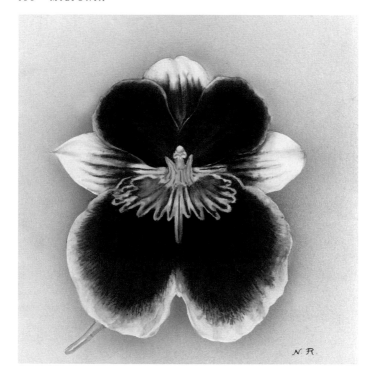

MILTONIA LYCAENA 'ORCHIDHURST'
(Above) In 1929, the great orchid amateur Baron Bruno Schroeder presented *Miltonia Lycaena* 'Orchidhurst'. A cross between *Miltonia* Princess Mary and *Miltonia* Lord Lambourne, it was in its day one of the largest-flowered hybrids in this group and, with its spectacular, radiating lines of colour, caused a sensation.

MILTONIA AUGUSTA 'STONEHURST'
(Opposite) Approaching the ideal among large-flowered *Miltonia* hybrids, *Miltonia* Augusta 'Stonehurst' combines *M.* Gattonensis and *M.* Lycaena. It received an Award of Merit when exhibited by R. Strauss of Ardingly, Sussex in March 1964. Recently pansy orchids like this one have become popular as houseplants.

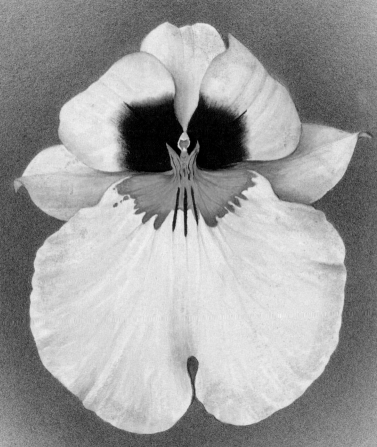

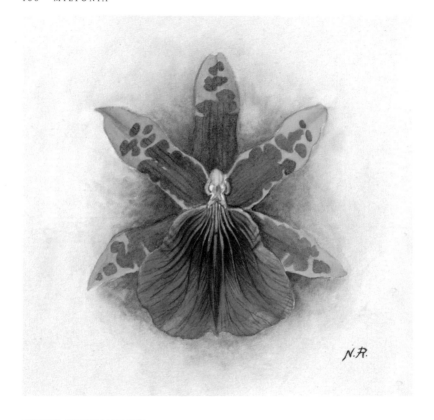

MILTONIA BINOTII 'GABRIEL'S'
Shown in 1905 by G. B. Gabriel of Surrey, *Miltonia* Binotii 'Gabriel's'
is thought to have been a naturally occurring hybrid between *Miltonia
candida* and *Miltonia regnellii*. Both are species from Brazil: the first
with chestnut-banded, yellow-white tepals and a white, purple-stained
lip; the second with flowers that range from palest pink to lilac-mauve.
The influence of both can be clearly seen in the hybrid.

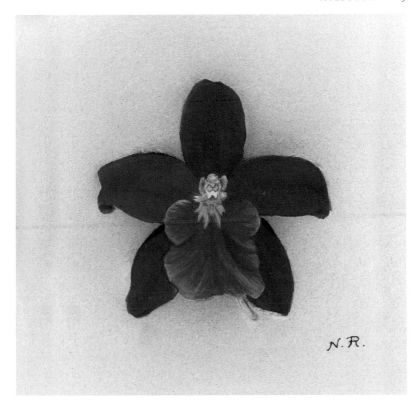

MILTONIODA MRS CARL HOLMES

Miltonia belongs to the *Odontoglossum* alliance – a fact that creates potential for some complex and fascinating crosses. *Miltonioda* Mrs Carl Holmes, for example, combines *Miltonia* William Pitt with *Odontioda* Chanticler; that is, *Miltonia* with an *Odontoglossum* crossed with a *Cochlioda*. This orchid was shown in 1931, earning the growers, Black & Flory of Slough, an Award of Merit.

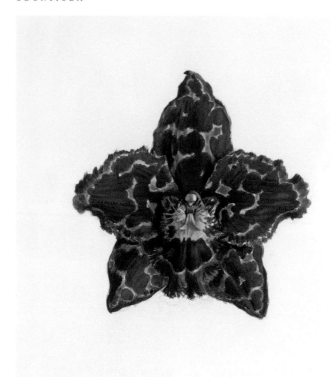

ODONTIODA WEST 'MOUNT MILLAIS'
Odontioda is the first of the intergeneric crosses to be made within
the *Odontoglossum* – *Oncidium* alliance, the earliest hybrid having been
registered in 1904. In size and shape they are very variable plants,
but many show the flat, lacy outline of the *Odontoglossum* parent and the
vivid colouring (reds, pinks and dusky magentas) of *Cochlioda*. *Odontioda*
West 'Mount Millais', for example, is a cross between *Odontioda* Ingera
and *Odontoglossum* Panise shown by the Eric Young Orchid Foundation
in 1988.

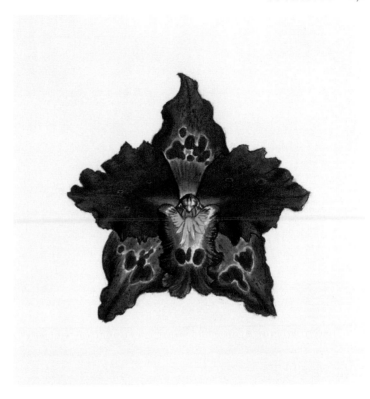

ODONTIODA DURHAN GALAXY 'LYOTH SUPREME'
Toward the end of the twenieth century, interest in *Odontioda* crosses
had by no means abated. Plants were appearing with ever more colourful
and outlandishlypatterned flowers. Typical of this is *Odontioda* Durhan
Galaxy 'Lyoth Supreme',presented by Charlesworth of Haywards Heath
in 1990. A cross between *Odontioda* Ingera and *Odontioda* Florence
Stirling, its long-lasting flowers were like cerise moths and gained it a
well-deserved Award of Merit.

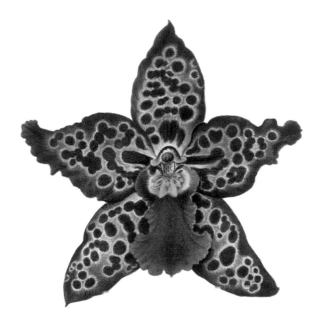

ODONTIODA HYBRIDS
While many odontiodas follow the flat and frilly
pattern of an *Odontoglossum crispum* ancestor,
some present less conventional faces; for example,
Odontioda La Hougue Bie 'Jersey' (opposite) and
Odontioda Becquet Vincent 'Saint Helier' (above),
both of which were exhibited by the Eric Young
Orchid Foundation of Jersey and received Awards
of Merit in 1991 and 1998 respectively.

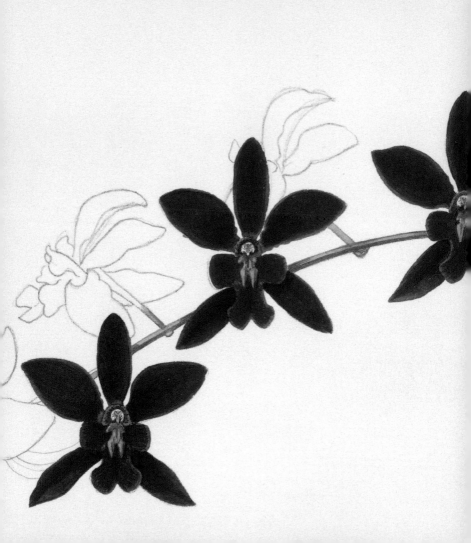

**ODONTIODA DEVOSSIANA
'SAINT HELIER'**
Odontioda Devossiana 'Saint Helier',
a primary cross which combines the
much-branching *Odontoglossum eduardii*
with the brilliantly coloured *Cochlioda
noezliana*. Shown by the Eric Young
Orchid Foundation of Jersey in 1995,
this *Odontioda* received an Award of Merit
and demonstrated amply that primary
crosses (hybrids directly made between
two species) can produce plants of greater
garden value than even the most complex
examples of the breeder's art.

ODONTOCIDIUM HYBRIDS

With over 450 species scattered over the Tropical and Subtropical Americas,
it is hardly surprising that the genus *Oncidium* should have such potential for
hybridisation. What is surprising is that relatively few crosses should have been
made with its ally, *Odontoglossum*. *Oncidium* flowers are usually small, abundant,
brightly coloured and strong on yellows and browns. Combined with *Odontoglossum*,
they acquire size and substance, as can be seen from these two crosses:
Odontocidium Purbeck Gold 'Tigeran' (above), a cross between the Mexican
Oncidium tigrinum and *Odontoglossum* Gold Cup that gained an Award of Merit for
Keith Andrews Orchids of Dorset in 1983, and *Odontocidium* Sunrise Valley 'Mont
Millais' (opposite), another hybrid involving *Oncidium tigrinum* that was raised by the
Beall Company and shown by the Eric Young Orchid Foundation of Jersey in 1981.

ODONTOGLOSSUM CRISPUM 'WALKERAE'
Horticulturally, *Odontoglossum* is one of the most important
orchid genera, having spawned thousands of hybrids.
In particular, the Colombian species *Odontoglossum crispum*
has given shape to many of the best *Odontoglossum* hybrids.
Odontoglossum crispum 'Walkerae' is a pure selection of the
species, given an Award of Merit in 1906.

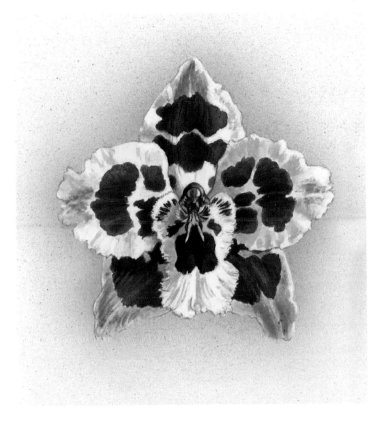

ODONTOGLOSSUM HYBRIDS
Among the numerous hybirds descended from
Odontoglossum crispum are: *Odontoglossum* Grouville Bay
'Mont Millais' (above); *Odontoglossum* Wilckeanum 'Pittiae'
(overleaf, left); and *Odontoglossum* Crispinum 'Delicatum'
(overleaf, right), a cross between *Odontoglossum crispum* and
Odontoglossum citrinum.

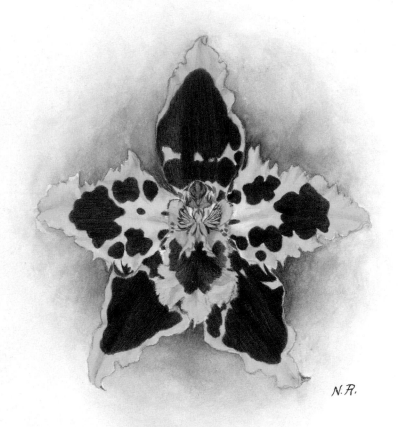

N.R.

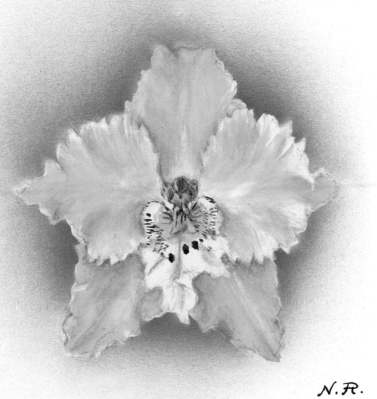

N.R.

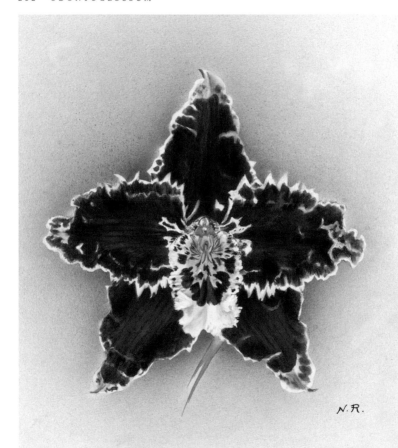

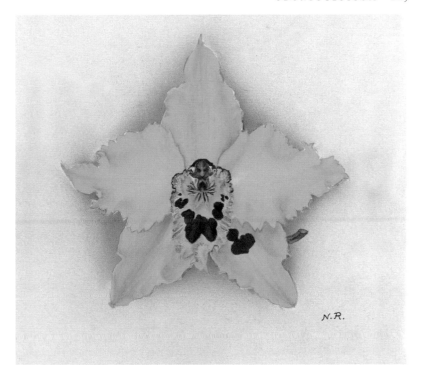

ODONTOGLOSSUM HYBRIDS

The sixty or so species of *Odontoglossum* are found growing, usually at high elevations, in South America. They take their name from the Greek *odontos*, 'tooth' and *glossa*, 'tongue', a reference to the tooth-like projections that are found on the lip. in 1898. This characteristic is strikingly clear in *Odontoglossum* Clonius 'Colossus' (opposite), a cross between Odontoglossum Aquitania and Odontoglossum The Czar that was shown by Charlesworth & Co of Sussex in 1938, and *Odontoglossum* Aureol (above), which was presented by Pantia Ralli of Surrey and received an Award of Merit in 1923.

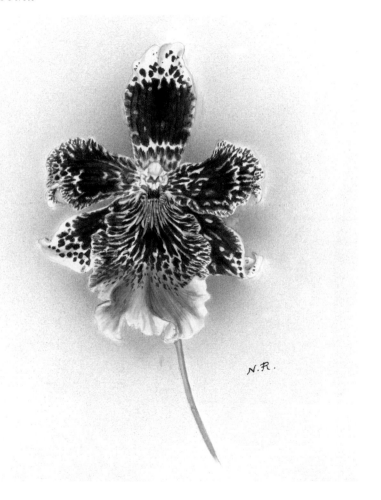

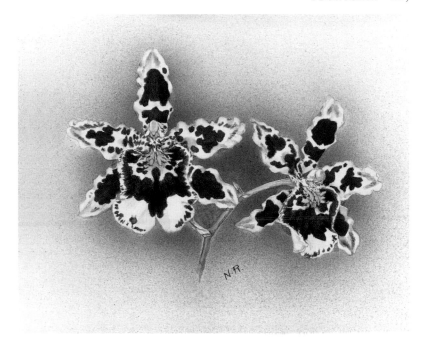

ODONTONIA HYBRIDS

Two further examples of primary hybrids in the
Odontoglossum alliance, *Odontonia* Saint Alban (above)
was shown by Sander's Nursery of St Albans in 1912.
It combines *Miltonia warscewiczii*, a species from Costa Rica,
Colombia and Peru, with the Colombian *Odontoglossum
pescatorei*. Since botanists have decided that the first parent
should now be called *Oncidium fuscatum*, and the second
Odontoglossum nobile, this hybrid should, strictly, be described
as an *Odontocidium*. *Odontonia* Joiceyi (opposite) is a cross
between *Odontonia* Pittiae and *Odontoglossum* Tityus shown
by Charlesworth & Co of Sussex in 1924.

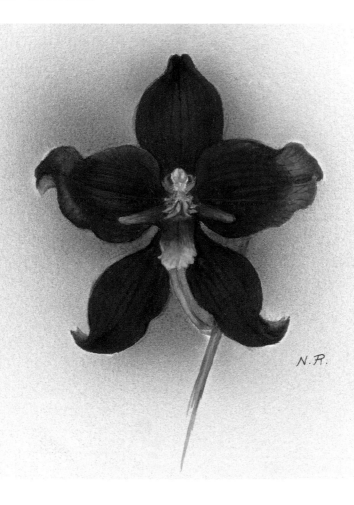

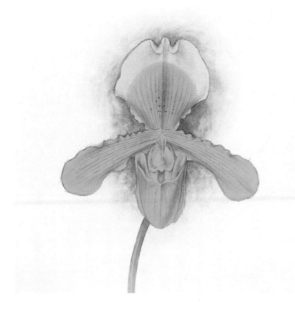

ONCIDIODA COOKSONIAE 'RALLI'S'

Oncidium macranthum, from Ecuador, Peru and Colombia, is a strange orchid.
Its flower spikes can be up to 3m tall, branching and sometimes even twining
through their tree supports. The flowers are large with clawed and wavy, deep-ochre
tepals and a small, white lip edged in maroon. By contrast, the Peruvian *Cochlioda
noezliana* is a neat plant with spikes of brilliant scarlet flowers. The resulting cross
is the spectacular *Oncidioda* Cooksoniae 'Ralli's'(opposite), with airy, branching
sprays of cardinal red flowers. This plant was shown by Pantia Ralli of Astead Park
in Surrey in 1913.

PAPHIOPEDILUM INSIGNE 'SANDERAE'

Ever since its introduction from Nepal in 1819, *Paphiopedilum insigne* has been
among the most widely grown slipper orchid species. Beauty apart, its popularity
can be explained by its sheer resilience. It will withstand cold, neglect, atmospheric
pollution – almost any peril save prolonged drought or saturation and burning
sunlight. Numerous varieties of *P. insigne* have been named, one of the most famous
being 'Sanderae' (above), with unmarked flowers midway between pale primrose
and mustard yellow, with a distinctive white peak to the dorsal sepal.

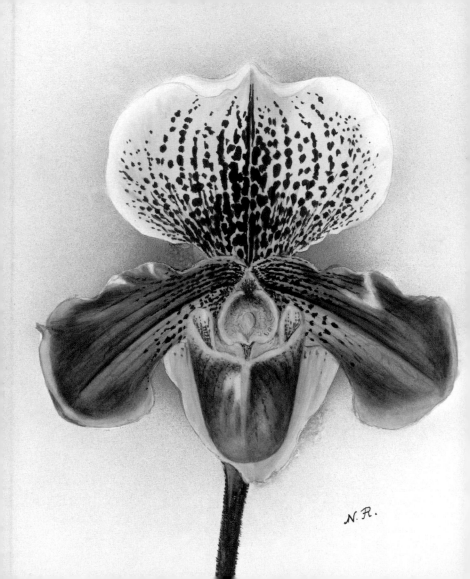

N. R.

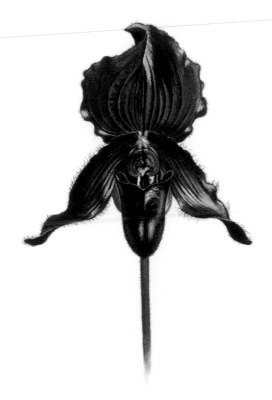

PAPHIOPEDILUM HYBRIDS
Two *Paphiopedilum* hybrids that capture, between them, something
of the magic of this most popular of orchid genera: *Paphiopedilum*
Baldovan (opposite), a cross between *P.* Chloris and *P.* Nellie Pitt,
shown by Robert Paterson of Ardingly, Sussex in 1929; and
Paphiopedilum Faire-Maude 'Royal Black' (above), a wonderfully
sinister cross between *P.* Maudiae and *P. fairrieanum* shown by
The Royal Orchid of Bonn, Germany in 1988.

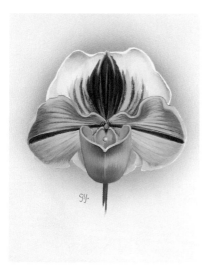

**PAPHIOPEDILUM BONNE NUIT
'COOKSBRIDGE GIANT'**
(Left, above) *Paphiopedilum* Bonne Nuit
'Cooksbridge Giant' exemplifies the
alternative and more recent trend for
hybrids that show all of the strange beauty
of their wild forebears. Exhibited in 1992
by J. & A. L McBean of Sussex, this cross
combines *Paphiopedilum* Wedding Bell
with *P. rothschildianum*.

**PAPHIOPEDILUM ARAGON
'MAJESTIC'**
(Left, below) Shown by Ratcliffe Orchids
in Oxfordshire in 1982, *Paphiopedilum*
Aragon 'Majestic' is a fine example of
a trend in slipper orchid breeding that
predominated for much of the late nine-
teenth and the twentieth centuries. The ideal
was a perfectly balanced, all-but-circular
flower with fine markings and a high gloss.

**PAPHIOPEDILUM FAIRRIEANUM
'BLACK PRINCE'**
(Opposite) Few crosses could really match
the whimsical charm of *Paphiopedilum
fairrieanum* from Northern India, Sikkim
and Bhutan, however. This selected form,
named 'Black Prince', received an Award of
Merit for Sander's of St Albans in 1907.

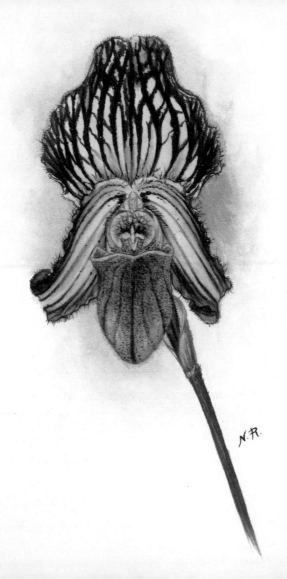

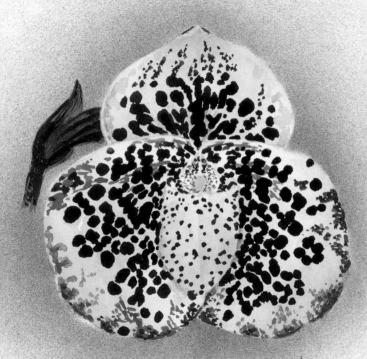

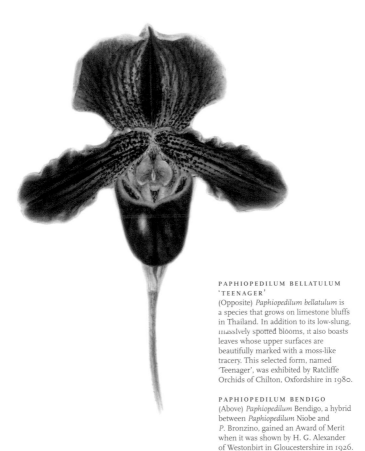

**PAPHIOPEDILUM BELLATULUM
'TEENAGER'**
(Opposite) *Paphiopedilum bellatulum* is
a species that grows on limestone bluffs
in Thailand. In addition to its low-slung,
massively spotted blooms, it also boasts
leaves whose upper surfaces are
beautifully marked with a moss-like
tracery. This selected form, named
'Teenager', was exhibited by Ratcliffe
Orchids of Chilton, Oxfordshire in 1980.

PAPHIOPEDILUM BENDIGO
(Above) *Paphiopedilum* Bendigo, a hybrid
between *Paphiopedilum* Niobe and
P. Bronzino, gained an Award of Merit
when it was shown by H. G. Alexander
of Westonbirt in Gloucestershire in 1926.

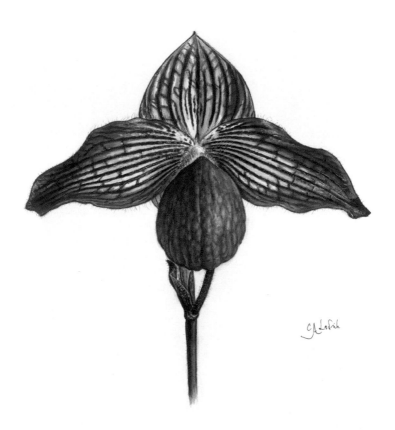

PAPHIOPEDILUM GLORIA NAUGLE 'MONT MILLAIS'

(Opposite) *Paphiopedilum* Gloria Naugle 'Mont Millais' brings together two of the most striking slipper orchids in an unlikely but highly successful combination. The rosy, squat and strongly inflated flowers of the Chinese *P. micranthum* meet with *P. rothschildianum*, a species from Borneo with long petalled, heavily veined and spotted flowers. Shown by the Eric Young Orchid Foundation, it gained an Award of Merit in 1998.

PAPHIOPEDILUM MINA DE VALEC 'FRANÇOISE LECOUFLE'

(Right) In the same year, Vacherot & Lecoufle exhibited a somewhat more classical hybrid. *Paphiopedilum Mina de Valec* 'Françoise Lecoufle' is a cross between *P. Almalune* and *P. Mitylene*, and a fine example of the popular group of slipper orchids known as the Maudiae-type hybrids.

PAPHIOPEDILUM MALIPOENSE 'BAILIFF'S COTTAGE' & PAPHIOPEDILUM VICTORIA VILLAGE 'ISLE OF JERSEY'

(Overleaf) Toward the end of the last century, *Paphiopedilum* cultivation was transformed by the discovery of a cluster of remarkable new species from Southern China. These were plants whose flowers were not only remarkable for their size and colour (yellow in *P. armeniacum*, green and maroon in *P. malipoense*, rosy pink in *P. micranthum*), but also for their lips, which were puffily inflated and superficially closer in appearance to *Cypripedium*. Mrs S. Holland of Crawley Down, Sussex exhibited *Paphiopedilum malipoense* 'Bailiff's Cottage' (left) in 1999. In the same year, Jersey's Eric Young Orchid Foundation also received an Award of Merit for *Paphiopedilum Victoria Village* 'Isle of Jersey' (right), an innovative cross between *Paphiopedilum micranthum* and *P.* Vanda M. Pearman.

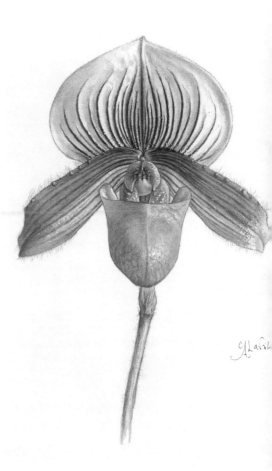

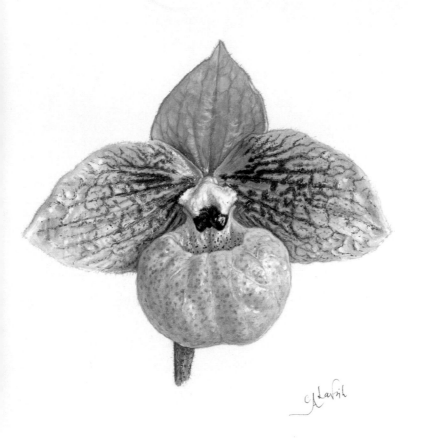

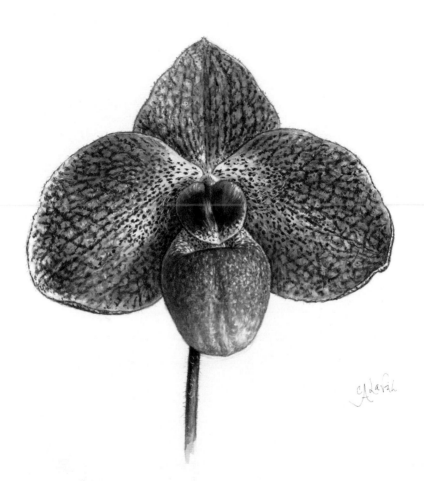

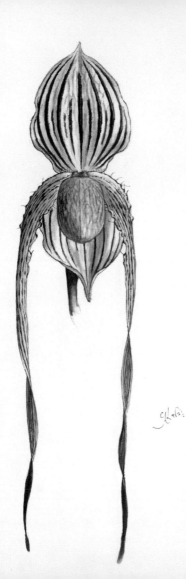

**PAPHIOPEDILUM VERA
PELLECHIA**
By the 1990s, the fashion for
Paphiopedilum hybrids that resembled
species in their form and colouring,
and which broke with the tradition of
circular, polished flowers, was well and
truly established. The formidable talents
of the Eric Young Orchid Foundation
of Jersey were turned this time on a
primary hybrid between *Paphiopedilum
philippinense* and *P. rothschildianum* that
had originally been made by Sanders
in 1946. It was known as *Paphiopedilum*
Saint Swithin, and the foundation
decided to cross it with *P. stonei*,
a spectacular species from Sarawak.
The result was the grex *Paphiopedilum*
Vera Pellechia, two clonesof which we
see here – 'Jersey' (left), which won
an Award of Merit in 1999, and 'Trinity'
(opposite), which had beensimilarly
honoured the year before.

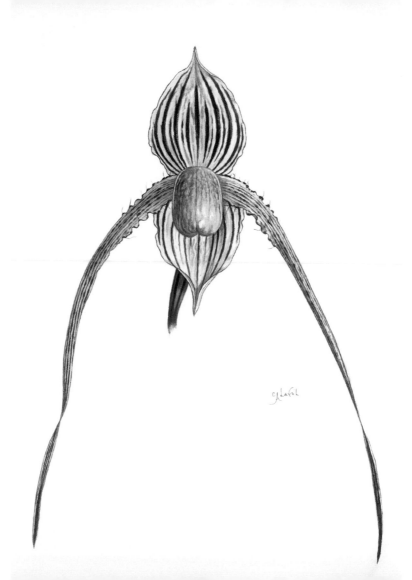

N.R.

PHAIUS

Phaius tankervilleae was among the first exotic orchids to flower
in Western cultivation. A genus of fifty or so species found in Asia,
the islands of the Indian Ocean and Northern Australia, *Phaius* takes
its name from the Greek for 'grey' – a reference to the inky discolouring
that affects damaged parts of the plants. They are magnificent orchids –
terrestrial, with handsome pleated leaves and robust spikes of flowers –
strange, then, that they should never have been particularly popular.
Phaius Harold (opposite) is a cross between *Phaius* Norman and
Phaius Sanderianus, exhibited by Norman Cookson of Oakwood,
Northumberland in 1903. Somewhat less flamboyant is *Phaius cooperii*
(below), which was exhibited by Sander's of St Albans in 1910.

PHAIUS FRANCOISII
(Below, left) Formerly included in the genus *Gastrorchis*, several of the
most fascinating *Phaius* species belong to a distinct group that is found
in Madagascar. In 1982, the Royal Botanic Gardens, Kew exhibited 'Anne',
a selected clone of *Phaius francoisii*.

PHAIUS PULCHER 'CLARE' & PHAIUS PULCHELLUS 'CLARE'
In the 1990s, interest in the orchids of Madagascar was given renewed
impetus by the work of orchid growers like Johan Hermans in London.
His plants include *Phaius pulcher* 'Clare' (below, right) and the delicate
Phaius pulchellus 'Clare' (opposite), both of which were named for his wife.

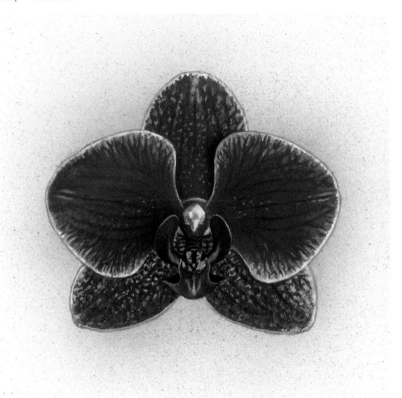

PHAIUS NORMAN
Raised by Norman Cookson and shown in 1898, *Phaius* Norman is a cross between
Phaius Sanderianus and *Phaius tuberculosus*. The rich colouring of the first parent
(closer to the Oriental *Phaius* species) dominates in this hybrid. The second parent
is a Madagascan *Phaius* species with white flowers and a brilliantly coloured lip.

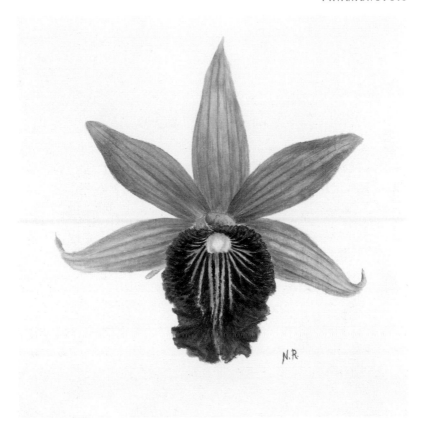

N.R.

PHALAENOPSIS BARBARA KING 'ROYAL RED'
In 1988, this elegant moth orchid hybrid with its colouring of creamy yellow,
dusky pink and maroon is *Phalaenopsis* Barbara King 'Royal Red', and won praise
from the Orchid Committee of the RHS. It is a cross between the evocatively named
Phalaenopsis Red Hot Chilli and *Phalaenopsis* Mollie's Lullaby.

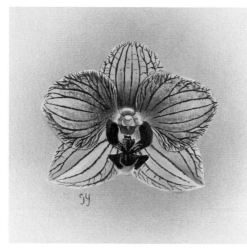

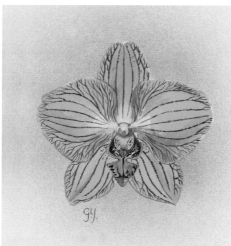

PHALAENOPSIS AMADO VASQUEZ 'ZUMA CANYON'

(Left, above) Having had a reputation for being difficult to grow, from the 1980s onwards *Phalaenopsis* found itself among the most popular and commonly available orchids of all. Breeders were producing myriad new plants that broke with the more usual pure white or pink types. Heavily veined flowers became desirable, as did shades of yellow and purple. *Phalaenopsis* Amado Vasquez 'Zuma Canyon' is a cross between *Phalaenopsis* Hawaiian Suns and *Phalaenopsis* Pin Up Girl. It was shown by Zuma Canyon Orchids of Malibu, California in 1985, and won an Award of Merit.

PHALAENOPSIS BONNIE VASQUEZ 'AUMA CANYON'

(Left, below) Another golden-flowered moth orchid from the Zuma Canyon stable is *Phalaenopsis* Bonnie Vasquez 'Zuma Canyon', a cross involving *P. venosa*. It boasts brilliant-yellow tones and detailed veining.

PHALAENOPSIS AUBRAC 'MONIQUE'

Despite the demand for colourful, veined varieties, there was still room for the classic, snowy-white moth orchid. Produced by the French growers Vacherot & Lecoufle, *Phalaenopsis* Aubrac 'Monique' won an Award of Merit in 1984. It is one of the finest large, white-flowered *Phalaenopsis*, plants that are themselves striking examples of the vagaries of horticultural fashion: what had been a rich man's fancy in 1900 was toward the century's end, commonplace, available from most florists and super-markets and visible in the lobbies of countless office buildings.

PHAL: AUBRAC 'MONIQUE'

A.M., R.H.S., 21·5·84

PHALAENOPSIS BRYHER 'MONT MILLAIS'
& PHALAENOPSIS BEL VROUTE 'TRINITY'
Although *Phalaenopsis* breeding had become big business by the
1980s, it was still possible to achieve startling results by staying
close to nature and crossing and recrossing with species. Jersey's Eric
Young Orchid Foundation excelled at this, producing *Phalaenopsis*
Bryher 'Mont Millais' (above), which contains elements of the stripy
Philippine *Phalaenopsis lueddemanniana* and violet-mauve *P. violacea*
from Borneo, and the cool classic moth orchid *Phalaenopsis* Bel Croute
'Trinity' (opposite), a cross between the pale rose Philippine species
Phalaenopsis equestris and *P.* Abendrot.

**PHALAENOPSIS BRECKINRIDGE ROSEGOLD 'BIG MARKIE'
& PHALAENOPSIS BEAUPORT 'MONT MILLAIS'**
Phalaenopsis takes its name from the Greek *phalaina*, meaning 'moth'.
These two award-winning hybrids typify the broad-petalled, flat flower
form that led to this lepidopteran sobriquet. *Phalaenopsis* Breckinridge
Rosegold 'Big Markie' (opposite) is a cross between *P*. Ai Gold and
P. Malibu Strip. It was exhibited by Breckinridge Orchids in North
California in 1997. Exhibited by the Eric Young Orchid Foundation,
Jersey, *Phalaenopsis* Beauport 'Mont Millais' (above) is a cross between
Phalaenopsis Hokuspokus and *P*. Cabrillo Star.

PHALAENOPSIS CELEBENSIS 'TRINITY'
& PHALAENOPSIS BONNE NUIT 'TRINITY'

Despite the frenzied hybridisation that took place within the genus
Phalaenopsis toward the end of the twentieth century, it was still
possible to encounter unadulterated species. In 1991, the Eric Young
Orchid Foundation of Jersey received an Award of Merit for this superb
plant, *Phalaenopsis celebensis* 'Trinity' (opposite), which is unusual among
Phalaenopsis species in producing pendulous spikes massed with
smaller flowers. At the same time, the foundation was also capable of
producing complex hybrids such as *Phalaenopsis* Bonne Nuit 'Trinity'
(above), a cross between *Phalaenopsis* Saint Martin and *P.* Beaumont
that received an Award of Merit in 1988.

PHALAENOPSIS EVER-SPRING KING 'BLACK PEARL'
& PHALAENOPSIS CHARISMA 'MONT MILLAIS'

While the pure white-flowered *Phalaenopsis* became something of a florist's ideal at the end of the twentieth century, the search continued among orchid breeders for blooms with ever more exotic markings and colour combinations, as shown here in *Phalaenopsis* Ever-spring King 'Black Pearl' (above). The Philippine *Phalaenopsis stuartiana* is a magnificent species, with silver-mottled leaves and branching sprays of scented flowers that are pure white, freckled in their lower half with green, chocolate and gold. *Phalaenopsis* Charisma 'Mont Millais' (opposite) brings this species together with *Phalaenopsis* Jolly Roger.

PHALAENOPSIS SPRING CREEK 'MONT MILLAIS'
& PHALAENOPSIS SWEET MEMORY 'BONNIE'

Another Philippine native, *Phalaenopsis mariae* produces 5cm-wide flowers with creamy-white petals striped in purple and brown. Its influence can clearly be seen in the hybrid *Phalaenopsis* Spring Creek 'Mont Millais' (overleaf, left). *Phalaenopsis* Sweet Memory 'Bonnie' (overleaf, right) is a cross between *Phalaenopsis* Deventeriana and *P. violacea*. The latter is a small species from Sumatra, Borneo and Malaysia, with short-stalked flowers that range in colour from pale lilac to deep amethyst.

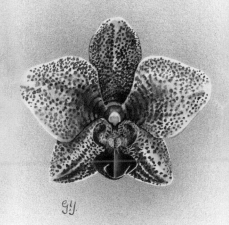

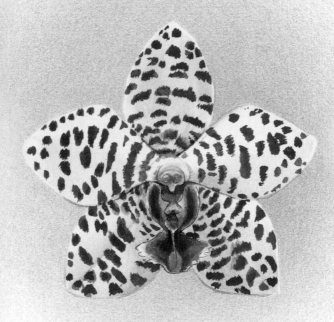

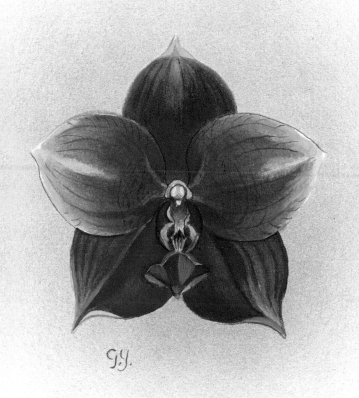

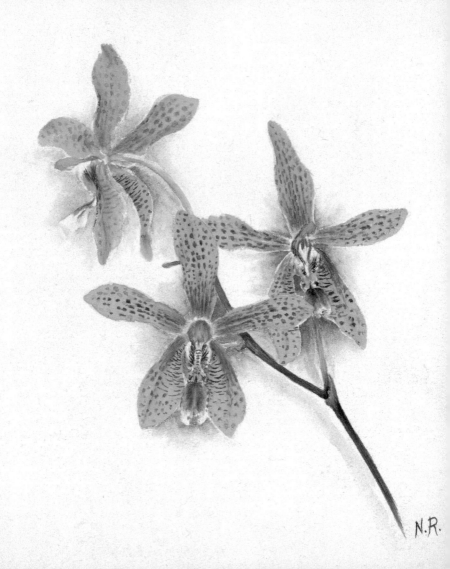

N.R.

PHALAENOPSIS STUARTO-MANNII
(Opposite) A primary hybrid between two
very dissimilar moth orchids, *Phalaenopsis*
Stuarto-Mannii was exhibited in 1898 by
James Veitch & Sons of Chelsea. It has
the ascending, elegant flower spikes and
beautifully poised blooms of *P. stuartiana*
and the dense, rusty mottling of *P. mannii*,
a native of Vietnam and the Himalayas.

PHALAENOPSIS GIGANTEA 'FINCHAM'
A selected form of a species native to Borneo
and Sabah, *Phalaenopsis gigantea* 'Fincham'
(below) was exhibited by L. Maurice Mason
of Talbot Manor, Fincham, Norfolk in 1968,
gaining an Award of Merit. It is a
fine example of a species that produces
magnificent, pendulous trusses crowded
with perfumed, heavily marked flowers.

PHRAGMIPEDIUM SORCERER'S APPRENTICE 'JERSEY'

Twenty species of *Phragmipedium* are found in Central and South America. Superficially, they resemble the other slipper orchids, *Paphiopedilum* and *Cypripedium*. Because of their strangely and extravagantly shaped flowers, they have interested hybridists since the last quarter of the nineteenth century. One of the earliest examples, *Phragmipedium* Sedenii, is a handsome, rosy-flowered cross between *P. longifolium* and *P. schlimii*. Its name commemorates John Seden (1840–1921), a pioneer of orchid hybridisation at the Veitch nursery. *Phragmipedium longifolium* also features in the parentage of *Phragmipedium* Sorcerer's Apprentice 'Jersey' (above), a hybrid shown by the Eric Young Foundation in 1995.

PHRAGMIPEDIUM ERIC YOUNG 'TRINITY'

A century after *Phragmipedium* Sedenii, interest revived in *Phragmipedium* breeding, largely as a result of the appearance of a remarkable species from Peru and Colombia, he scarlet-flowered *Phragmipedium besseae*. This, with *Phragmipedium longifolium*, is a parent of *Phragmipedium* Eric Young 'Trinity' (opposite), shown by the Eric Young Foundation in 1991, winning an Award of Merit.

POTINARA JULIETTAE 'BROCKHURST' & POTINARA DOROTHY 'DELL PARK'
Potinara is a quadrigeneric hybrid in the *Cattleya* alliance – it involves species from the genera
Brassavola (or *Rhyncholaelia*), *Cattleya*, *Laelia* and *Sophronitis*. It was named for Monsieur Potin,
a French orchid grower. Within the hybrid mix, the influence of *Sophronitis* is clear. In *Potinara*
Juliettae 'Brockhurst' (above), a cross between *Sophrolaeliocattleya* and *Brassocattleya*, the vivid scarlet of
Sophronitis coccinea is evident. In Baron Bruno Schroeder's exhibit of 1929, *Potinara* Dorothy 'Dell Park'
(opposite), the pigmentation of the miniature, Brazilian *Sophronitis coccinea* can be seen in the rich
tangerine tepals and cinnabar-red lip.

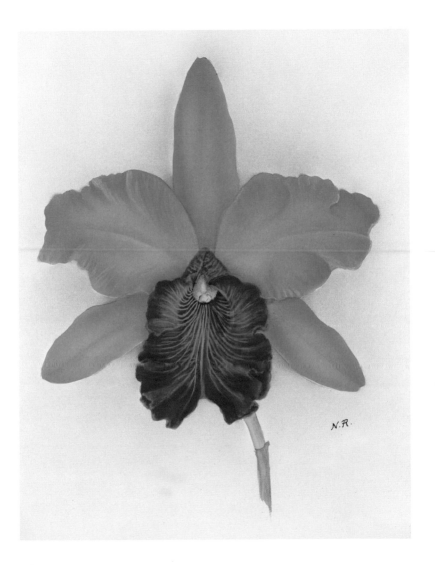

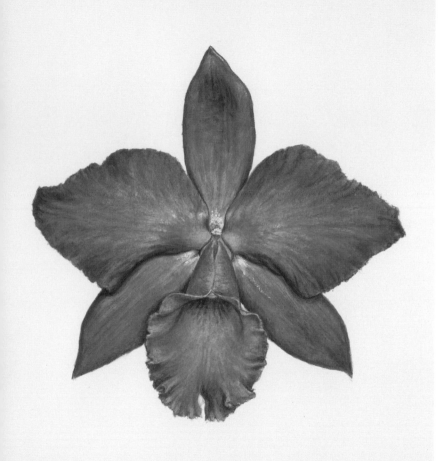

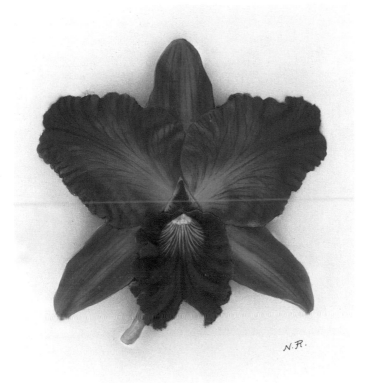

N.R.

POTINARA AFTERNOON DELIGHT 'MAGNETISM'
& POTINARA MEG DARELL

Potinara Afternoon Delight 'Magnetism' (opposite) is a cross between *Potinara* Em Green and *Brassolaeliocattleya* Oran. In 1998 it was shown by Colin Howe of the Hermitage, Berkshire, winning an Award of Merit for its regularity of shape and sunset-like tones. The flamboyant *Potinara* Meg Darell (above) is another of the magnificently colourful hybrids shown by the orchid breeder Baron Bruno Schroeder circa 1930.

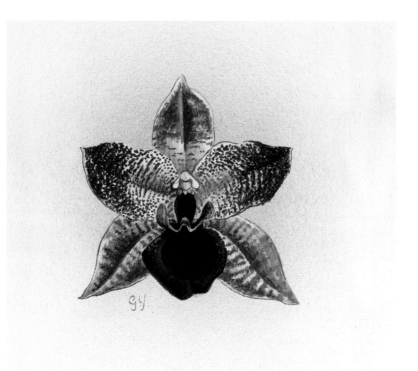

PROMENAEA DINAH ALBRIGHT 'BROMESBERROW PLACE'
The Greek Historian Herodotus mentioned Promeneia, the prophetess of Dodona. Over 2000 years later, John Lindley blew away the dusts of antiquity, resurrecting her in the shape of a new genus, comprising fifteen species of small orchids from Brazil. With the revival of interest in species – and especially in miniatures – that took place toward the end of the twentieth century, *Promenaea* became popular. *Promenaea* Dinah Albright 'Bromesberrow Place' is a fine hybrid example and was exhibited in 1984.

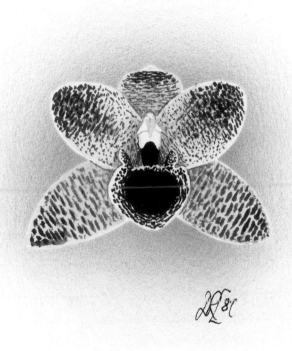

PROMENAEA DINAH ALBRIGHT 'CHASE END'

Two years after showing *Promenaea* Dinah Albright 'Bromesberrow Place', the exhibitor, Dinah Albright of Bromesberrow Place in Ledbury, won an Award of Merit for another outstanding hybrid, *Promenaea* Dinah Albright 'Chase End'. Both hybrids show the influence of *Promenaea stapelioides*, a species with grey-green foliage and off-white flowers richly mottled with maroon and violet.

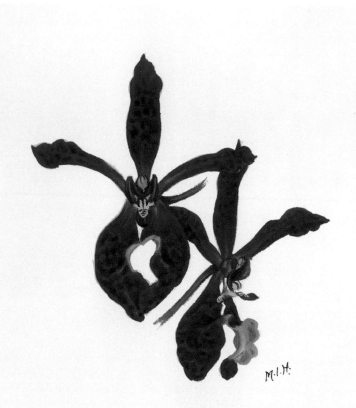

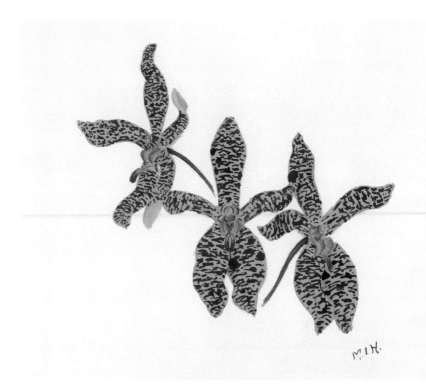

RENANOPSIS LENA ROWOLD 'ORCHID HAVEN'
& RENANOPSIS EMBERS 'ALLISON'

Renanopsis fuses two genera of Southeast Asian orchids, *Renanthera* and *Vandopsis*. The crosses were first made in Singapore and have since been remade: in most cases the plants are very large and vigorous (often over 2m tall), and the flowers boldly coloured. In character the flowers combine the size and sheer quantity of *Vandopsis* with the elegance and fiery palette of *Renanthera*. This is shown in the hybrid *Renanopsis* Lena Rowold 'Orchid Haven' (opposite) and *Renanopsis* Embers 'Allison' (above).

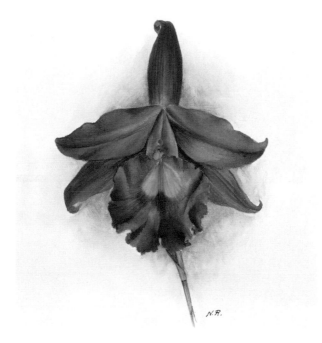

SOBRALIA LOWII & SOBRALIA RUCKERI 'CHARLESWORTHII'

The tropical American genus *Sobralia* is named for the eighteenth-century Spanish botanist Francisco Sobral. They are mostly large plants with clumps of reedy stems crowned by magnificent but short-lived blooms. Because of their size and ephemeral flowers, sobralias have been somewhat neglected in recent years, but they are handsome plants which are easy to please and would be superb additions to conservatory borders and interior landscapes. At the beginning of the twentieth century, when private glasshouses were larger and less expensive to heat, these terrestrial orchids enjoyed greater popularity. *Sobralia* Lowii (above) was shown in 1906 by Henry Little of Twickenham in Middlesex, winning an Award of Merit. In 1910, Charlesworth & Co of Haywards Heath showed *Sobralia ruckeri* 'Charlesworthii' (opposite), a selection of a species that can grow to 2m tall and which bears a succession of fragrant flowers, each as much as 20cm across, on a zigzagging stalk.

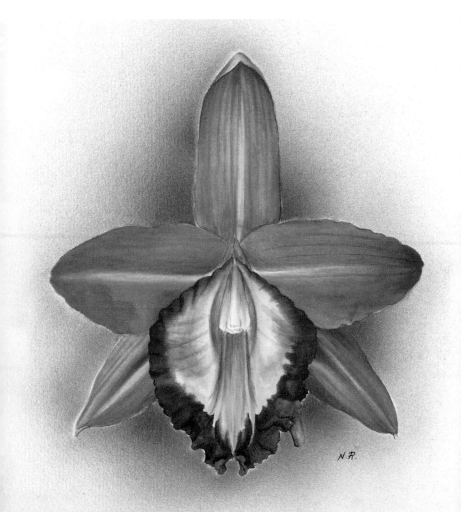

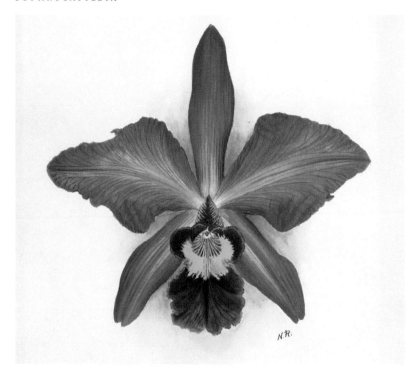

SOPHROCATTLEYA ANTIOCHUS
& SOPHROCATTLEYA WESTFIELDENSIS
A cross between *Cattleya warscewiczii* and *Sophrocattleya* Cleopatra,
Sophrocattleya Antiochus (above) was exhibited by Charlesworth & Co in
1907, gaining an Award of Merit. *Sophrocattleya* Westfieldensis (opposite)
combines *Cattleya labiata* with *Sophrocattleya* Eximia. The first parent
gives this hybrid its extravagant size and shape, while the *Sophrocattleya*
endows its intensely coloured lip. It was shown in 1912 by Francis
Wellesley of Westfield, Woking, winning a well-deserved Award of Merit.

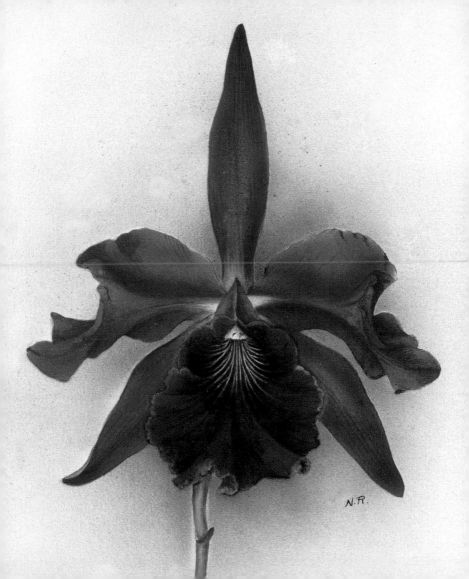

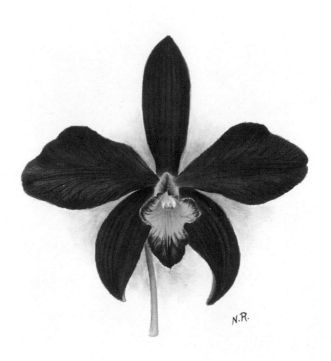

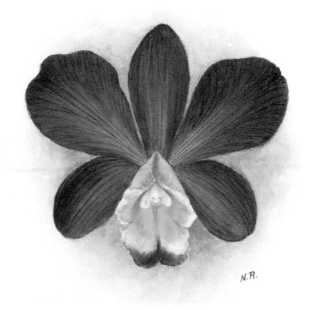

N.R.

SOPHROCATTLEYA CHAMBERLAINII 'RRIUMPHANS'
& SOPHROCATTLEYA CALYPSO

British statesman Joseph Chamberlain was a celebrated orchid amateur. His trademark
Odontoglossum buttonhole notwithstanding, he grew a vast range of orchids at his
home in Highbury, Birmingham. In 1899, he won an Award of Merit with this plant
of *Sophrocattleya* Chamberlainii 'Triumphans' (opposite), a cross between *Sophronitis
coccinea* (syn. S. *grandiflora*) and *Cattleya harrisoniana*. Shown by James Veitch & Sons of
Chelsea in 1892, *Sophrocattleya* Calypso (above) is a cross between *Sophronitis coccinea*
(syn. S. *grandiflora*) and *Cattleya loddigesii*. It shows that not all hybrids are intermediate
in their effects, or even successful: this plant favours the *Cattleya* parent almost
exclusively, but exhibits nothing of its inherent, natural gracefulness.

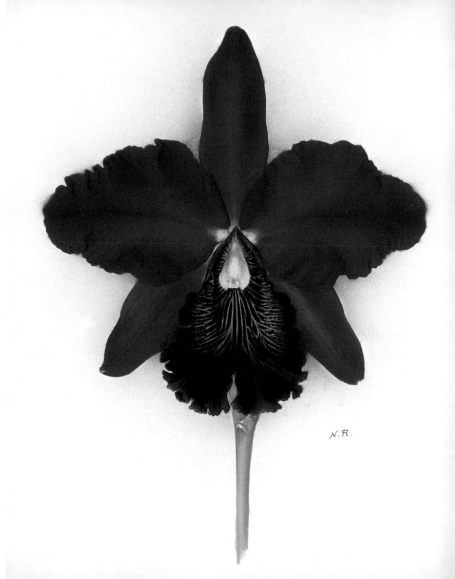

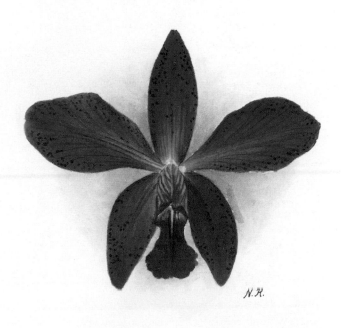

N.K.

SOPHROCATTLEYA PURPLE MONARCH & SOPHROCATTLEYA NYDIA
In 1928, J. & A. McBean of Cooksbridge, Sussex took an Award of Merit
for *Sophrocattleya* Purple Monarch (opposite). A cross between *Cattleya
dowiana* and *Sophrocattleya* Faboris, it shows the ruby and gold-veined lip that
is characteristic of *Cattleya dowiana*. Also showing a clear influence from its
first parent is a hybrid from Charlesworth & Co of Bradford shown in 1907.
Sophrocattleya Nydia (above) is close in form and colour to *Sophronitis coccinea*
(syn. *S. grandiflora*) – its narrowly lipped and demurely poised scarlet flowers
all but eclipse the influence of the second parent, *Cattleya* Calummata.

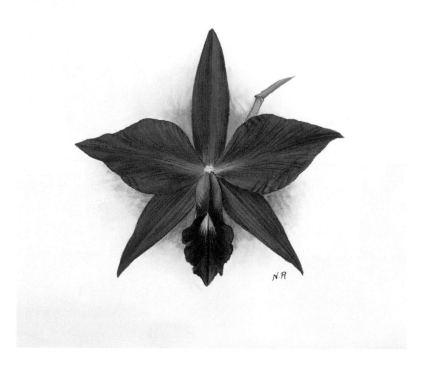

SOPHROLAELIA FELICIA
In form, the *Sophrolaelias* generally reflect the diminutive size of the *Sophronitis* family as well as the pointed, almost heart-shaped lip of the *Laelia* family – as shown here in *Sophrolaelia* Felicia. It is a small plant with disproportionately large flowers. A cross between *Laelia pumila* 'Praestans' and *Sophrolaelia* Heatonensis, it was shown by Charlesworth & Co of Bradford in 1908.

N. R.

SOPHROLAELIA GRATRIXIAE
The richly coloured hybrid *Sophrolaelia* Gratrixiae brings together
two unlikely parents, the magnificent *Laelia tenebrosa* with its dusky
flowers, and the brilliantly flowered miniature *Sophronitis coccinea*.
It was shown by Charlesworth & Co of Bradford in 1907, gaining an
Award of Merit.

SOPHROLAELIA GRATRIXIAE 'MAGNIFICA' & SOPHROLAELIA HEATONENSIS
A good example of the variation possible among the offspring of a single parentage, *Sophrolaelia* Gratrixiae
'Magnifica' (above) again combines *Sophronitis coccinea* and *Laelia tenebrosa*, producing rather less sombre
flowers. It shown in 1907 by F. Menteith Ogilvie of The Shrubbery, Oxford. *Sophrolaelia* Heatonensis
(opposite) brings together another of the larger *Laelia* species, *Laelia purpurata*, with the dwarf
Sophronitis coccinea (syn. *S. grandiflora*). It was shown by Charlesworth & Co in 1902.

N.R.

SOPHROLAELIOCATTLEYA MEDEA
& SOPHROLAELIOCATTLEYA BEACON 'LUSTRISSIMA'
In *Sophrolaeliocattleya Medea* (above), the influence of the Brazilian
Cattleya bicolor can be seen in the protruding tongue-like, cerise lip.
It was shown in 1907 by Sir George Holford of Westonbirt,
Gloucestershire. Shown by H. G. Alexander in 1932, *Sophrolaeliocattleya*
Beacon 'Lustrissima' (opposite) is a splendidly flamboyant hybrid that
shows all of the glory of such immense *Cattleya* species as *C. labiata* and
the intensity of *Sophronitis*.

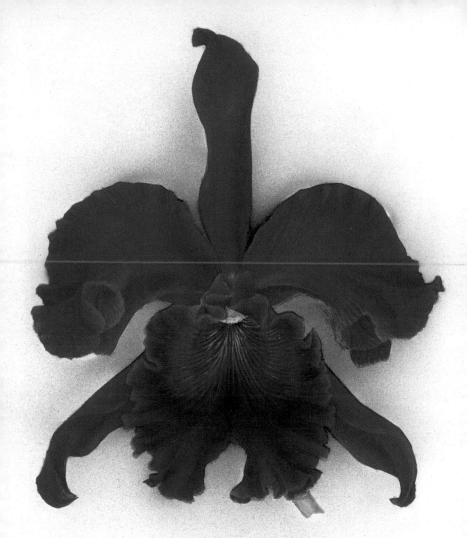

N.R.

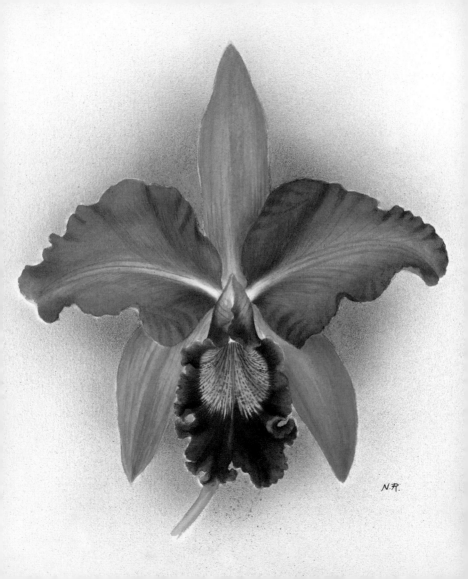

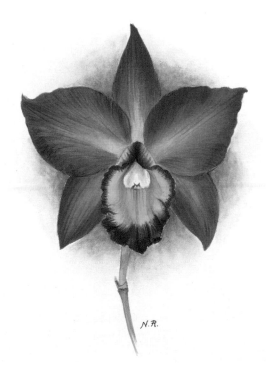

SOPHROLAELIOCATTLEYA ALETHAEA
& SOPHROLAELIOCATTLEYA DANAE 'SUPERBA'

The Venezuelan *Cattleya percivaliana* produces showy, fragrant, lilac-rose flowers.
In *Sophrolaeliocattleya* Alethaea (opposite), it combines with *Sophrolaelia* Gratrixiae
to give longer-lasting blooms with glowing salmon and apricot tints. It was shown
by H. S. Goodson of Putney, London in 1910. In *Sophrolaeliocattleya* Danae 'Superba'
(above), the influence of the *Sophronitis* parent is virtually indiscernible, while the
Cattleya and *Laelia* parents predominate. A cross between *Cattleya harrisoniana* and
Sophrolaelia Laeta, it was shown in 1908 by Sir George Holford of Westonbirt,
Gloucestershire.

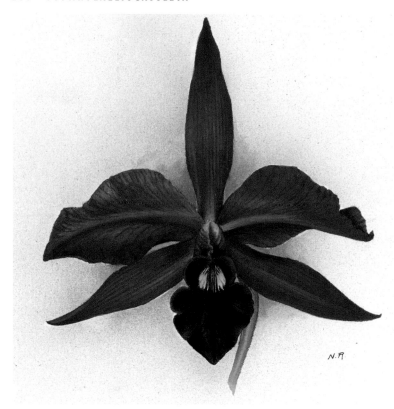

SOPHROLAELIOCATTLEYA GOODSONII & SOPHROLAELIOCATTLEYA NANETTE
Shown in 1911 by H. S. Goodson of Putney, *Sophrolaeliocattleya* Goodsonii (above) combines
Sophrolaelia Heatonensis and *Laeliocattleya* Luminosa. The flowers owe much to *Laelia* in
shape and the deep colouring of the lip. In contrast, the brilliant pink and blowsy frame of
Sophrolaeliocattleya Nanette (opposite) reflects the influence of its *Cattleya* parentage. A cross
between *Sophrolaeliocattleya* Meuse and *Cattleya* Dinah, it was exhibited in 1930 by J. & A.
McBean of Cooksbridge, Sussex, gaining an Award of Merit.

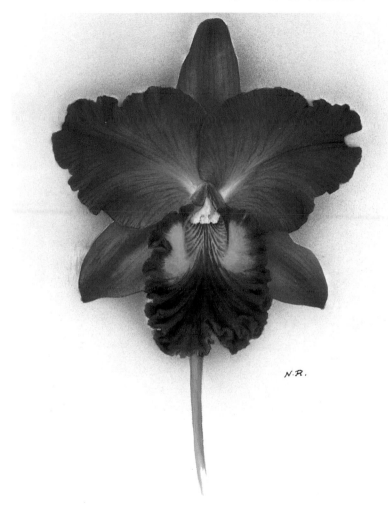

N.R.

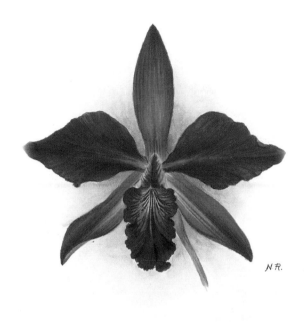

SOPHROLAELIOCATTLEYA ROCKET BURST 'DEEP ENAMEL'
& SOPHROLAELIOCATTLEYA OLIVE
These two examples demonstrate the dwarfing impact of *Sophronitis* parentage. In 1993, the Rod
McLellan Company of San Francisco, California received an Award of Merit for *Sophrolaeliocattleya*
Rocket Burst 'Deep Enamel' (opposite). A cross between *Sophrolaeliocattleya* Rajah's and *Laeliocattleya*
Rojo, it gathers influences from a number of the smaller, fiery-flowered cattleyas and laelias
as well as *Sophronitis coccinea*. The dwarfing, intensifying effect of *Sophronitis* can also be seen in
Sophrolaeliocattleya Olive (above), a cross between *Sophrolaelia* Psyche and *Cattleya* Enid,
exhibited by J. Gurney Fowler of South Woodford, Essex in 1909.

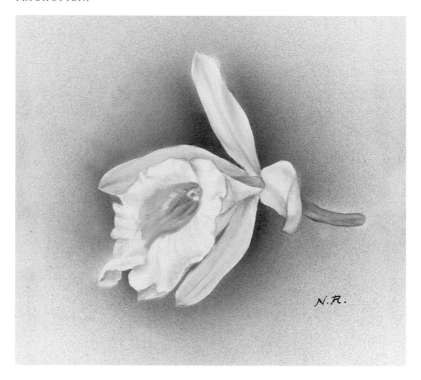

TRICHOPILIA BACKHOUSEANA & TRICHOPILIA BREVIS

Trichopilia is a genus of thirty or so species of epiphytic and lithophytic orchids from the Tropical Americas. Most of them bear large flowers that hang or sit low among the pseudobulbs. Their lips are typically funnel-shaped and the tepals wavy or, in some species, spiralling. *Trichopilia backhouseana* (above) was exhibited by E. R. Ashton of Broadlands, Tunbridge Wells in 1932. *Trichopilia brevis* (opposite) received an Award of Merit when it was shown by Sir Frederick Wigan of East Sheen, Surrey in 1897.

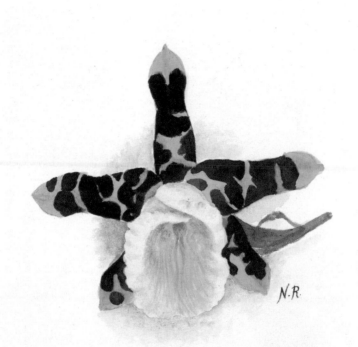

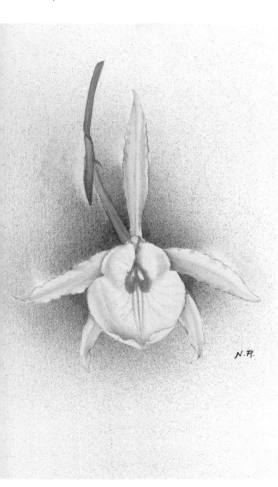

TRICHOPILIA FRAGRANS

(Left) *Trichopilia fragrans* has a widespread distribution, from the West Indies to Peru and Bolivia. Strongly fragrant, its long-lasting flowers are between 7cm and 12cm across and the tepals are characteristically wavy. This example was shown under the name *T. lehmannii* in August 1911 by Sir Trevor Lawrence, the great orchid collector and President of the Royal Horticultural Society.

TRICHOPILIA GOULDII

(Opposite) In the same year, Charlesworth & Co of Bradford received an Award of Merit for *Trichopilia* Gouldii, a cross that combines the species mentioned above, *Trichopilia fragrans*, with the densely spotted *T. suavis*.

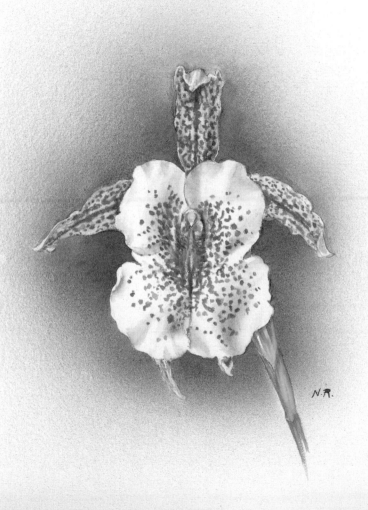

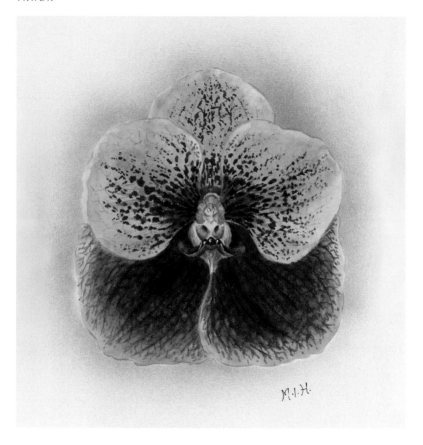

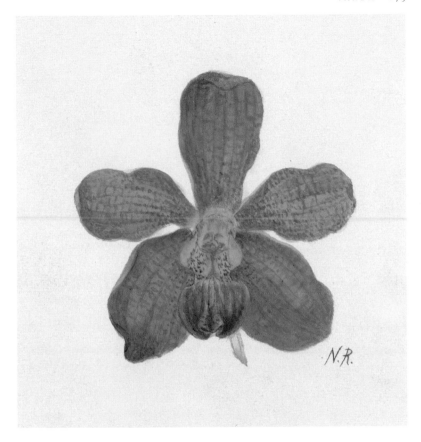

VANDA ADRIENNE 'FLAMBOYANT' & VANDA AMOENA
Vanda Adrienne 'Flamboyant' (above) and *Vanda* Amoena (opposite) show the influence of *Vanda sanderiana* (now known as *Euanthe sanderiana*), a Philippine species with magnificent flat flowers up to 10cm across, in a range of rosy-pink, cinnamon and apricot-yellow tones.

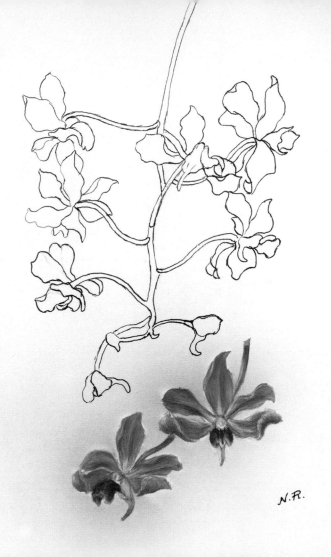

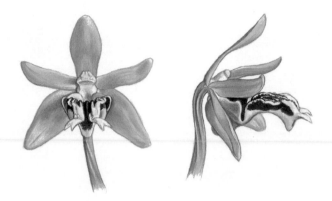

VANDA CRISTATA 'PAT'
(Above) A genus of some thirty-five species found in Asia,
Vanda takes its name from Sanskrit. The plants are monopodial,
with usually strap-shaped leaves lining tall, erect stems in two ranks.
The butterfly-like blooms are carried in racemes that emerge from
the leaf axils. Shown in 1992 by J. Addis of Malvern, Worcestershire,
Vanda cristata 'Pat' is a selected form of a species that is now more
properly known as *Trudelia cristata*. Unlike many true vandas,
it tolerates cool conditions and is an excellent beginner's orchid.

VANDA COERULESCENS 'BLUEBIRD'
(Opposite) *Vanda coerulescens* 'Bluebird' is a selection of a species found
in India, Burma and Thailand that was shown by Sander's of St Albans
in 1945, gaining an Award of Merit. Like the larger-flowered *Vanda
coerulea*, it bears lilac flowers that, for many years, were thought to come
as close to true blue as an orchid can.

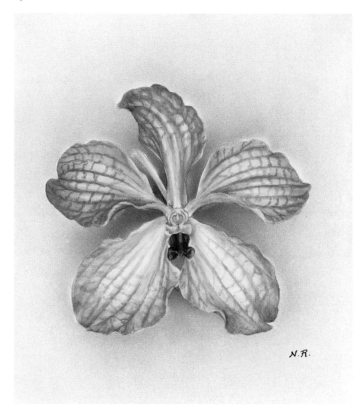

VANDA COERULEA 'THE NODE' & VANDA NALU 'SELSFIELD'
The celebrated 'blue' orchid, *Vanda coerulea* 'The Node' (above) is a native of India, Burma and Thailand with flowers that range in colour from mauve-white to lavender-blue. Because of its unusual colouring and ease of culture, it became much in demand and was heavily collected from the wild. Shown in 1964 by David Sander's Orchids of East Grinstead, *Vanda* Nalu 'Selsfield' (opposite) is one of the many *Vanda coerulea* hybrids (the most famous being *Vanda* Rothschildiana) that have taken the pressure off the wild species.

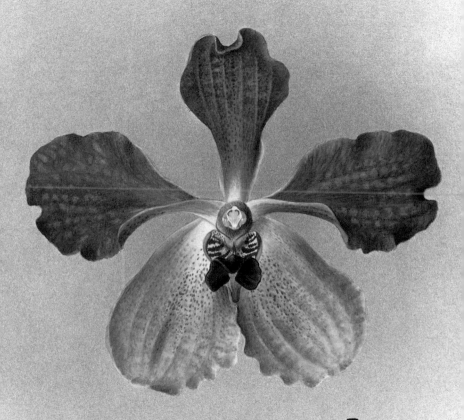

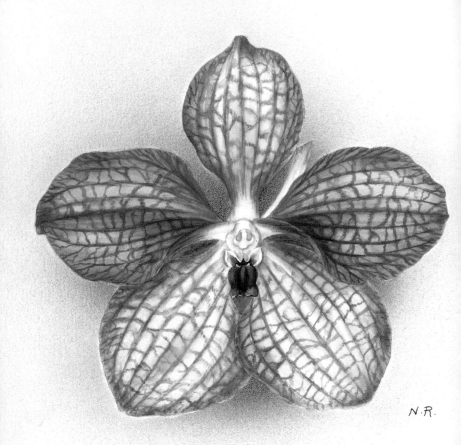

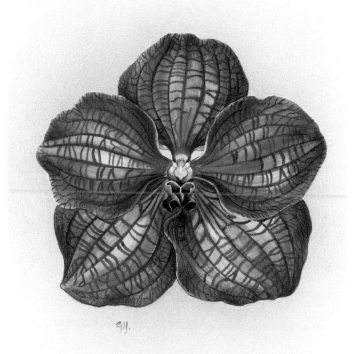

VANDA COERULEA 'WESTONBIRT' & VANDA WIRAT 'BOSS'
One of the finest selections of the legendary blue vanda is *Vanda coerulea* 'Westonbirt'
(opposite), which was exhibited by Sir George Holford of Westonbirt, Gloucestershire
in 1910. The 'blue' of *Vanda coerulea* meets with the large, beautifully marked flowers
of *Euanthe sanderiana* (syn. *Vanda sanderiana*) to give *Vanda* Rothschildiana, with broad
and intricately tessellated lavender–blue blooms. This and grexes like it maintained
their popularity over the twentieth century and are among the most easily grown of
all the vandas. Exhibited by James Lim in 1983, *Vanda* Wirat 'Boss' (above) is a superb
modern reworking of this favourite old cross.

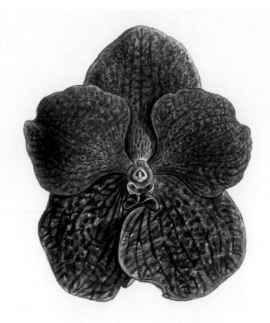

VANDA FUCHS FANFARE 'STONEHURST'
(Above) Showing the influence of *Vanda sanderiana* (*Euanthe sanderiana*)
in its broad and softly coloured flowers, *Vanda* Fuchs Fanfare 'Stonehurst'
is a cross between *Vanda* Laurel Yap and *Vanda* Keeve. It received an Award
of Merit in 1992 when shown by Stonehurst Nurseries of Ardingly, Sussex.

VANDA JANET KANCALI 'GRACE CHEAH'
(Opposite) Much of the important work in *Vanda* hybridisation has taken
place in Malaysia. *Vanda* Janet Kancali 'Grace Cheah' was shown in 1961
by Cheal Kam Yean of Penang, Malaysia.

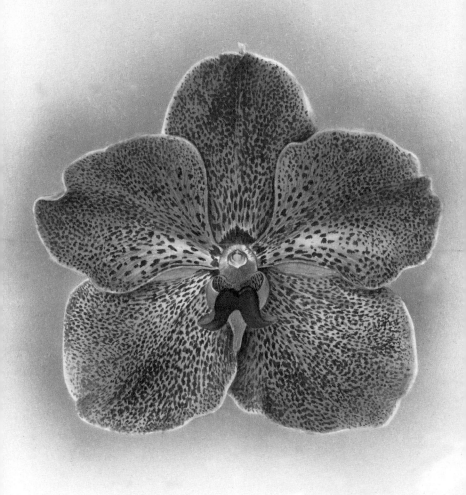

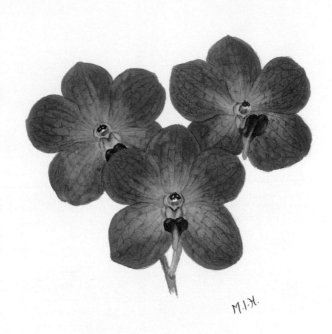

VASCOSTYLIS SUSAN 'ST HELIER'
& VASCOSTYLIS THAM YUEM HAE 'BLUE QUEEN'

Vascostylis are trigeneric hybrids between *Vanda*, *Ascocentrum* and
Rhynchostylis. The resulting plants are usually compact, with ascending
sprays of flat, brilliantly colourful flowers: *Vascostylis* Susan 'St Helier'
(above) is a cross between *Ascocenda* Meda Arnold and *Rhynchovanda*
Blue Angel; *Vascostylis* Tham Yuem Hae 'Blue Queen' (opposite) is a cross
between *Rhynchovanda* Blue Angel and *Ascocenda* Ophelia.

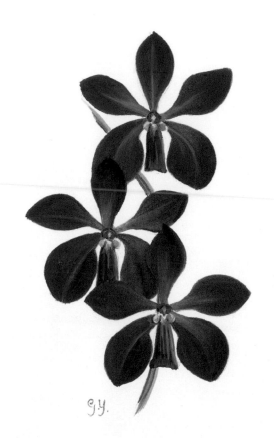

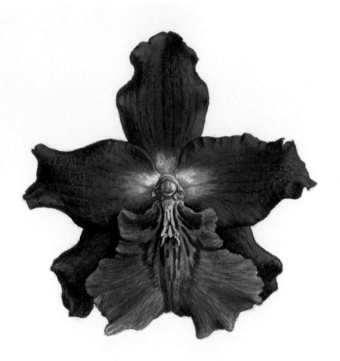

VUYLSTEKEARA ROBIN PITTMAN 'TRINITY'
Vuylstekearas are trigeneric hybrids that involve *Cochlioda*,
Miltonia and *Odontoglossum* in their parentage. Given this
complex pedigree, however, the flowers vary greatly in shape
and size with strong reds and maroons inherited from the
Miltonia and *Cochlioda* parents. *Vuylstekeara* Robin Pittman
'Trinity' takes its rich colouring from *Miltonia spectabilis* and
its ruffled outline from *Odontioda* Les Landes.

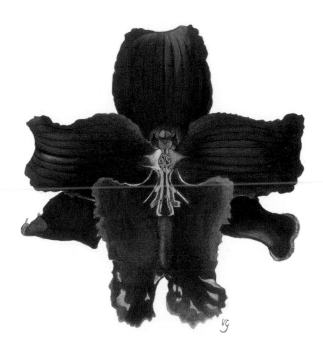

VUYLSTEKEARA ELKARA 'COOKSBRIDGE'
Vuylstekeara Elkara 'Cooksbridge', with its stiff, dark-crimson
waxy petals and frilly lip won an Award of Merit in 1973.
It was shown by Charlesworth, by then a division of
McBean's of Cooksbridge in Sussex.

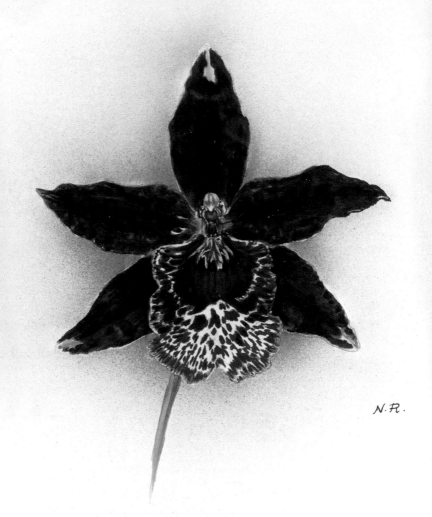

N. R.

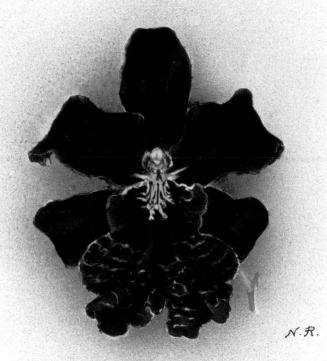

N.R.

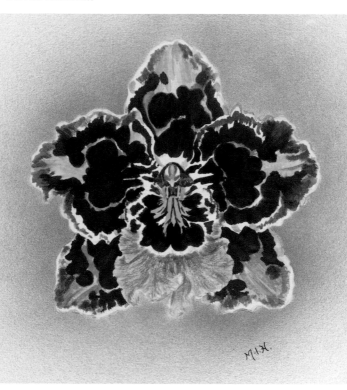

VUYLSTEKEARA CAMBRIA 'CANNIZARO'
(Previous page) *Vuylstekeara* Cambria 'Cannizaro' (left) is
a close relation to what is possibly the best-selling orchid of all,
Vuylstekeara Cambria 'Plush', which became an outstandingly
successful houseplant in the 1980s. This plant is a cross between
Vuylstekeara Rudra and *Odontoglossum* Clonius. The extraordinary
(and somewhat delayed) success of *Vuylstekeara* Cambria poses
the question why other grexes should have been less favoured –
for example, the velvety *Vuylstekeara* Agatha (right).

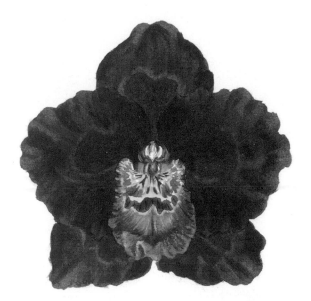

M.I.H.

**VUYLSTEKEARA ELKARA 'LYOTH GEM'
& VUYLSTEKEARA MARAENA 'LYOTH JOY'**
The influence of Odontioda can be seen in *Vuylstekeara* crosses
with rounded, frilly flowers and marbled colouring. *Vuylstekeara*
Elkara 'Lyoth Gem' (opposite) is a cross between *Vuylstekeara* Yokara
and *Odontioda* Elpheon; *Vuylstekeara* Maraena 'Lyoth Joy' (above) is
a cross involving *Odontioda* Andaena and *Odontioda* Astomar.

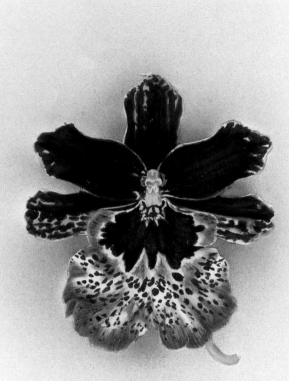

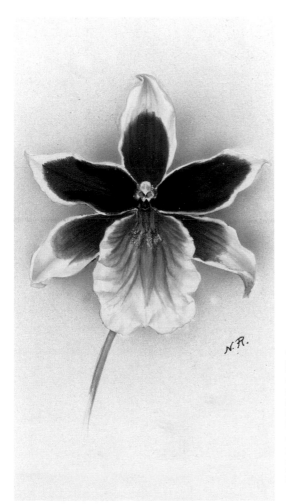

N.R.

VUYLSTEKEARA ESTELLA JEWEL
& VUYLSTEKEARA INSIGNIS
'PICTA'
These two *Vuylstekeara* hybrids from
Charlesworth & Co of Bradford
strongly reflect their *Miltonia*
parents: *Vuylstekeara* Estella Jewel
(opposite), a cross between
Vuylstekeara Aspasia and *Miltonia*
William Pitt; and *Vuylstekeara*
Insignis 'Picta' (left), a cross between
Miltonia Bleuana and *Odontioda*
Charlesworthii. They won Awards of
Merit in 1930 and 1923 respectively.

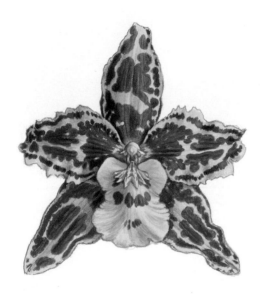

WILSONARA DURHAM SUNSET 'LYOTH SUNSET'
& WILSONARA DURHAM INGOT 'LYOTH SUPREME'
Three genera are involved in the parentage of *Wilsonara*: *Cochlioda*, *Odontoglossum* and
Oncidium. One of the earliest trigeneric crosses, in practice *Wilsonara* usually entails
crossing *Odontioda* (*Odontoglossum* and *Cochlioda*) with *Oncidium* or *Odontocidium*
(*Odontoglossum* and *Oncidium*). They are excellent plants for amateur greenhouses and
for growing in the home, producing large and long-lived panicles of small but vividly
colourful, satiny flowers. *Wilsonara* Durham Sunset 'Lyoth Sunset' (above) matches
Odontocidium Tiger Butter with *Odontioda* Astmo. It was shown by Charlesworth,
a division of McBean's Orchids of Cooksbridge, Sussex in 1994. *Wilsonara* Sussex Gold
crossed with *Odontioda* Ingmar produces *Wilsonara* Durham Ingot 'Lyoth Supreme'
(opposite), shown by McBean's Orchids in 1990.

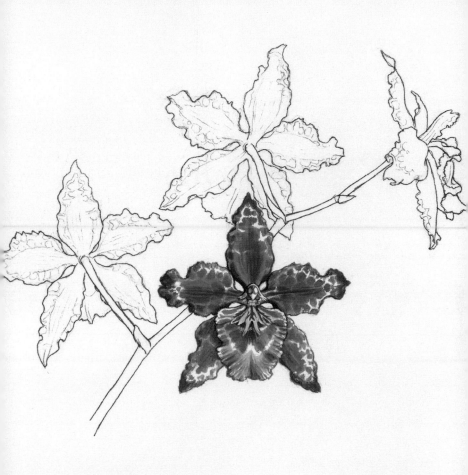

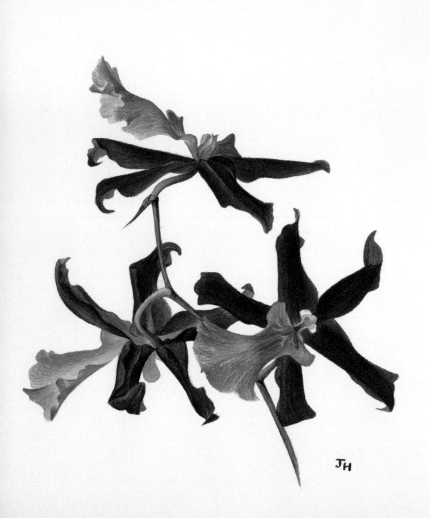

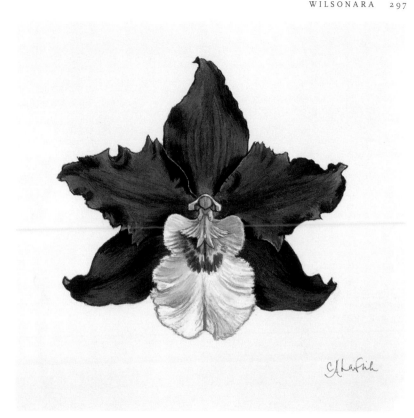

WILSONARA MYSTERY 'WICS' & WILSONARA MARVIDA 'LYOTH NIGHT'
The Brazilian species *Oncidium tigrinum* combines with *Wilsonara* Tigrina to produce
Wilsonara Mystery 'Wics' (opposite), which won an Award of Merit for David Sander
Orchids of East Grinstead when it was exhibited in 1965. Shown by Charlesworth
(by then a division of McBean's) in 1991, *Wilsonara* Marvida 'Lyoth Night' (above) is
a cross between *Oncidium tigrinum* and *Odontioda* Fremar.

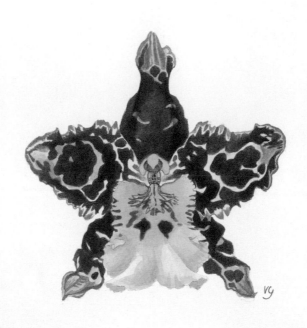

WILSONARA CELLE 'VENUS'
The striking contrast between the creamy yellow lip and intriguing pink patternimg on the petals of this hybrid helped H. Wichmann & Son of Celle in Germany to an Award of Merit in 1973. *Wilsonara* Celle 'Venus' is a cross between *Oncidium tigrinum* and *Odontioda* Margia.

WILSONARA DURHAM VISION 'LYOTH GLOBE'
Wilsonara Durham Vision 'Lyoth Globe' is a cross between *Odontocidium* Crowborough and *Odontioda* Pacific Gold. As the second parental name suggests, this hybrid is distinctive for the pattern of tan mottling against a brilliant-gold background. It won an Award of Merit for Charlesworth in 1993.

WILSONARA HYBRIDS

Many wilsonaras show the influence of the Mexican species *Oncidium tigrinum*. Here it is crossed with *Odontioda* Trixon to produce *Wilsonara* Uruapan 'Tyrone' (below, left); with *Odontioda* Esterel to produce *Wilsonara* Ravissement 'La Reunion' (below, right); with *Odontioda* Grouse Mount to produce *Wilsonara* Five Oaks 'Jersey' (right); and with *Odontioda* Taw to produce *Wilsonara* Tiger Talk 'Beacon' (overleaf, left). Also native to Mexico, as well as Honduras and Guatemala, *Oncidium leucochilum* bears small, chocolate-blotched flowers in masses on large branching sprays. Here it combines with *Odontioda* Carmine to produce *Wilsonara* Jean DuPont 'Clown Loach' (opposite), a hybrid exhibited by Tom Perlite of Golden Gate Orchids, San Francisco in 1996. Shown by David Stead Orchids of Wakefield in Yorkshire and raised by George Black of Brize Norton, Oxfordshire, *Wilsonara* Harvest Moon 'Spring Promise' (overleaf, right) is a cross between *Wilsonara* Tigerwood and *Odontioda* Dorold that received an Award of Merit in 1984.

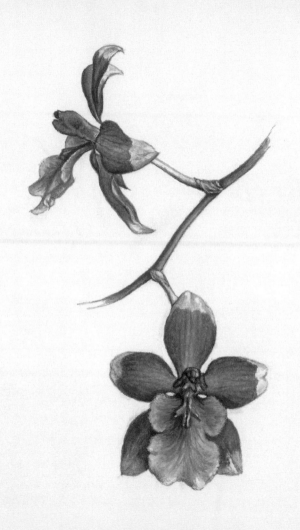

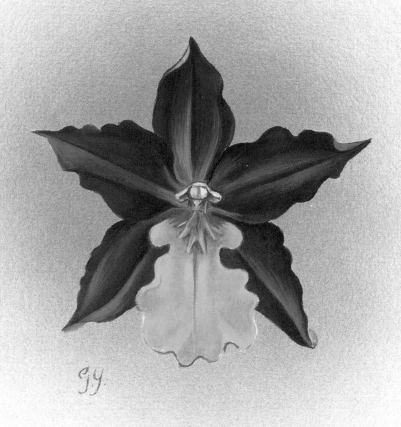

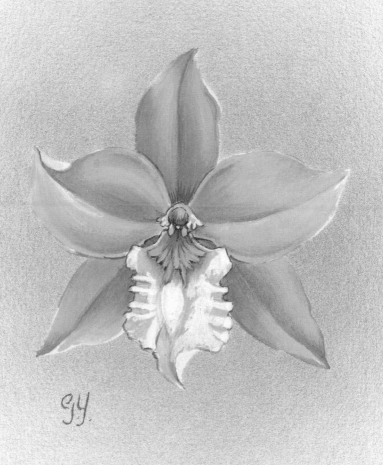

ZYGOCOLAX CHARLESWORTHII 'RUBIDA'

The genus *Zygopetalum* takes its name from the Greek *zygon*, 'yoke', and *petalon*, 'petal',
a reference to the fusion of the tepals to the base of the floral column. Their flowers have maroon-
banded or -blotched tepals and a contrasting mauve lip. They hybridise readily with other genera
in the subtribe *Zygopetalinae*. *Zygocolax* Charlesworthii 'Rubida' is a cross between *Zygopetalum*
Perrenoudii and *Pabstia jugosa* (syn. *Colax jugosus*), a species from Brazil with sparkling white
flowers whose petals and lip are heavily patterned with burgundy.

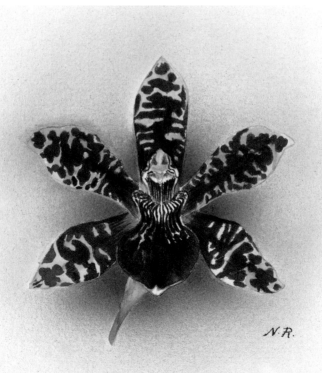

ZYGOCOLAX LEOPARDINUS 'WIGAN'S'

A species from Brazil and Paraguay, *Zygopetalum maxillare* produces tall spikes of flowers each over 6cm across, waxy-textured and heavily scented of hyacinths. The tepals are apple green to olive blotched with chestnut, and the lip violet-purple to indigo. Its influence is clear in this hybrid, *Zygocolax* Leopardinus 'Wigan's', while the role of *Pabstia jugosa* (syn. *Colax jugosus*) is less evident. It was shown by Sir Frederick Wigan in 1900.

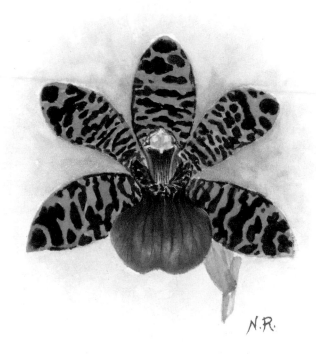

N·R·

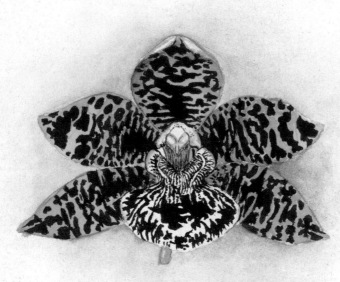

N.R.

ZYGOCOLAX WIGANIANUS 'SUPERBUS'
In 1902, Sander's of St Albans exhibited *Zygocolax* Wiganianus 'Superbus' (above),
a cross between *Zygopetalum intermedium* and *Pabstia jugosa* (syn. *Colax jugosus*). A species
from Peru, Bolivia and Brazil, *Zygopetalum intermedium* bears heavily scented flowers with
chocolate-blotched, green tepals and a violet-veined white lip. The *Pabstia* parent gives this
hybrid rather cupped flowers with far heavier markings. In 1899, Sander's received an
Award of Merit for *Zygocolax* Amesianus (opposite), a hybrid between the Brazilian
Zygopetalum brachypetalum and *Pabstia jugosa* (syn. *Colax jugosus*).

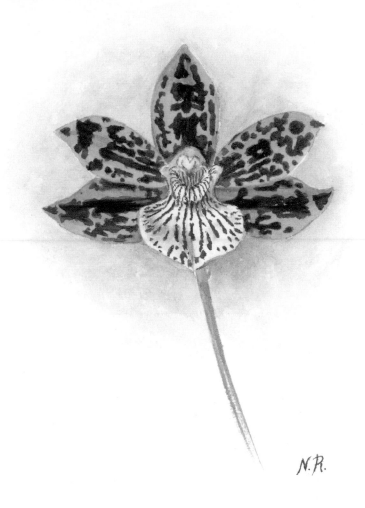

N.R.

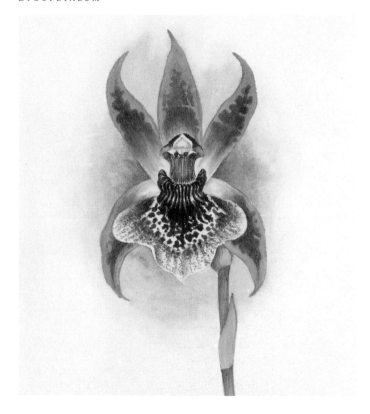

ZYGOPETALUM ROEBLINGIANUM & ZYGOPETALUM BREWII
Closely related to *Zygopetalum*, *Zygosepalum* is found in Venezuela, Colombia,
Brazil and Peru. *Zygosepalum labiosum* (syn. *Zygopetalum rostratum*) produces large,
solitary flowers on tall stalks. Here it is crossed with *Zygopetalum maxillare* to give
Zygopetalum Roeblingianum (above), a hybrid shown in 1903. *Zygopetalum* Brewii
(opposite), shown in 1912, is a cross between *Zygopetalum* Perrenoudii and
Zygosepalum labiosum (syn. *Zygopetalum rostratum*). With slender, outstretched tepals
and an elaborately veined lip, the cross favours its *Zygosepalum* parent.

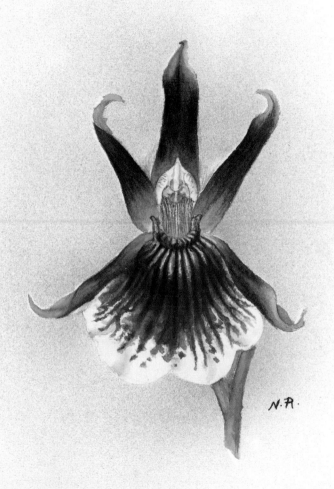

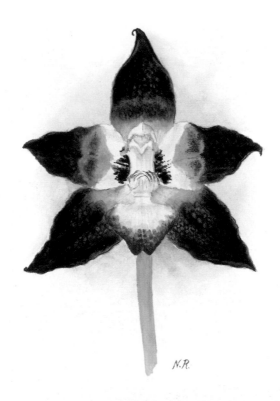

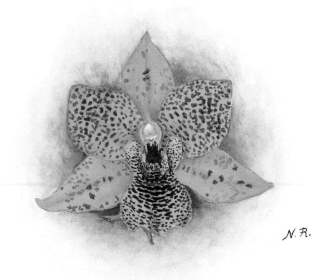

N. R.

HUNTLEYA BURTII (SYN. AYGOPETALUM BURTII)

(Opposite) *Huntleya burtii* (syn. *Zygopetalum burtii*) is a magnificent epiphyte from the forests of Central and South America. Its large, solitary flowers are borne in the axils of strap-shaped leaves. Lime green and arranged in fans, the foliage contrasts elegantly with the deep mahogany tepals with their glossy, diamond-patterned surfaces. *Huntleya* is closely related to *Zygopetalum* and, for the purposes of registration, tends to be included in it. This form, named 'Pitt's', was shown by H. T. Pitt of Stamford Hill, London in 1900.

ZYGOPETALUM CRAWSHAYANUM

(Above) Another distinctive genus that was formerly included in *Zygopetalum* is *Promenaea*. Unlike *Huntleya*, these are dwarf plants with disproportionately large flowers. Registered as *Zygopetalum* Crawshayanum, this hybrid brings together the two most popular *Promenaea* species, *P. xanthina* and *P. stapelioides* – the first has ginger-freckled, golden flowers, and the second has flowers that are ivory spattered with maroon and dark violet.

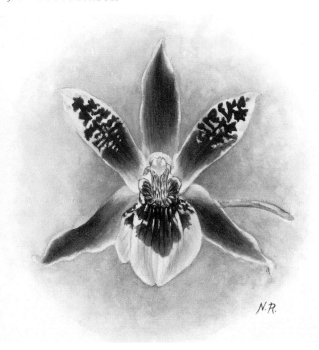

ZYGOPETALUM BALLII
& ZYGOPETALUM PERRENOUDII 'SUPERBUM'
These two hybrids from the *Zygopetalum* alliance show the variation and
potentialities within this group. Shown by G. Shorland Ball of Cheshire,
the dramatic white and pink *Zygopetalum* Ballii (above) received an
Award of Merit in 1900. Three years earlier, James Veitch & Sons of
Chelsea showed *Zygopetalum* Perrenoudii 'Superbum' (opposite), a cross
with *Z. maxillare* 'Gautieri' in its parentage.

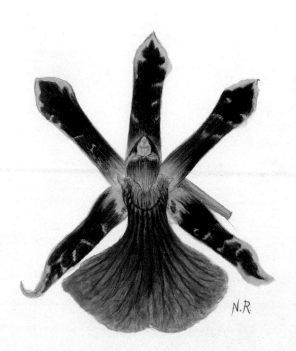

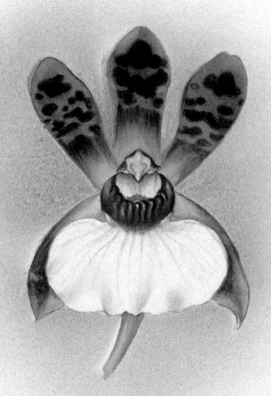

ZYGOPETALUM MAXILLARE 'SANDERIANUM'

(Opposite) In 1912, the great orchid amateur and President of the Royal Horticultural Society, Sir Trevor Lawrence brought this specimen to London from the orchid houses at his country seat, Burford, near Dorking in Surrey. Named *Zygopetalum maxillare* 'Sanderianum', it is an exceptional example of a species found in Brazil and Peru. One of the most striking features of its 7cm-wide flowers is the half-moon of fleshy, purple-pink callus at the base of the lip which acts as an attractant and guide for pollinators.

COCHLEANTHES AMAZONICA (syn. ZYGOPETALUM LINDENII)

(Left) *Cochleanthes* takes its name from the Greek, *kochlos*, 'a shell' – a reference to the shape of the lip. A genus of seventeen species, it is found in Central and South America, growing epiphytically in cloud forest. In 1892, the great Luxembourg-born plant hunter and nurseryman Jean Jules Linden (1817–1898) presented this specimen of *Cochleanthes amazonica* (syn. *Zygopetalum* Lindenii). A native of the Amazon, it has the largest flowers of any in the genus (to 7cm across), with the lip veining ranging in colour from violet to opaline blue.

ZYGOPETALUM HYBRIDS

Toward the end of the twentieth century, interest in members of the *Zygopetalum* alliance revived. Two of the hybrids that helped trigger this reversal in fortune were *Zygopetalum* James Strauss 'Stonehurst' (overleaf, left), raised by Stonehurst Orchids and shown by Derek Strauss of Stonehurst, Ardingly, Sussex in 1984; and *Zygopetalum* John Banks 'Remembrance' (overleaf, right), shown by Wyld Court Orchids of Newbury in 1977.

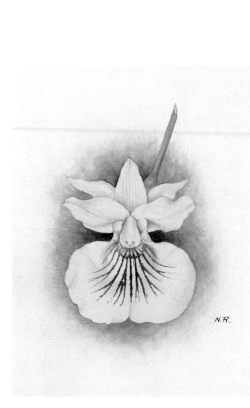

N.R.

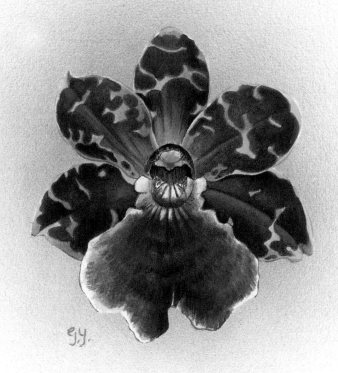

ZYGOPETALUM JORISIANUM
(Opposite) When Walter Cobb of Tunbridge Wells in Kent exhibited it in 1897, this
species from Brazil and Venezuela was known as *Zygopetalum jorisianum*. Later the
orchidologist A. D. Hawkes placed it (as *Mendoncella jorisiana*) in a new genus, whose
name commemorates Luis Mendonca, editor of the orchid journal *Orquidea*. Many of
the twelve or so species of *Mendoncella* have conspicuously fringed lips like this one.

ZYGOPETALUM CRINITUM 'COERULEUM'
(Above) A species from eastern Brazil, *Zygopetalum crinitum* bears large, long-lasting
and highly fragrant flowers with a characteristic pattern of radiating lines on the lip.
In this striking form, 'Coeruleum', shown by Charlesworth & Co in 1903, the lip
markings are violet verging on indigo – a colour that is especially valued among
orchid growers, even if it is not quite true blue.

ODONTIODA BECQUET VINCENT 'SAINT HELIER'

BIOGRAPHIES & LIST OF ILLUSTRATIONS

BIOGRAPHIES

OAKES AMES (1874–1950)

Oakes Ames came from an eminent Massachusetts family, and was educated at Harvard. Most of his career was spent as Director of the Harvard Botanical Garden, and latterly as Professor of Botany. Orchids were his principal interest, and he achieved the same international eminence that Lindley and Reichenbach had previously enjoyed. In 1905 he travelled to the Philippines to study their orchids, on which he became the principal expert; but his intended ten-volume work on the subject was destroyed during the Second World War. His collected papers on orchids were published in seven volumes as *Orchidaceae*; they included illustrations by his wife Blanche.

JAMES BATEMAN (1812–1897)

James Bateman made his fortune from banking and ironfounding. At his garden at Knypersley Hall, Staffordshire, he built greenhouses to house an important orchid collection, which he augmented by hiring, first Thomas Colley, and then George Ure Skinner, to collect orchids for him in Central and South America. On the basis of this collection he published the massive *Orchidaceae of Mexico and Guatemala* (1837–43), as well as *A Monograph of Odontoglossum* (1864–74), and *A Second Century of Orchidaceous Plants* (1967). In the late 1840s he acquired Biddulph Grange, also in Staffordshire, where with the help of the painter Edward Cooke he made a celebrated garden, currently owned and restored by the National Trust.

WILLIAM BOXALL (1844–1910)

Boxall began his career with the Veitch Nurseries in Chelsea in the 1860s, and later moved to Hugh Low and Company in Clapton, where he became foreman. His greatest fame, however, came as a plant collector, especially of orchids, for which he travelled in Burma, the Philippines, Borneo, Indonesia, and Central and South America. Reichenbach named *Dendrobium boxallii* in his honour. Diabetes and a stroke put an end to his collecting activisites in 1907; he retired to Clapton, and devoted his time to the RHS Orchid Committee.

CHARLES DARWIN (1809–1882)

Charles Darwin was the grandson of Erasmus Darwin, who had proposed a theory of evolution in the late eighteenth century. From 1831 to 1836 he was the naturalist on board HMS Beagle on a round-the-world expedition; in addition to publishing his journal of the voyage and the results of its collections, he also published a work on coral reefs. In 1859 he published *On the Origin of Species*, in which he launched his theory of natural selection as the means whereby populations differentiated into separate species. Most of his later works were botanical, with *The Various Contrivances by which Orchids are Fertilised by Insects* (1862) the most relevant to this book. Among his other botanical works were *Insectivorous Plants* (1975), *The Different Forms of Flowers on Plants of the Same Species* (1877), and *The Power of Movement in Plants* (1880).

JOHN DOMINY (1816–1891) AND JOHN SEDEN

John Dominy, after training at the Devonshire nursery of Lucombe, Pince & Co., entered the Exeter branch of the Veitch nurseries, later moving to their London headquarters. During the 1850s he began breeding orchids, and in 1856 announced the first artificially produced orchid hybrid, *Calanthe dominyi*. Dominy went on to produce twenty-five viable hybrids. He retired in 1880. His main successor as the Veitch hybridist was John Seden, who had joined the firm in 1861. Taught by Dominy, Seden went on to breed further hybrid orchids, as well as greenhouse foliage plants and fruits, to the eventual number of 490 crosses.

WALTER HOOD FITCH (1817–1892)

Walter Hood Fitch made over 2700 plates for *Curtis's Botanical Magazine* from 1834 to 1877, as well as illustrations for *Icones Plantarum*, Hooker's *Rhododendrons of Sikkim-Himalaya*, and Elwes' *Monograph of the Genus Lilium*. He frequently drew directly onto the lithographic stone, so that no separate original drawings survive for some of his works. He produced so much work that his reputation for facility came to be held against him, but his drawings always illustrated the accompanying description with great accuracy. Orchids appear frequently in his work, most often in the *Botanical Magazine*. Walter's son, John Nugent Fitch (1840–1927), succeeded him in the profession, making 2500 *Botanical Magazine* plates in his turn. He developed a style of illustrating orchid hybrids, depicting the flower alone, that was greatly influential. His major collection of orchid illustrations was made for *The Orchid Album*, compiled by B. S. Williams and Robert Warner.

JOHN GIBSON (1815–1875)

John Gibson became an apprentice gardener at Chatsworth at the age of seventeen, working under Joseph Paxton. He quickly became interested in orchids, and was sent to work briefly with Joseph Cooper, a successful grower of exotic plants. In 1835 the Duke of Devonshire arranged for Gibson to travel to India accompanying the new Governor General, Lord Auckland, in order to collect orchids and other tropical plants. He returned in 1837 with many orchids, some of them new species. He was appointed foreman of the exotic collection at Chatsworth, where he remained until 1849, when he became superintendent of the new Royal Parks, most notably Battersea Park, which he largely designed.

JOSEPH DALTON HOOKER (1817–1911)

The son of Sir William Jackson Hooker, the first Director of the Royal Botanic Gardens, Kew, Joseph was the botanist on the expedition of the *Erebus* (1839–43); From 1848 to 1851 he collected plants in the Himalayas 1848–51, introducing 26 species of rhododendrons into England and publishing three major books, *The Rhododendrons of Sikkim-Himalaya* (1849–51), *Illustrations of Himalayan Plants* (1855), and *Himalayan Journals* (1854). He later collaborated with George Bentham on *Genera Plantarum* (1862–83), and compiled the massive *Flora of British India* (1872–97). An early supporter of Darwin, he succeeded his father as Director of Kew from 1865 to 1887. His work on orchids is scattered through the many floras and expedition reports he published.

CHERRY-ANN LAVRIH (UNKNOWN)

Cherry-Ann Lavrih grew up in Kingston, Surrey, studying at the Kingston School of Art, and then the Brighton College of Art. For a time she was head of the art department at Whyteleafe Grammar School for Girls. During the 1980s she made illustrations for *The Kew Magazine* and *The Plantsman*. In 1987 she was appointed the RHS Orchid Artist, and has held that position ever since, painting nearly 700 orchids by the time this book is published. Many of her best works are published in these pages.

JEAN LINDEN (1817–1898)

Jean Linden conducted one of the first scientific expeditions commissioned by the Belgian government; from 1835 to 1837, he travelled through South America, collecting plants, and afterwards continued to do so as a collector for a group of English orchid growers. Returning to Europe in 1845, he set up a nursery at Ghent. Later, with his son Lucien, he set up a larger nursery called Horticulture Internationale at Brussels. He edited or published two journals, *Illustration Horticole* and the specialist orchid journal *Lindenia*. He eventually became consul for Luxembourg and Director of the Brussels Zoological Gardens.

JOHN LINDLEY (1799–1865)

Lindley, the son of a Norfolk nurseryman, served as an Assistant Secretary of the Horticultural Society, in which capacity he identified plants brought back by the Society's collectors, ran flower shows, and edited the Society's publications. He was also Professor of Botany at University College, London, and founder-editor of the gardening newspaper *The Gardeners' Chronicle*. His involvement with Orchidaceae began with his work for William Cattley, after whom he named the genus *Cattleya*. He was the first botanist to work out a classification of orchids, and wrote prolifically on the subject, most notable works being the *Sertum Orchidaceum* (1838) and *The Genera and Species of Orchidaceous Plants* (1830–40). He has been called the father of modern orchidology, and the American Orchid Society has named its scientific journal *Lindleyana* in his honour. His personal library, bought by the Society after his death, formed the nucleus of the present-day Lindley Library.

HUGH LOW (1824–1905)

Hugh Low was born into a nursery family (Hugh Low and Company was established in London in 1820). In the early 1840s he went to work for the East India Company, and became a friend of James Brooke, the founder of the Sarawak colony, where he travelled in 1845, eventually becoming the Colonial Treasurer. In 1848 he published a book about the country and his experiences there. In 1851 he climbed Mount Kinabalu in search of orchids. In 1876 he was made the Chief Resident of the Perak colony in Borneo, and devoted the next decade and a half to reforming the colonial administration.

SIR JOSEPH PAXTON (1803–1865)

Paxton, the son of a Bedfordshire farmer, became an

(Left to right)
James Bateman,
Charles Darwin,
Joseph Dalton Hooker.

apprentice gardener at the Horticultural Society's new garden at Chiswick in 1823; three years later, he was swept off by the Duke of Devonshire to be head gardener at Chatsworth in Derbyshire. He was soon making alterations to the grounds, and designing glasshouses; before the end of the 1830s he had begun designing gardens and glasshouses for other owners and for local corporations; in 1843–47 he laid out Birkenhead Park, perhaps the first true public park in England. In 1850 he was contracted to design the Great Exhibition building in Hyde Park the following year; christened the Crystal Palace, it was re-erected on a grander scale on Sydenham Hill in south London after the Exhibition ended. Paxton was one of the most important figures in the history of greenhouse cultivation, both for innovating prefabricated building (including his patent 'Glasshouses for the Million') and for his skills in practical cultivation. He ended his days a millionnaire and a Member of Parliament.

HEINRICH GUSTAV REICHENBACH (1823–1889)

H. G. Reichenbach was the son of H. G. L. Reichenbach, the Director of the Dresden Botanical Garden and the compiler of the *Icones Florae Germanicae*. Young Reichenbach devoted himself to orchids, publishing a three-volume work (*Xenia Orchidacea*, 1854–83) and many articles; after the death of John Lindley, he became Europe's foremost authority on orchids. In 1883, the nurseryman Frederick Sander began publishing a massive illustrated orchid work named *Reichenbachia* in his honour. His will left his specimens, notes and drawings to the Hofmuseum in Vienna, on condition that no one could have access to them for twenty-five years; the

international orchid community was outraged, but by the time access was allowed, orchidology had moved on and caught up with Reichenbach's work.

NELLIE ROBERTS (1872–1959), JEANNE HOLGATE (1920–), & IRIS HUMPHREYS (UNKNOWN)

These three artists recorded the prize-winning orchids of the RHS Orchid Committee for almost a century between them. In 1896 the committee appointed Nellie Roberts its official orchid painter; her job was to depict all the award-winning orchids at the Society's shows. She had already been painting orchids for Sir Trevor Lawrence, the Society's President, in a style influenced by John Nugent Fitch and J. L. Macfarlane. She held her post for over fifty years, and was awarded the Veitch Memorial Medal on her retirement in 1953. Her successor was Jeanne Holgate, a former teacher at the Royal College of Art, who was given a silver trophy by the 5th World Orchid Conference in 1966. She in her turn was succeeded in 1966 by M. Iris Humphreys, who had begun painting orchids for the firm of Charlesworth in the 1930s; her husband, J. L. Humphreys, moved to Armstrong and Brown in 1936, later becoming its Director. Mrs Humphreys also made illustrations for *The Orchid Review*, and was awarded the Westonbirt Orchid Medal in 1977.

BENEDIKT ROEZL (1823–1885)

Benedikt Roezl was born in Prague, and worked as a gardener at various estates in central Europe and Belgium. In 1854 he travelled to Mexico, where he started a fruit nursery. In 1867 he lost his left hand while demonstrating a machine he had invented for extracting hemp fibres.

(Left to right)
**John Lindley,
Heinrich Gustav Reichenbach,
George Ure Skinner.**

About 1870 he began collecting orchids for Frederick Sander, sending back enormous quantities of plants, from 3000 to 10,000 specimens at a time, before finally retiring once again to Prague. He discovered some 800 species, but also earned an ambiguous reputation for virtually clearing natural sites of their orchid populations.

FREDERICK SANDER (1847–1920)
Henry Frederick Conrad Sander was born in Germany, and moved to England at the age of twenty in order to work in English nurseries. At the seed house of James Carter and Co., he met Benedikt Roezl, whom he persuaded to collect orchids for him. Sander set up his own firm in St Albans, Hertfordshire, and as the 1870s progressed gradually became famous for the range and quality of his collections. In the 1880s and 1890s his firm established branches in New Jersey and Belgium. He published an enormous illustrated book on orchids entitled *Reichenbachia*, in honour of the German orchidologist. Before the First World War, his firm also started maintaining a register of orchid hybrids; this was eventually, after the closure of the St Albans nursery, taken over by the Royal Horticultural Society; today, it is the International Register, and still bears the name of *Sander's List of Orchid Hybrids*.

FRIEDRICH SCHLECHTER (1872–1925)
Friedrich Richard Rudolf Schlechter was born in Berlin, and at the age of 19 began a career of plant hunting, beginning in the German colonies in Africa. In the first decade of the twentieth century he made two expeditions to New Guinea, publishing *Die Orchidaceen von Deutsch-*

Neu-Guinea in 1911–14. He built up an immense orchid herbarium at the Botanical Museum at Berlin-Dahlem, which was destroyed during the Second World War. His great monograph, *Die Orchideen*, first appeared in 1914–15; a revised edition was published posthumously; and a third edition began appearing in 1970, and is still in progress.

GEORGE URE SKINNER (1804–1867)
George Ure Skinner began his career as a merchant with connections in Guatemala, where he went in 1831 to found the firm of Klee, Skinner, and Co. While there, he was hired by James Bateman to collect orchids for him, and ended by introducing nearly 100 species, including the first odontoglossums. Bateman said of him, 'He may truly be said to have been the means of introducing a greater number of new and beautiful Orchidaceae into Europe than any one individual of his own or any other nation'. He died in Panama, while attempting to wind up his American affairs so as to retire to England.

SIR HARRY VEITCH (1840–1924)
Harry James Veitch was the second son of James Veitch, who had developed the century's major nursery in Chelsea. After training abroad, he entered the family firm, and became responsible for its programme of plant collection and hybridisation. He was the head of the firm from 1890 until he retired in 1914 and sold off the firm's collections and land. Among the collectors sent out by his firm were the brothers William and Thomas Lobb, John Gould Veitch, Richard Pearce, and F. W. Burbidge, all of whom brought back important orchid introductions.

LIST OF ILLUSTRATIONS

THE ORCHIDACEÆ OF

G. Cruikshank del.

INDEX

Page numbers in italics refer to illustrations

ACKNOWLEDGEMENTS

The publisher and author would like to thank everyone who helped with the production of this title.

Special thanks to all at the RHS and the RHS Lindley Library for their help and support, especially
 Susanne Mitchell,
 Brent Elliott & Jennifer Vine.

Thanks also to
 Photography of Original Artworks: Rodney Todd-White & Son.
 Colour Separation: Bright Arts Pty, Singapore